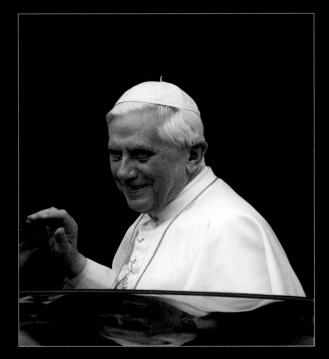

"*Dear brothers and sisters, after the great Pope John Paul II, the cardinals have elected me — a simple, humble worker in the vineyard of the Lord.*"

Benedictus PP XVI

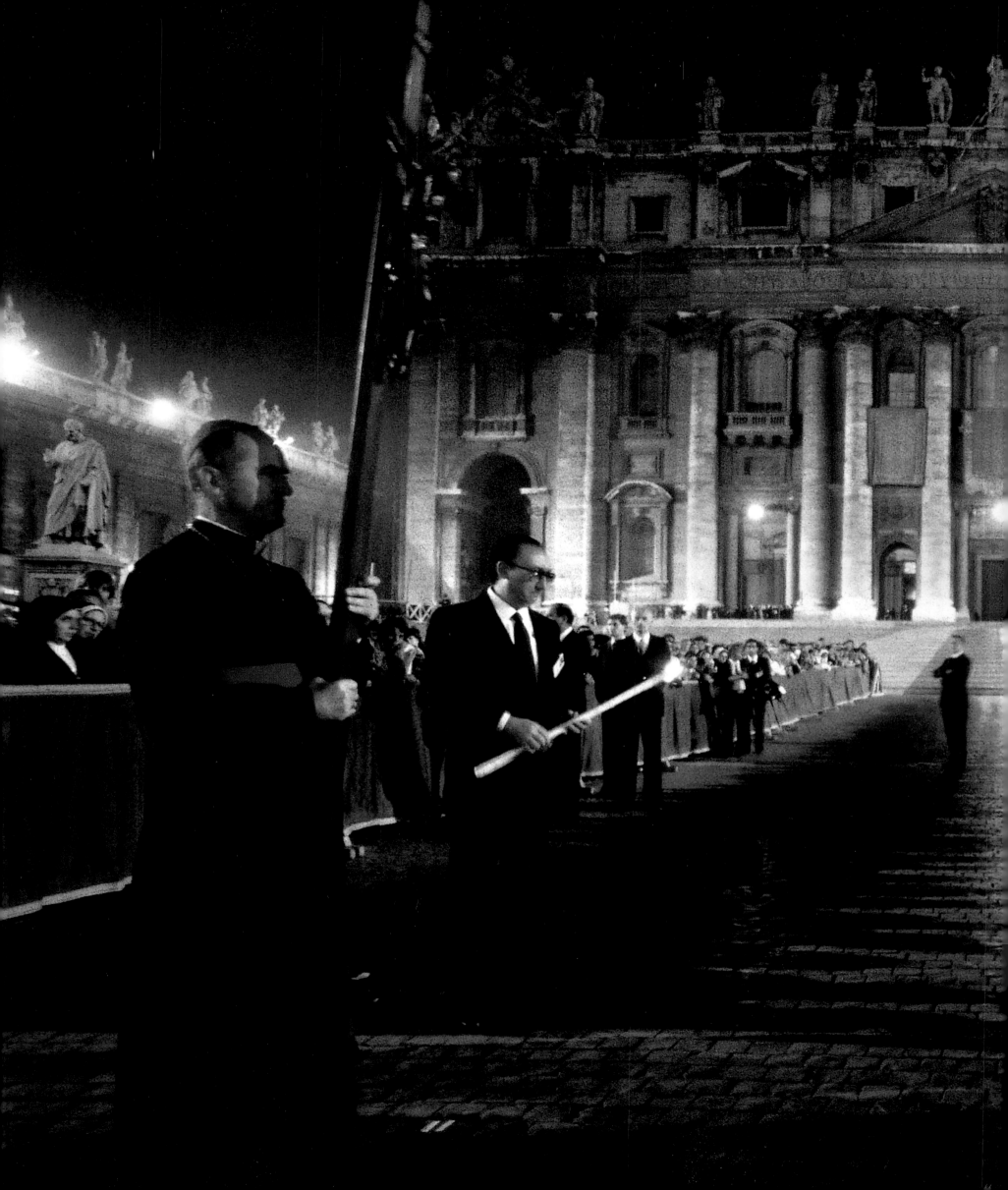

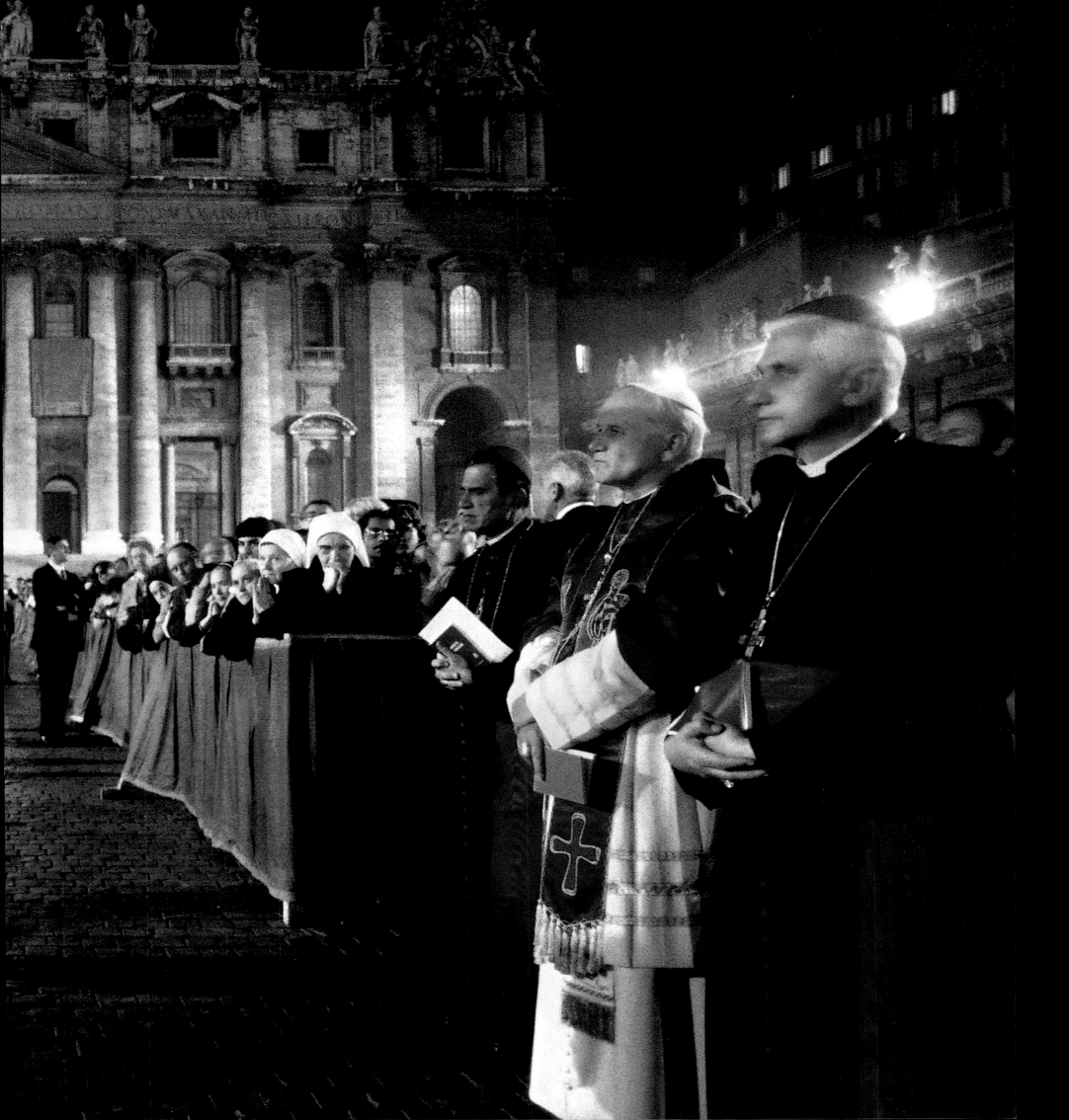

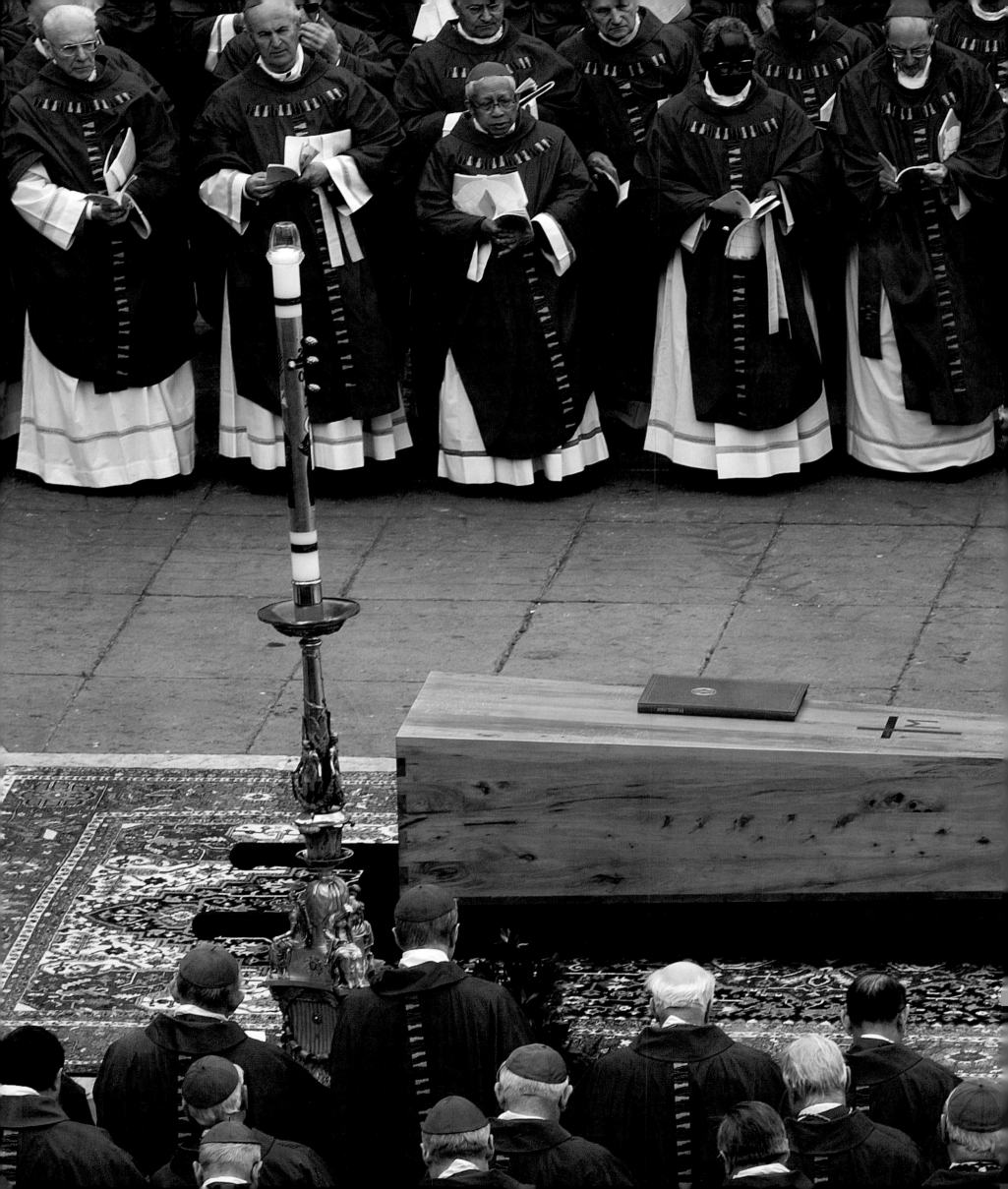

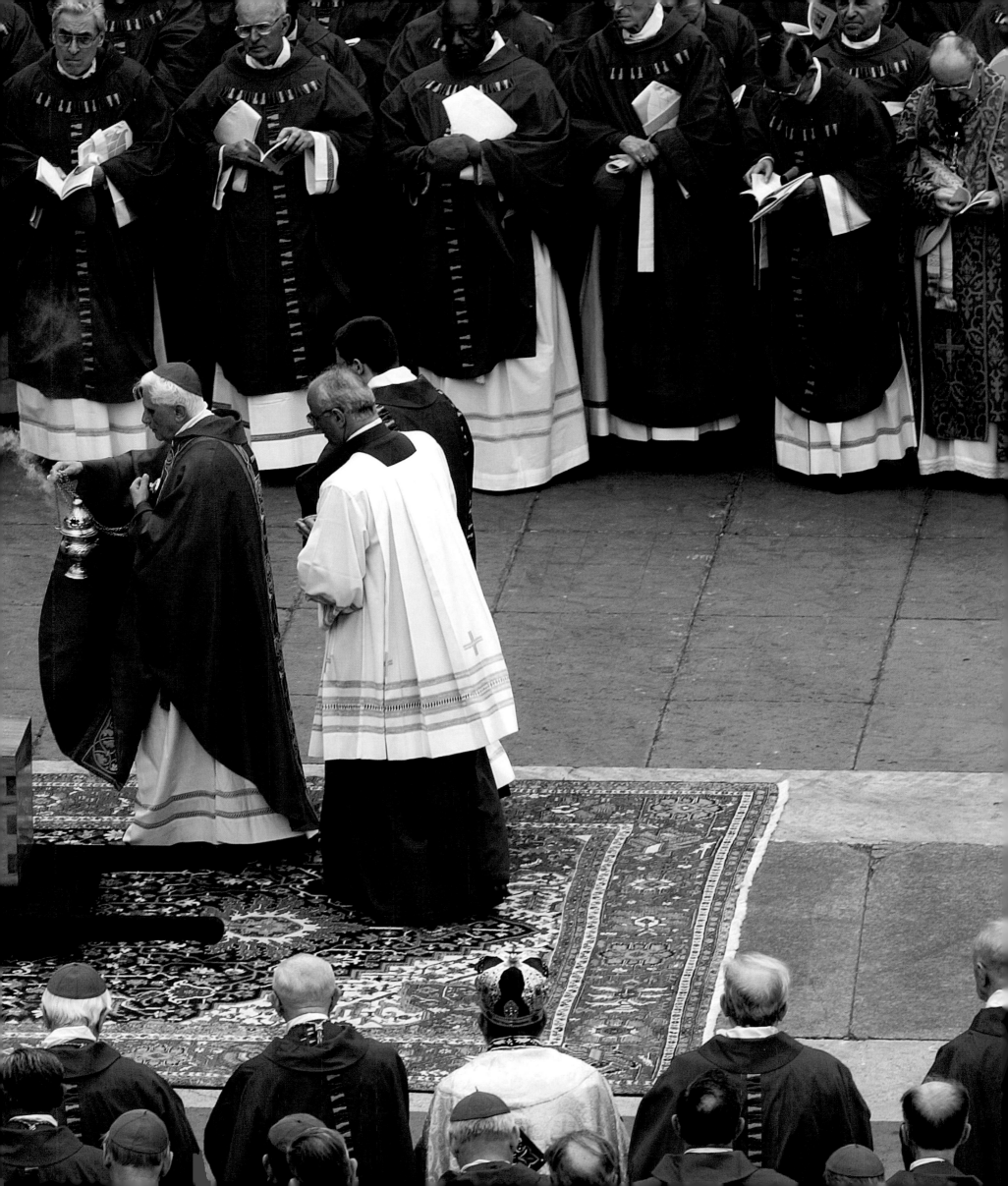

Photographs
GIANNI GIANSANTI

Text
JEFF ISRAELY

Editorial Coordination
ADA MASELLA

2-3 *A still young Cardinal Ratzinger, newly appointed Prefect of the Congregation for the Doctrine of the Faith by John Paul II, accompanies the pope during a service in front of St Peter's.*

4-5 *April 8th: Cardinal Joseph Ratzinger, surrounded by all his brother cardinals, officiates in front of St Peter's at the funeral of Pope John Paul II, who died on April 2nd after a long illness.*

6-7 *April 27th: the popemobile passing under the Arch of the Bells as it takes the new pope to his first Wednesday general audience in St Peter's Square.*

9 *Benedict XVI greets the faithful in his immaculate new papal vestments.*

10-11 *A gust of wind sweeps up the pope's mozzetta, covering his face, as he waves to the faithful in St Peter's Square during his regular Wednesday audience.*

12-13 *April 19th: Cardinal Joseph Ratzinger is elected pope choosing the name Benedict XVI, and becomes the 265th Bishop of Rome and new head of the Roman Catholic Church. He waves to the eager crowd of believers, who for two days never strayed from St Peter's Square.*

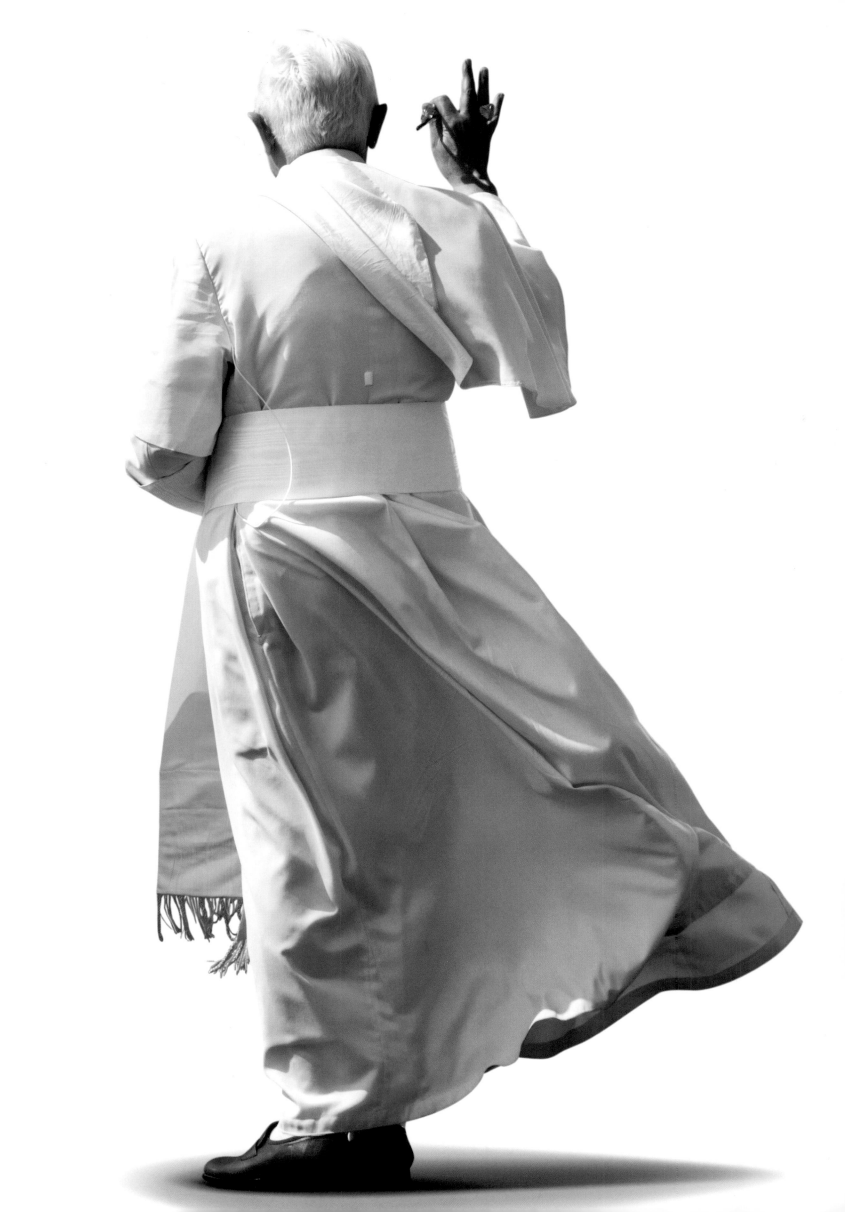

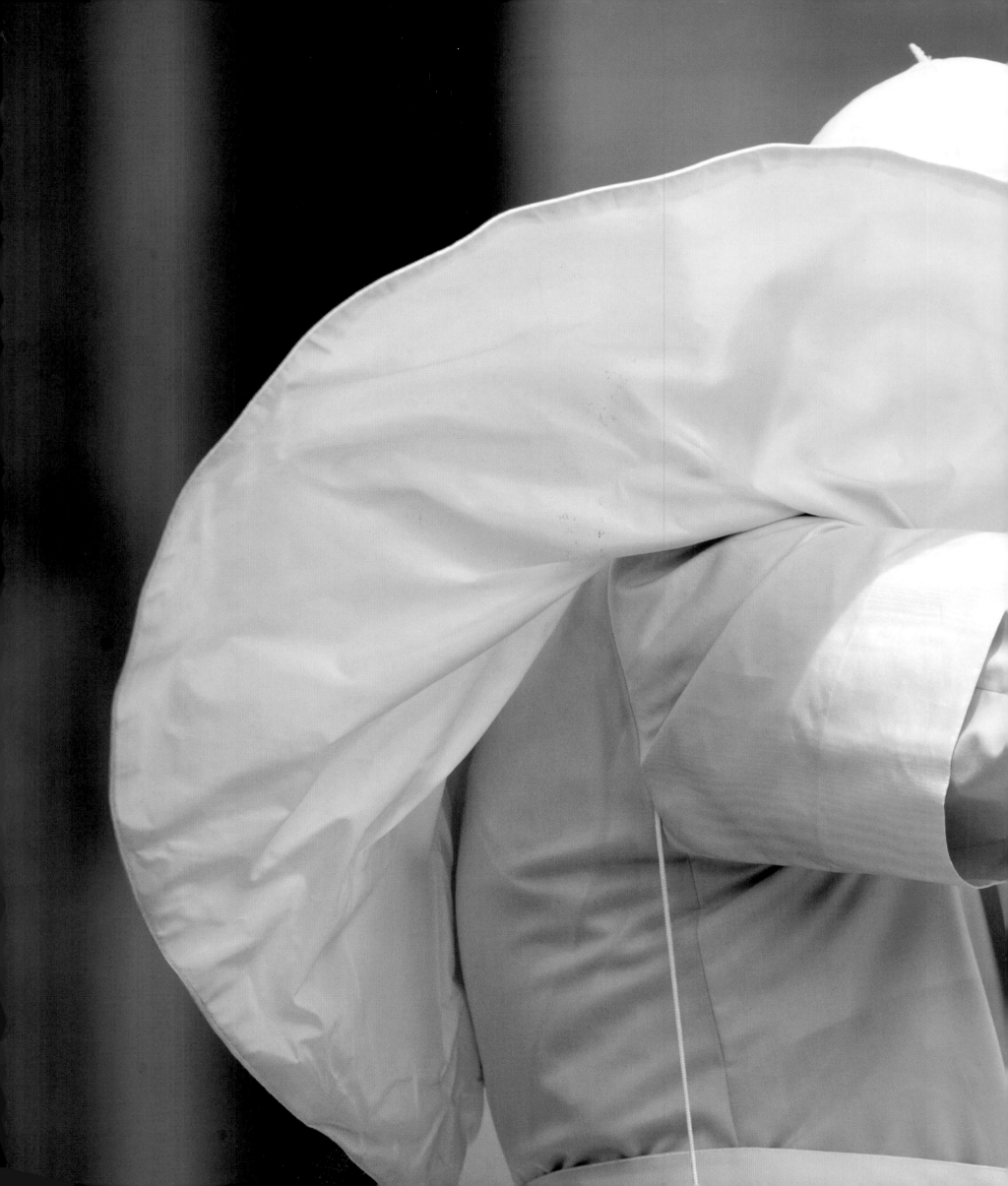

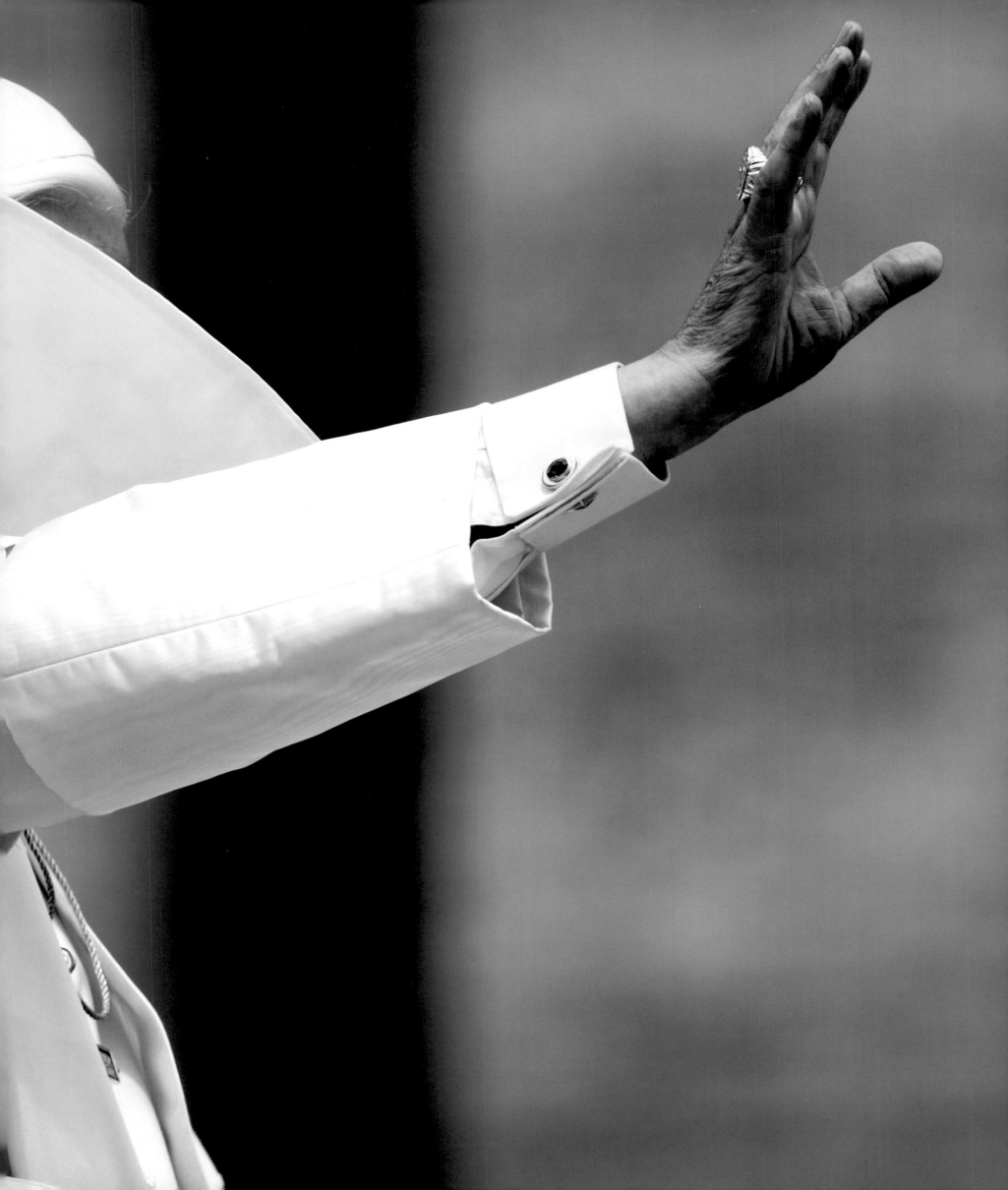

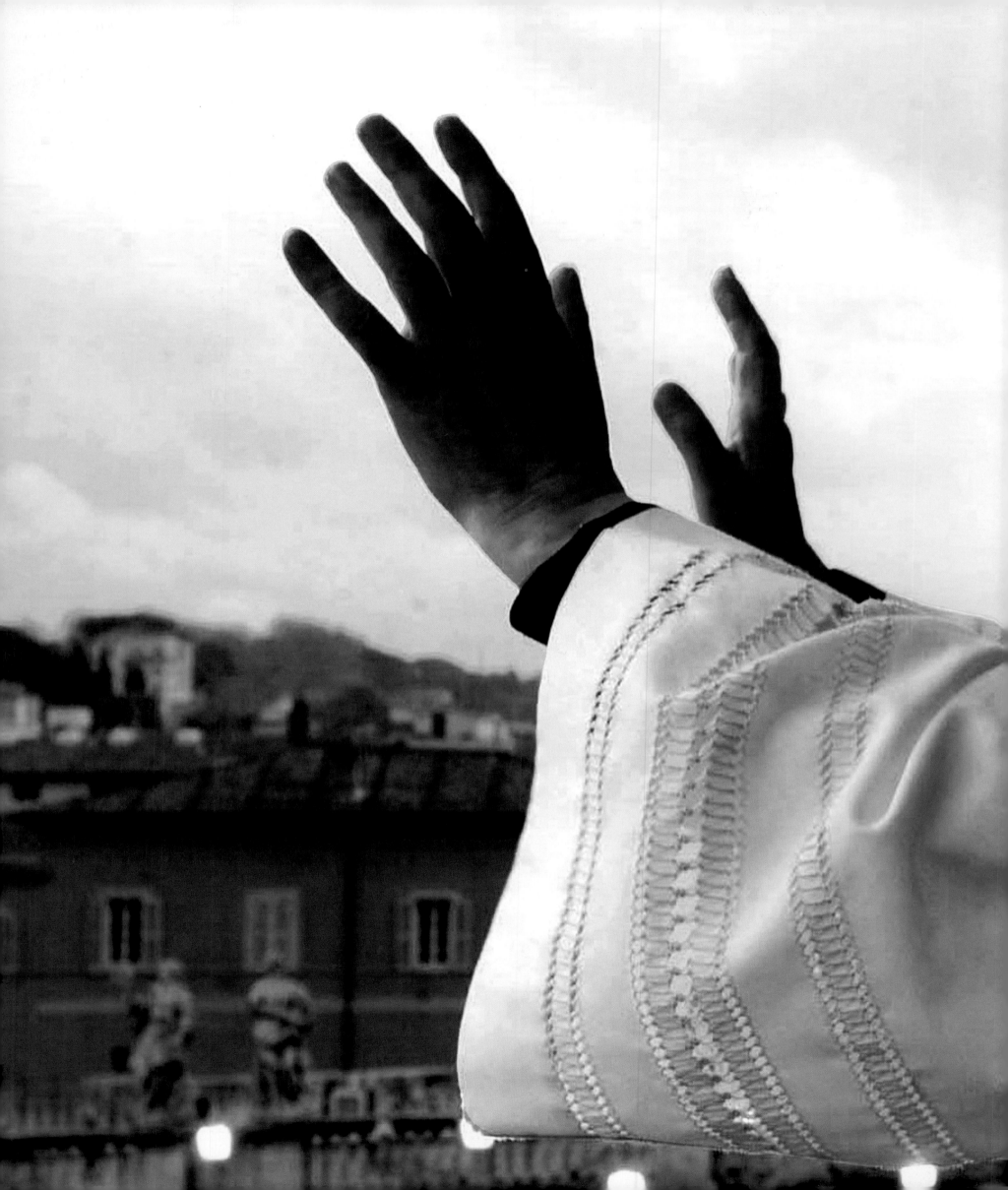

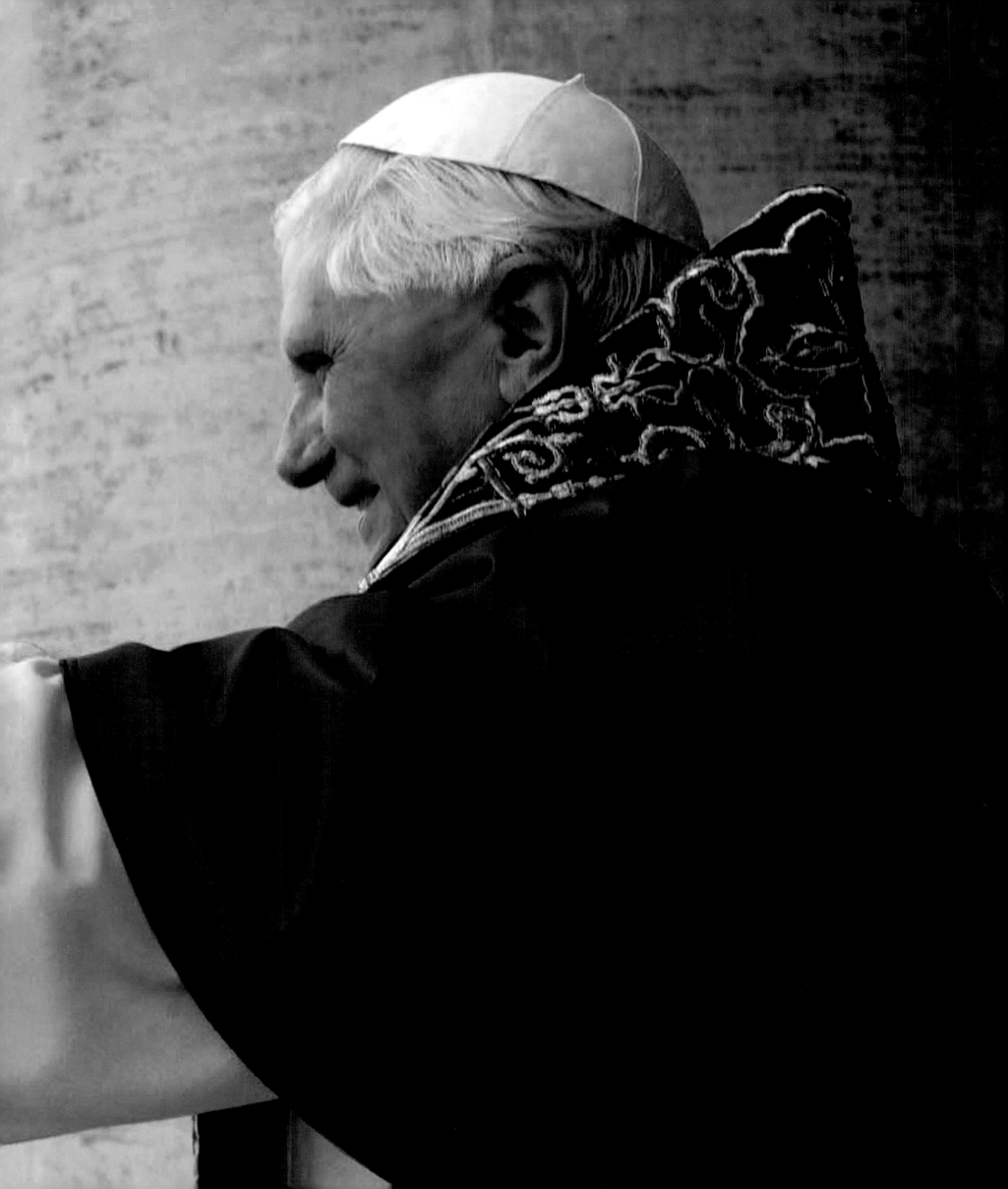

14-15 *For the traditional celebration of the Via Crucis held at the Colosseum on Good Friday, Pope Benedict XVI carried the cross from the first station to the last one. The pope's first Via Crucis was an event marked by resolute, determined opinions and positions on such major themes as the family, poverty and the need to take a stand.*

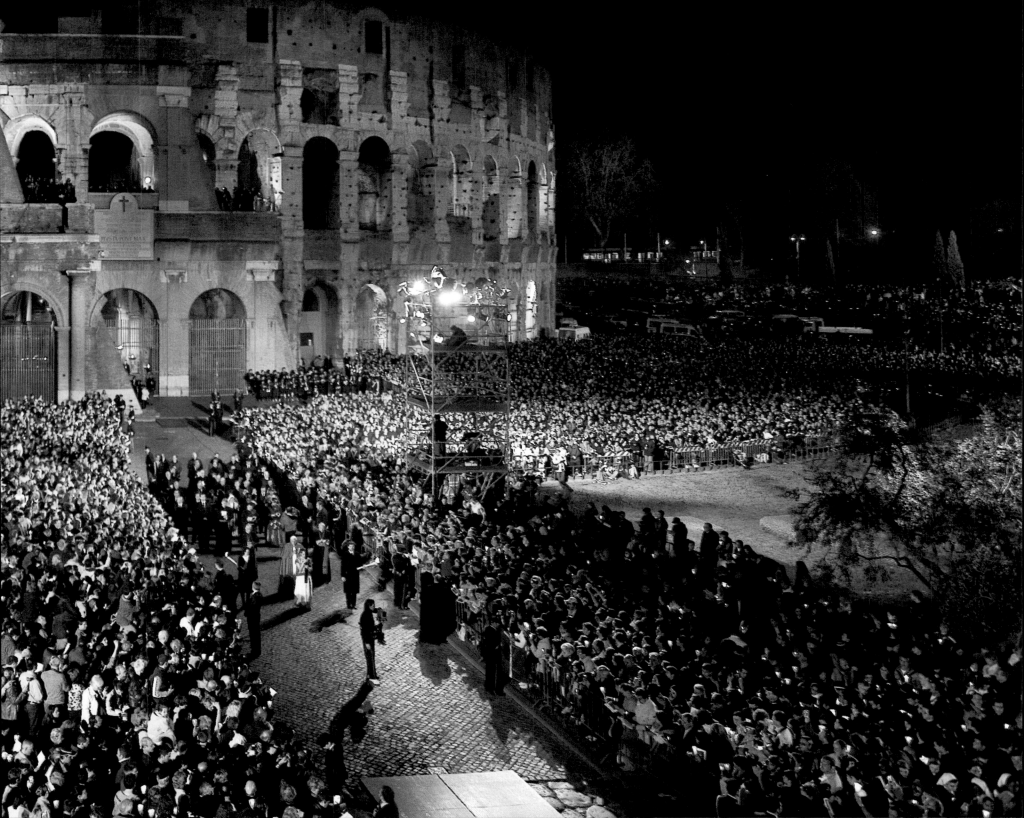

POPE BENEDICT XVI STEPS OUT OF THE SHADOWS

What the beginning of the Papacy tells us

16-17 *Benedict XVI, while still a cardinal, framed by the window of his study in the Vatican. Ratzinger was ordained a priest on June 29th 1951, after studying philosophy at Munich University and later at the Senior School of Philosophy and Theology in Freising. He then taught for ten years, from 1959 to 1969, in Bonn, Münster and Tübingen. In 1969 he was appointed Professor of Dogmatics and History of Dogma at the University of Regensburg.*

18-19 *An intense portrait of the cardinal in his study. Ratzinger was ordained Archbishop of Munich and Freising on March 24th 1977, and in the same year Pope Paul VI appointed him cardinal at the Consistory of June 27th. He then became Prefect of the Congregation for the Doctrine of the Faith under John Paul II, on November 25th 1981.*

20 *The cardinal pictured at work. As prefect, he also acted as Chairman of the Commission for the Preparation of the Catechism of the Catholic Church from 1986 to 1992.*

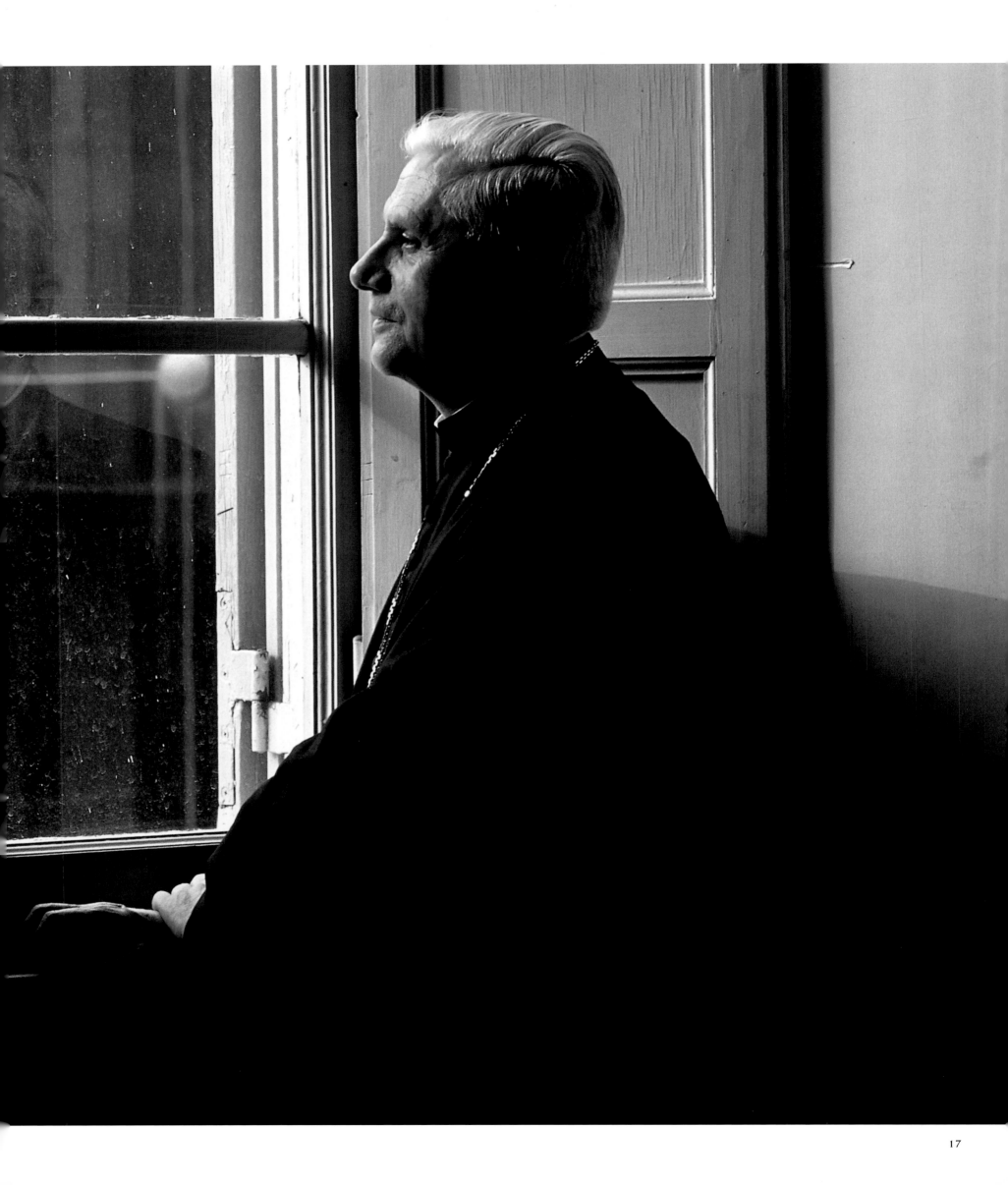

With the soft gray of twilight fading to black, Pope Benedict XVI is approaching the spot-lit stage that had quite literally been designed for his predecessor. The entire scene, in fact, seems an odd setting for the smiling but measured white-haired man waving through the plexiglass window of the popemobile. His mini-motorcade is snaking through a vast open field crammed with nearly one million young people. As the amplified chime of a giant bell mixes with the distant sound of an ambulance siren, small candles flicker like diamonds across the blanket of humanity. Some of the faithful cheer the sight of the pontiff on the giant video screen, others clasp their hands in prayer. There are also those who seem to simply gravitate toward the physical presence of their Holy Father – some running in the direction of the faraway stage, others wander with their heads up and mouths half-open, trusting their sixth sense will carry them to an anointed spot where the pontiff might just roll by. This is the kind of pulsating spiritual event – carried live on television around the world – that John Paul II had so boldly introduced into the centuries-old Roman Catholic liturgy. But this World Youth Day celebration in Cologne had finally become that one last appointment the globetrotting pontiff couldn't keep.

Thus here stood his 78-year-old successor – a natural-born scholar who had spent the previous two decades toiling in the relative obscurity of the Roman Curia – suddenly thrust into the role of *pontifex maximus* and international media superstar. But it was perhaps on this glowing night-time stage that Benedict would make clear once and for all that he was a very different man – and would be a very different pope – than what we had grown so accustomed to.

Inevitably, the dawn of a new papacy is a benchmark with whatever it follows. Sometimes a predecessor's shadow (or the mess he leaves) can color a pope's entire reign. But Papa Ratzinger has faced an unprecedented challenge in his early months in office: having to confront both the monumental legacy left by his predecessor, and the split-second demands of our new age of information. Never before would so many be watching so closely as he introduced himself to the world.

Never before has so much been at stake with a new pope's checklist of firsts: his first trip, encyclical, Christmas, gaffe, even summer vacation. Could this methodical changing of the guard of a millennial institution satisfy a modern thirst for quick and definitive judgments? Would the new pontiff connect with his far-flung flock? Was he the right man to lead the Church into the new millennium? Stepping to the microphone at this key moment of his first foreign trip, even a man

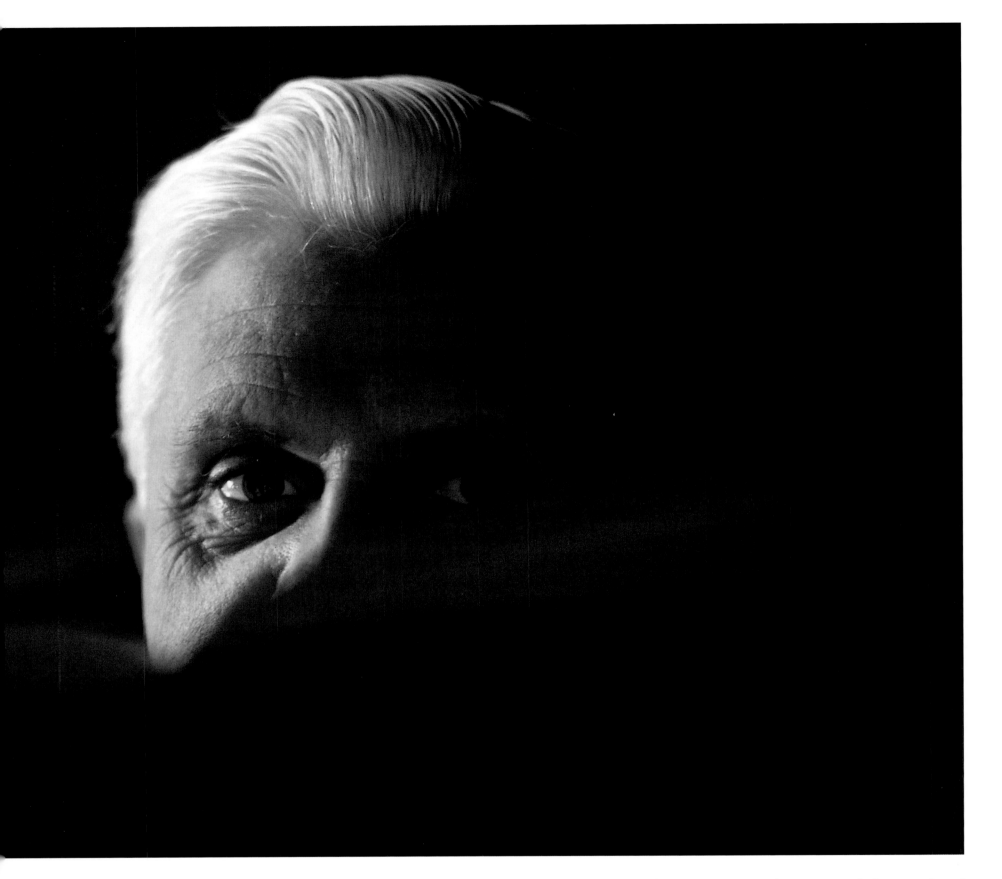

of such wisdom and faith must have felt the expectant eyes of the world's one billion Catholics, and other curious millions, training in on him. Though Benedict was certainly not about to succumb to nerves (many would note how clearly and confidently he spoke in five languages), his performance and very presence would be a wholly new experience for a Catholic Church that had grown to expect a papacy that carried the sweep of history around each new corner.

Papa Ratzinger by no means underestimated the weight of this appearance. The massed young people had come to this mid-August evening vigil – as they had so many times in the two decades since John Paul had created World Youth Day – to pray together with their Holy Father before a night of sleeping under the stars and a final Sunday morning Mass. Benedict had spent long hours honing the substance of his sermon. And it showed. The message was as incisive and rad-

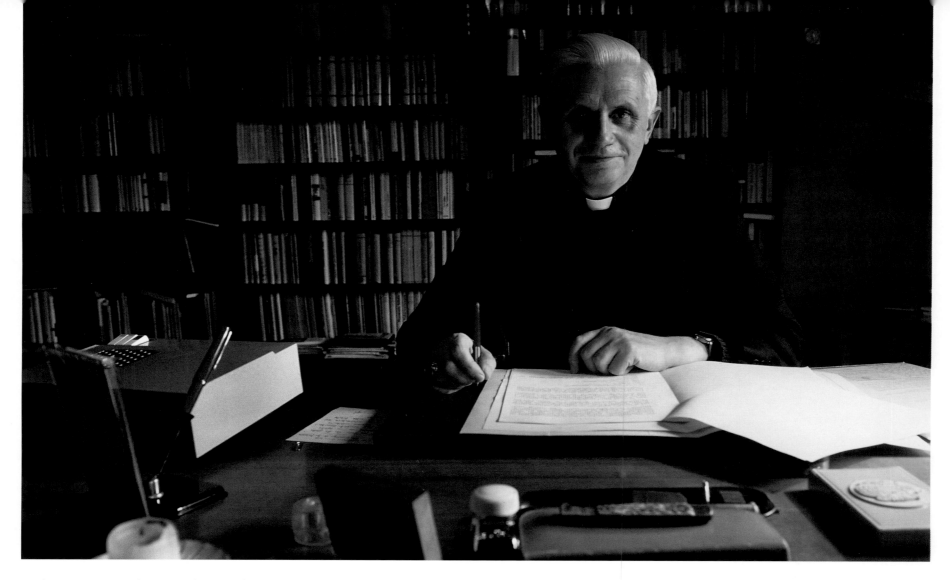

ical as it was plain and simple. "True revolution," he said, "consists in simply turning to God who is the measure of what is right and who at the same time is everlasting love."

He paused with a practiced orator's sense of timing, adding: "And what could ever save us apart from love?" It seemed his young audience – many with their ears to hand-held radios tuned to the translation in their respective languages – were largely taken in by the pope's sincerity and a lilting sing-song speaking style that he'd first developed as a university professor, and later refined as a leading Vatican official and occasional preacher at parishes around Rome. Still there was a key part of the performance that the new pope simply left out: the curtain call. For as soon as he was through with his speech, Benedict waved once, turned around and decisively sat back down in his papal throne. The Holy Father seemed more like a lecturer at a crowded round-table panel politely handing back over the floor – not a spiritual leader soaking up the global spotlight.

For the massive crowd that had come from 120 countries for a week of prayer and catechesis and interaction with fel-

low youth, this was the marquee moment, a chance to bite off as big a piece of His Holiness' presence as possible. So the clapping continued, and the rhythmic chanting, 'Ben-e-det-to!' grew louder and louder. For a few uncertain moments, the pope simply waved from his seat, perhaps thinking this would satisfy the flock and allow the evening's program to continue on schedule. Finally he stood up and waved his affectionate, two-arm wave to the roar of the crowd. But even this only lasted some 20 seconds extra, without his venturing out to the corners of the stage, before he was back down in his seat – bright-eyed and smiling, for sure, but also apparently more than content to sit back and let the rest of the evening proceed.

After a pontificate that had largely been defined by its electric moments, where John Paul sometimes had to be coaxed by his aides to not linger so long with the crowd, Benedict seems to believe that it is the message – not the messenger – that now must draw the doubtful to the word of God. We had all grown so accustomed to John Paul's ability to not just communicate, but connect, to wow the crowd

with his very being, even when his illness had sapped his strength and robbed his actor's gift for oratory. And instead, here for Benedict's first major public event since his installation, we were offered a show without a showman, an elaborate liturgical spectacle with a humble preacher at the altar, a sermon delivered less with fervent passion, and more with a professorial knack for guidance and clarity. Not everyone was satisfied. John Mertes, a 33-year-old lay youth minister had to explain to the teens he'd brought to Cologne from Burnsville, Minnesota, that following up on John Paul's opera is no mean task. Benedict clearly isn't "out there" like his predecessor, the kids told Mertes. "We've got to cut him some slack," he responded, "Give him some time to grow into the persona." But one Church official who hasn't always agreed with Ratzinger's views says the persona is exactly what it should be at this key moment in Church history. 'John Paul was good at exaltation – if you were already on board he got you fired up. Benedict is better at persuasion."

Still, the new pope is also learning a bit about the job's public relations requirements, loosening up his wave and his smile, letting the crowds cheer his words, the kids chant his name, and exhibiting day-in, day-out a basic human warmth that makes a mockery of the caricature of the *panzerkardinal* painted by his critics. A man often described as methodical and contemplative – even downright shy – has created a global charisma all his own, one that seems to defy our turn-up-the-volume, look-at-me times. Benedict is the archetype of the quiet, lifelong believer who suddenly sees it is his turn to speak up, a rejuvenated old soul surprisingly well-equipped for his final mission.

Father Joseph Fessio, who has known the pope since the 1970s, said his former professor "actually seems healthier, younger, more radiant, more at peace" since assuming the papal throne. German Cardinal Walter Kasper says his old friend is "rejuvenated" by the new role. Vatican officials know the way the papacy begins is of utmost importance. Benedict cannot afford to squander the gains John Paul made in raising the pope's profile in the world, and transforming the job from a largely stay-at-home head of the hierarchy to

a sort of missionary-in-chief among the faithful. But the new pope also has other priorities, which may be best handled from Rome, and most likely will have to be compressed into well fewer than the 26 years his predecessor had to work with. The work has already begun, though much of it is not immediately visible to outsiders. Benedict has subtly begun to reshape the very way the Universal Church is governed, showing signs of wanting more input from bishops and a streamlined curial bureaucracy. The man who served as the Vatican's chief of orthodoxy for 20 years has shown an eagerness to make the hard line on questions of doctrine, family and morals stick with certainty, suprising some by speaking out loud on national political questions in Catholic countries like Spain and Italy. And as the first pope elected after September 11, Benedict has already staked out a much firmer line in confronting radical Islam and the threat of terrorism. On all of these fronts, the new Pope has benefited from an unquestioned authenticity and a personal witness of faith that indeed recalls his predecessor. So measuring the first chapter of Benedict's reign is not a question of a stronger or weaker pontiff, of Rome vs the bishops, or even really about style. It is a question of whether this is the right man, at the right moment, with the right list of skills and priorities.

For those who care about the future of the Church, this is a time to listen as much as watch, reason rather than react. One top Vatican official noted that after a papacy of gestures and "signs," Benedict's reign is being cemented with words and concepts. Still, Ratzinger is too smart – and, yes, too modern – a man to dare disregard the power of the public stage his predecessor had created for Peter's throne. He knows he must find a way to keep us watching if he wants us to listen too. With the passing of a 20th-century titan, the one billion-strong Catholic flock has witnessed a diligent worker from inside headquarters become a potent world leader. As he labors on, Benedict's unshakeable faith and razor-sharp ideas will earn him ever more fans, and foes. He will follow the prophets instead. For it was Jesus who taught that the humble will be exalted, and John Paul II who showed that a missionary's work is never done.

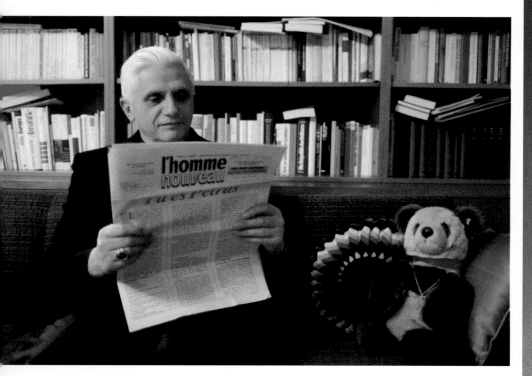

22 The future pope in a break from work, as he reads the newspaper on the sofa in his private apartment accompanied by a stuffed toy bear, an important symbol for him of the legend of St Corbinian, the first Bishop of Freising. Tradition has it that while the saint was on his way to Rome, he was attacked by a bear, which killed his horse. Corbinian gave the bear a piece of his mind and forced it to carry his baggage all the way to Rome, where he let him loose.

22-23 Cardinal Ratzinger at the piano: the pope is a great classical music buff and particularly enjoys Mozart.

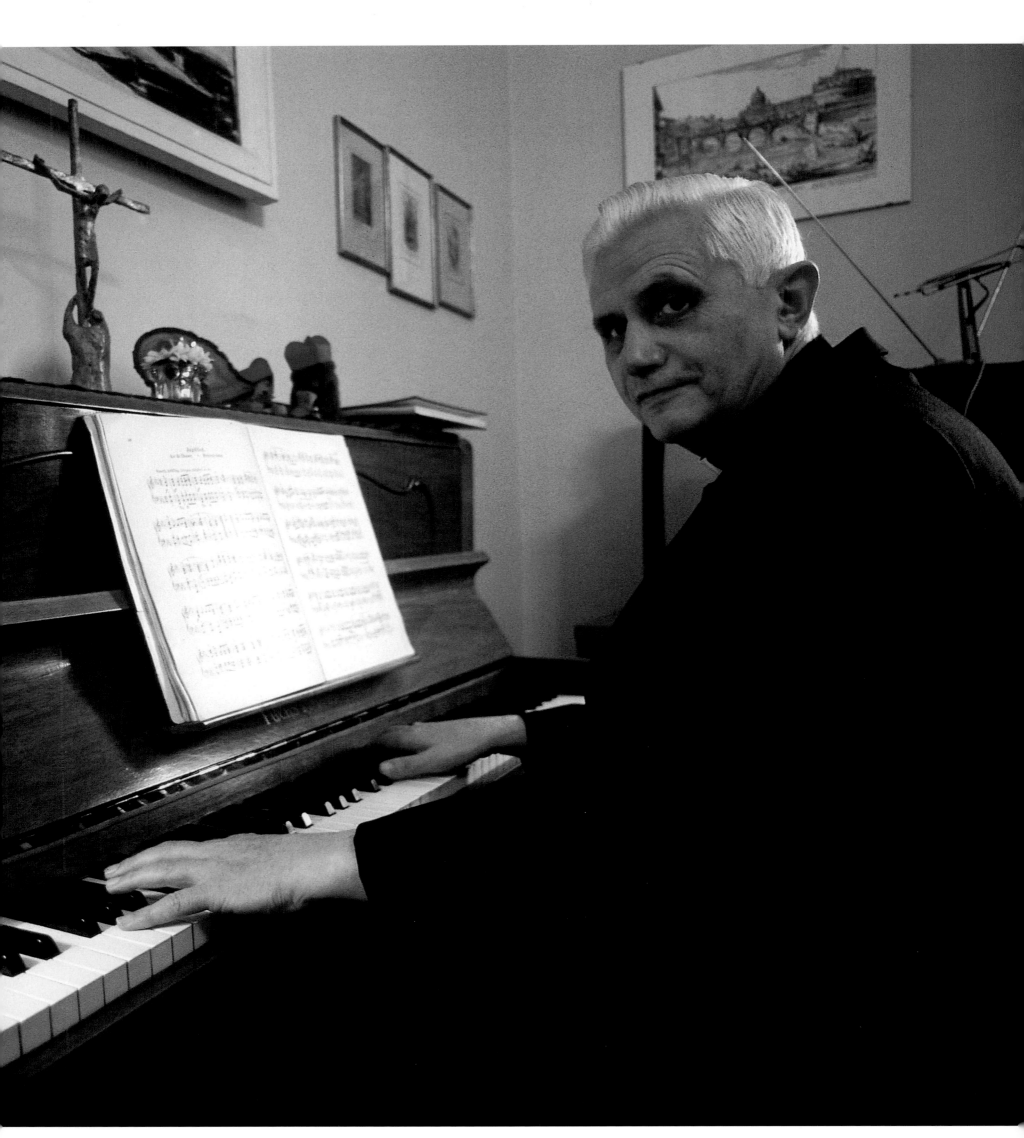

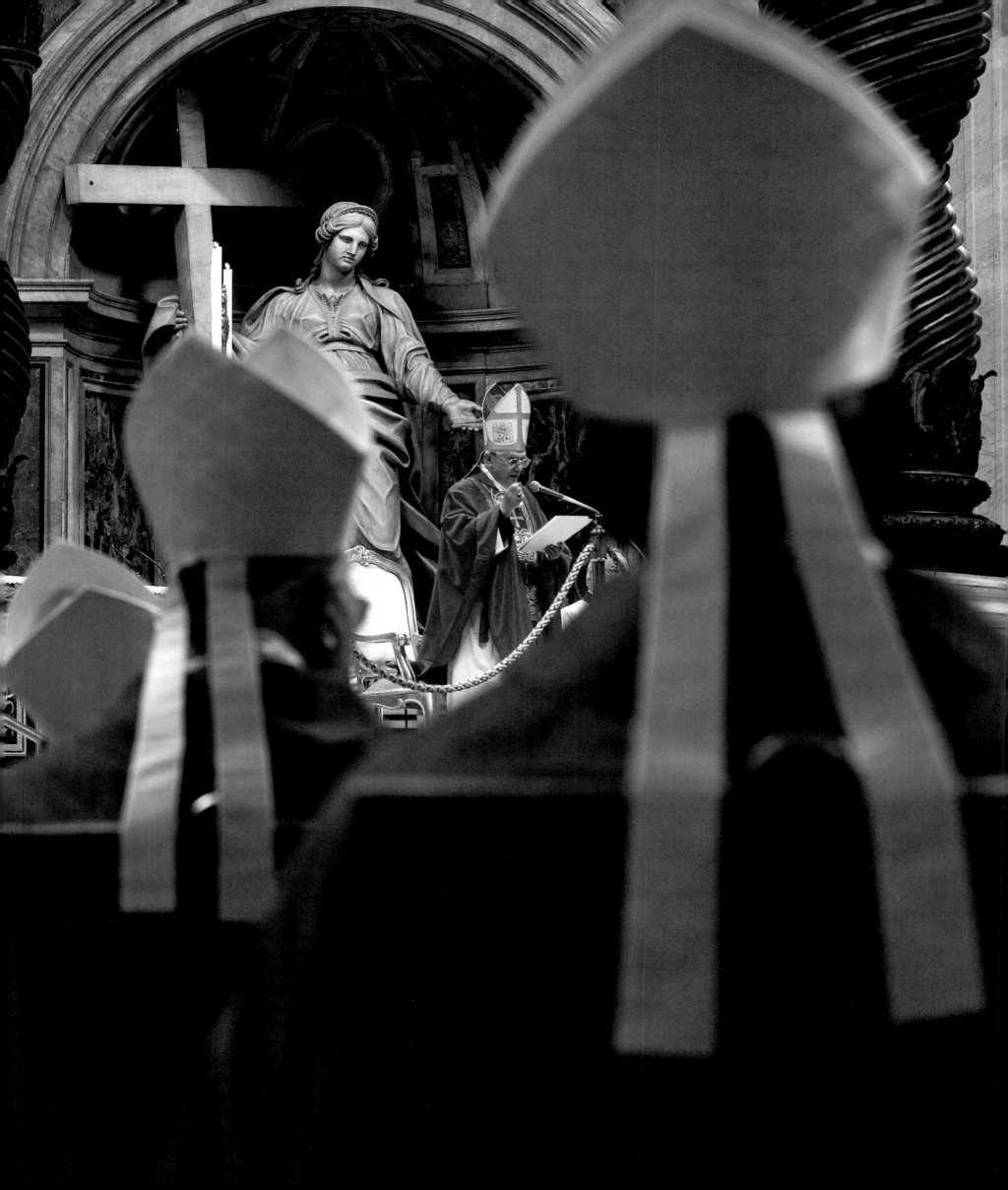

24-25 and 26-27 As Dean of the College of Cardinals, Ratzinger preaches the final sermon in S. Peter's Basilica on April 18th 2005, during the "Pro Eligendo Romano Pontifice" Mass, which comes before the enforced isolation of the cardinals in the Sistine Chapel. The sermon was a heartfelt denunciation on the "dictatorship of relativism."

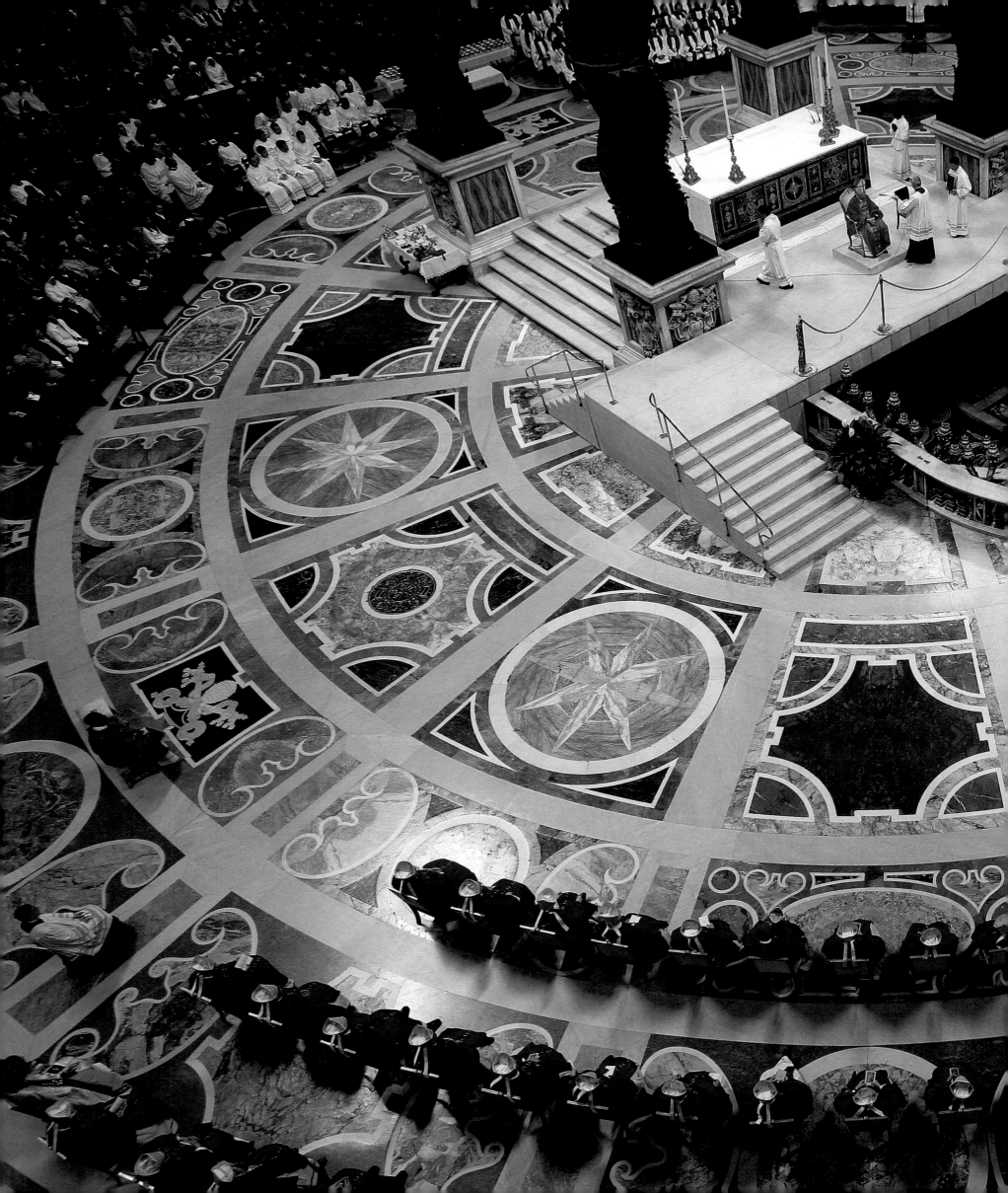

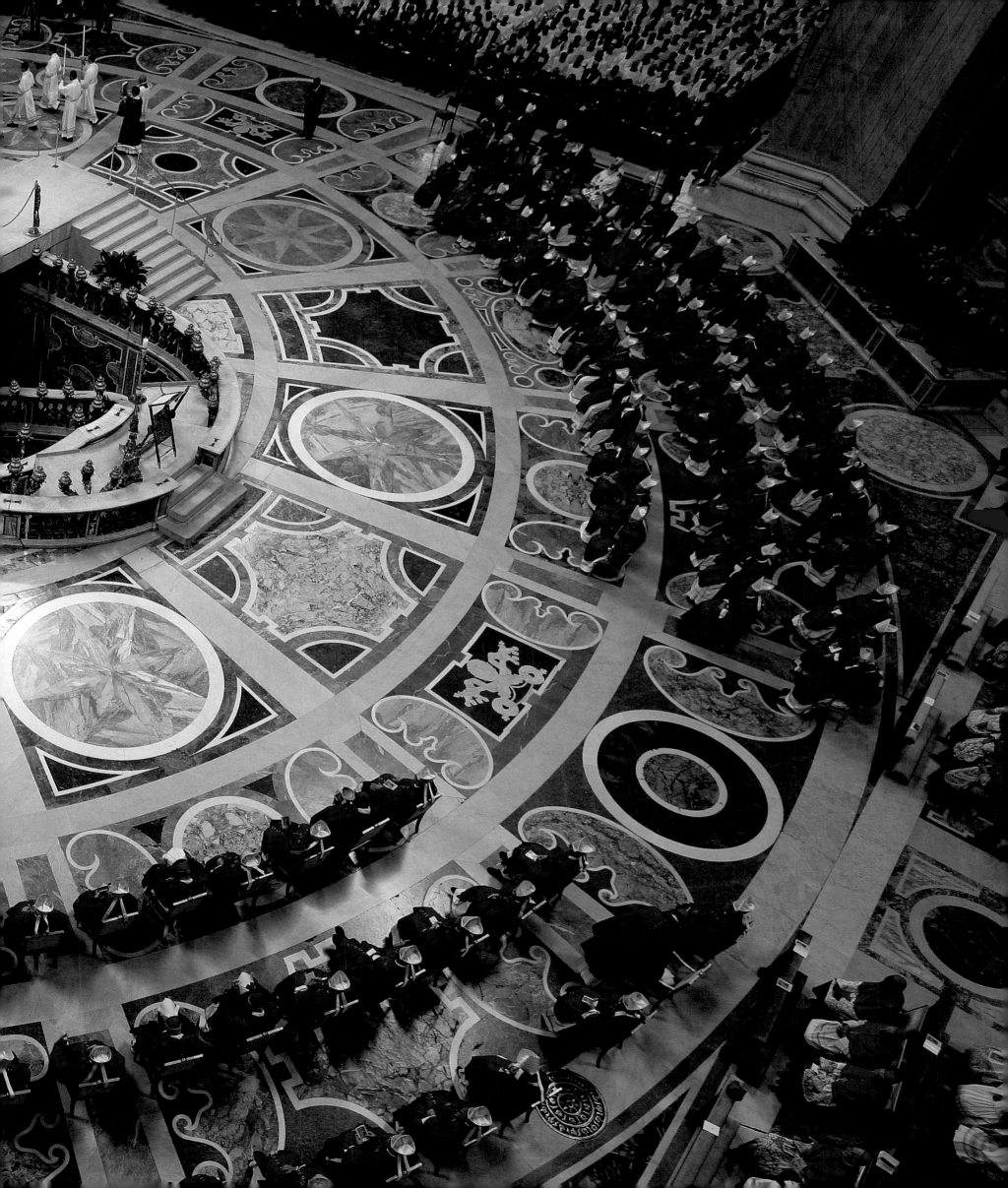

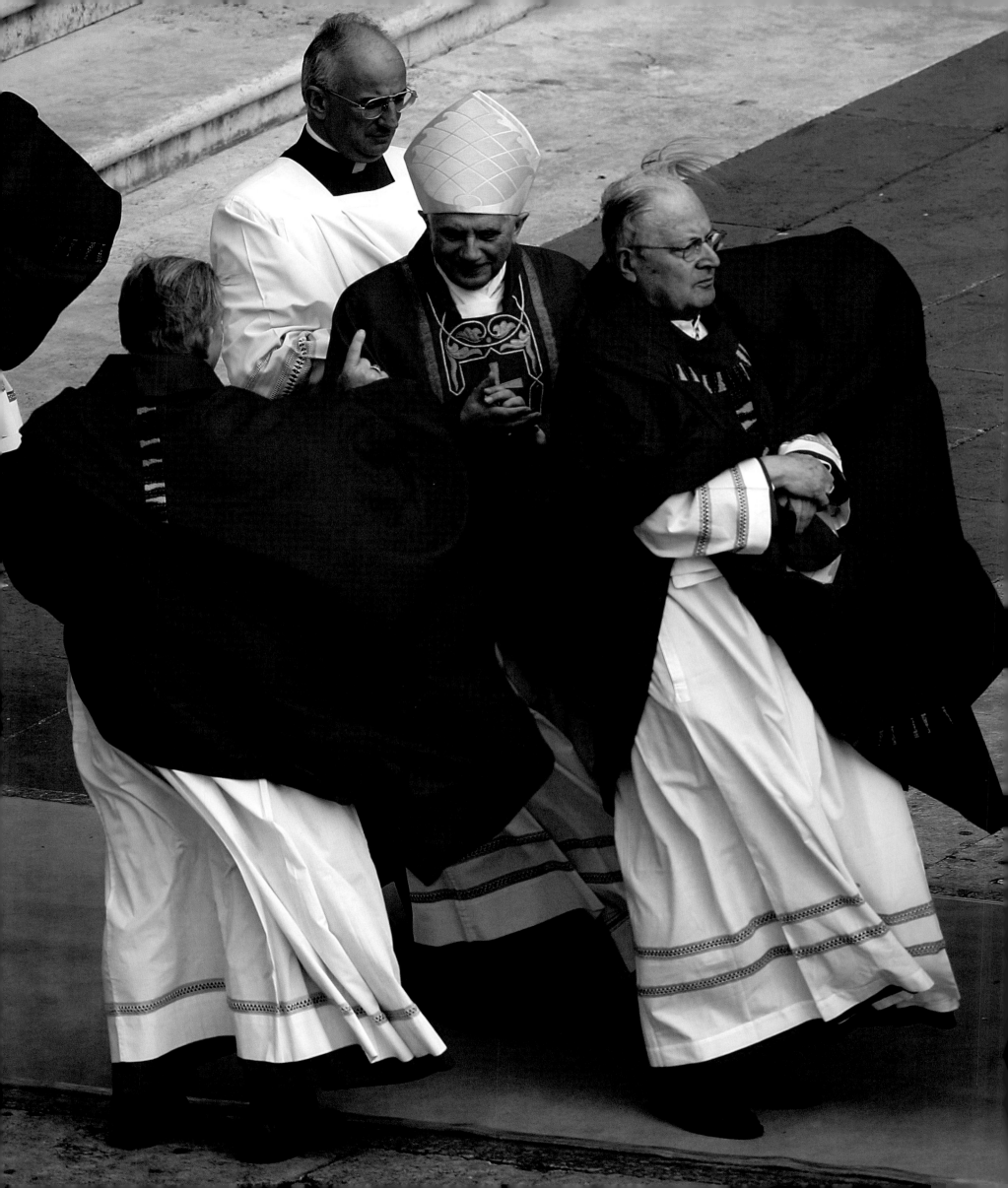

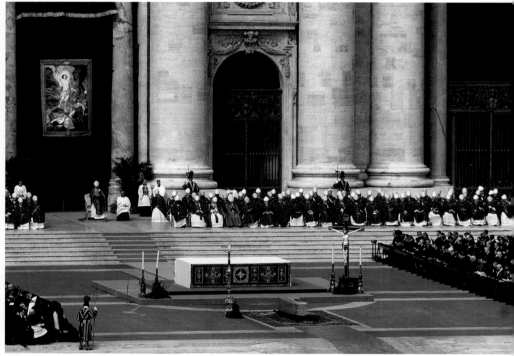

28-29 and 29 April 8th 2005: the Polish Cardinal Jozef Glemp points at Ratzinger as if in premonition, as the future Pope joins Cardinals Sodano, Etchegaray and Gantin in the line to kiss the altar during the solemn funeral of John Paul II.

30-31 A special moment in the funeral of Karol Wojtyla: the pope-to-be blesses the cypress-wood coffin of the dead pope. As Dean of the College of Cardinals, it was Cardinal Ratzinger's task to officiate at the funeral of the deceased Pontiff.

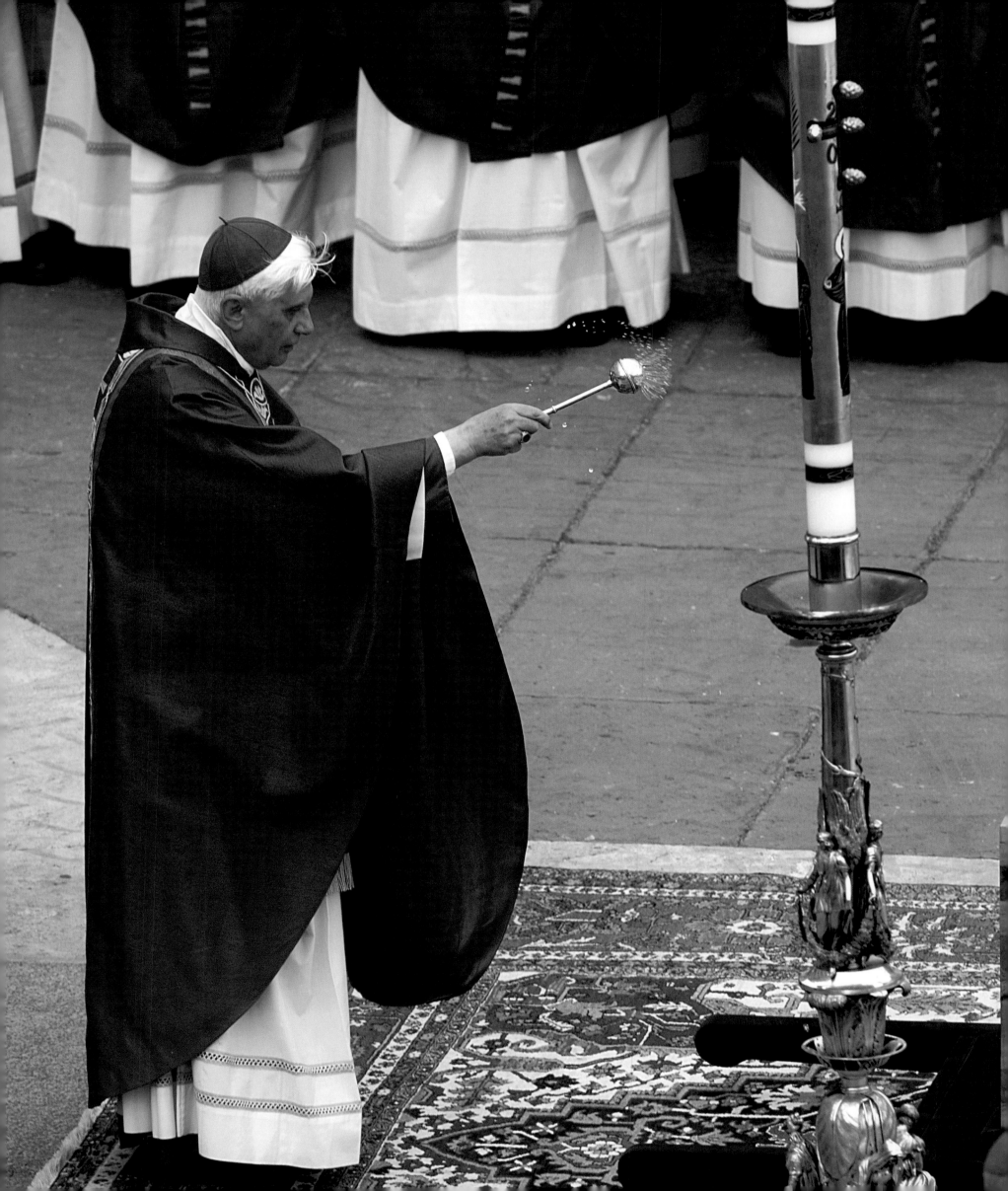

RATZINGER'S RISE

*The Conclave chooses
John Paul II's successor*

32-33 It is around 6:50 pm on April 19th when the new
pope appears at the central balcony of St Peter's Basilica to
greet the faithful. He was elected on the fourth ballot, after a
day and a half of Conclave, the first time there had been such
a short wait, 36 hours, since the cardinals chose Pius XII in
1939. The whole of Rome echoes to the sound of bells.

34 and 37 April 18th: the 115 cardinals file into the
Sistine Chapel to begin the Conclave, the first of the third
millennium. After each had been sworn the oath, the Master
of the Liturgical Celebrations of the Supreme Pontiff,
Monsignor Piero Marini intoned the "extra omnes,"
"everybody out" at 5:25 pm, announcing the closing of the
doors of the Sistine Chapel.

36 From the death of John Paul II to the election of
Benedict XVI, the leading television stations of the whole
world maintained studios in the neighborhood of the
Vatican, with their cameras constantly pointed in the
direction of St Peter's Square.

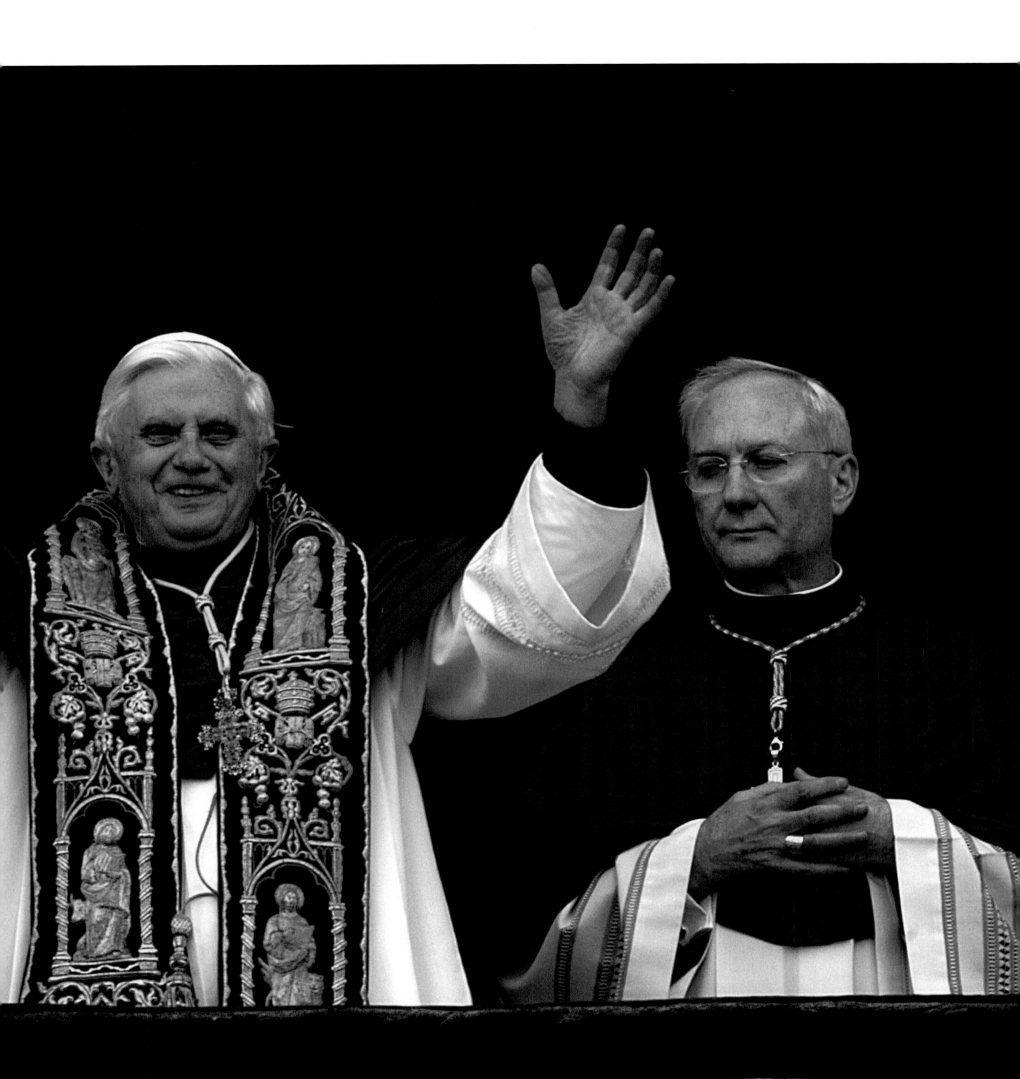

Cardinal Joseph Ratzinger was in the midst of a typically busy Thursday morning at the office when he got the call to come quickly. After Pope John Paul II's long and brave battle with failing health — and two recent trips to the hospital — the end appeared to be near. It would be Ratzinger's duty, as Dean of the College of cardinals, to formally notify his brother cardinals once the pope has died. Ratzinger wasted no time once he hung up the phone, hurrying into a black Mercedes that took him from the office of the Congregation for the Doctrine of the Faith, around the one-lane road behind St. Peter's Basilica, to the elevator that would bring him up to the pope's private quarters. It was around noon when the cardinal approached the Holy Father's bedside.

John Paul's condition had been deteriorating through that Thursday morning. His blood pressure had plummeted and his fever was running near 42°C as the same infection that had kept him at Gemelli Hospital for much of the previous two months rapidly began to spread. Ratzinger arrived at the bedside not only as dean of the College of Cardinals and the controversial architect of the pope's traditionalist moral doctrine, but also as one of John Paul's best friends and confidantes after a quarter-century of intense collaboration. He must have sensed that this was different than John Paul's other medical emergencies over the years. Still, by late afternoon the pope's condition had begun to stabilize as word spread of his latest crisis, and much of Rome and the Catholic world went to sleep holding out some hope for another miracle. Early Friday morning, however, John Paul suffered another serious setback. Papal spokesman Joaquin Navarro-Valls announced a few hours later to a jam-packed live press conference that John Paul was indeed in very serious condition. The words weren't used, but everybody in the Vatican press room understood that the 85-year-old pontiff was clinging to life. Still officials insisted that the pope was lucid and was taking part in prayer from his bed. But perhaps the clearest sign of the inevitable was that he'd made it known to his closest aides that, this time, he did not want to be taken back to the hospital.

By early Friday evening, a new written communiqué said John Paul's condition continued to worsen. With the latest news in hand and the sun already dropping behind St. Peter's Basilica, a reporter hurried to a meeting in an archway along the Via della Conciliazione with a veteran Vatican official who worked with Cardinal Ratzinger at the doctrinal office. The priest recounted how that morning at the commencement of the workday, his boss had called together 20 or so of his closest collaborators for a praying of the rosary, at which time he informed them of John Paul's health. The aide had never seen the German prefect as shaken as he was when describing his visit to the apostolic palace. Almost as an afterthought, the aide mentioned that Ratzinger had nonetheless decided to keep an appointment he had scheduled outside of Rome that evening.

The prominent cardinal and theologian was to receive an award and deliver a talk at a Benedictine monastery in the hillside town of Subiaco, east of the capital.. The loyal aide, not one to ever question his mentor, wondered aloud why Ratzinger had decided not to postpone the speech in light of the pope's rapidly worsening condition.

In retrospect, the discourse at Subiaco, delivered to an audience of monks and local dignitaries, will forever stand as a memorable footnote of Church history — both as the final act of Cardinal Ratzinger's reign as doctrinal prefect, and an early preview of the principles and priorities of Benedict XVI's papacy. (In fact, two months later it would be published as part of his first book as pontiff.) His discourse began with the words: "We are living in a time of great dangers and great opportunities for man and the world." Ratzinger went on to denounce the dominance of "relativism" as the great hidden evil afflicting the Western world. His words rang with a clarity that the Catholic world now knows well, and in light of his subsequent election, such an imposing speech might sound like a warm-up before his inevitable rise to the papacy.

At the time, though, his decision to make the trip 30 miles east of Rome, even despite John Paul's sinking health, was simply the move of a man on a higher mission. Anyone maneuvering to succeed John Paul would never have considered leaving the Vatican grounds amid so much apparent uncertain-

ty. Instead Ratzinger's mission was the same one that had driven him from his first days as a teenage seminarian in Bavaria to his work as a brilliant young theology professor in Tübingen to his taking over the Archdiocese of Munich and eventually the day John Paul called him to Rome in 1981 to be Catholicism's guardian of orthodoxy: To live and preach and teach and defend the gospel with a clarity that only comes from an unshakeable faith and the rarest of intellectual gifts. There was something, however, in the final phase of John Paul's papacy that seemed to give a renewed impulse to Ratzinger's lifelong calling. Just three years earlier, when he'd

turned 75 – the age when Church leaders are supposed to step down from their positions – he'd gone to the pope to request his retirement so he could devote his final years to theological study and reflection. Once John Paul denied that request, Ratzinger seemed to understand his mission had taken on added weight. He published even more writings, spoke out publicly with greater frequency, encountered prominent leaders both inside and outside the Church hierarchy. His message was clear: the Church, particularly in Europe where it was born, had to reaffirm its guiding principles in order to be

rejuvenated. He denounced the threat of terrorism after 9/11; he declared that Europe must openly defend its "Christian identity," in the wake of the growing plague of clerical sex abuse, he penned the meditations for the Good Friday procession of the Way of the Cross, decrying "the filth" that had crept into Catholicism. Consciously or not, Ratzinger spent part of the final months of Wojtyla's papacy stepping into the void that is inevitably created when the boss has taken ill.

Still, the forcefulness and candor that made Ratzinger among the key Church leaders in the twilight of John Paul's papacy did not make him an obvious candidate for succession. In the eyes of many, in fact, it simply reinforced his status as utterly "unelectable." For years, the doctrinal chief was the epitome of the cardinal who is powerful and respected, but nonetheless possesses exactly the wrong kind of résumé to be chosen pope. He was too divisive, had made too many enemies, he was too close to the current pontiff, he was a theologian, he was German. But by the time John Paul died the following day, Ratzinger was on almost everybody's "papabili" short list for succession. But while Vatican insiders and bookmakers split as to whether he was really a candidate, or simply a flagbearer for the traditionalist wing of the College of Cardinals, the man himself was still on the same old mission. This would now mean a much more public role for Ratzinger. As the Cardinal Dean, he was institutionally destined to become the single central figure through the interregnum, leading the funeral rites for the departed pontiff and steering the cardinals through pre-Conclave assemblies. Over a 10-day period, Ratzinger exhibited a mix of quiet wisdom, brotherly presence and public wherewithal that carried the Church through the emotional and uniquely delicate interval when an absolute monarch is buried and his successor must be found without the benefit of

bloodlines. A Curial cardinal recalled: "After John Paul died, Ratzinger seemed to be carrying the entire Church on his shoulders." The unprecedented outpouring of millions of mourners who waited for 14 hours to pay their respects to John Paul was also bound to raise the odds for anyone with personal and ideological connection to the departed pope. There was no one closer than Ratzinger. But for many doubters, voting cardinals and ordinary folk alike, it took the cardinal's eulogy at John Paul's funeral to realize that he indeed could minister to the flock. His words were as simple as they were insightful, articulating what millions around the world were feeling. In the days that followed, charged with running the daily General Congregations to debate Church priorities, the cardinals got to see more evidence that this was not in fact the rigid enforcer that his opponents painted: he encouraged open discussion, he showed a sense of humor, his facility with languages allowed him to address most of the cardinals in their native tongue. Describing Ratzinger's tour de force, one Vatican official commented that "some inner fire was lit, like God had chosen him." After the final day of meetings, Ratzinger stopped by his office so his staff could celebrate his 78th birthday with a lemon cake and a rendition *in rondo* of

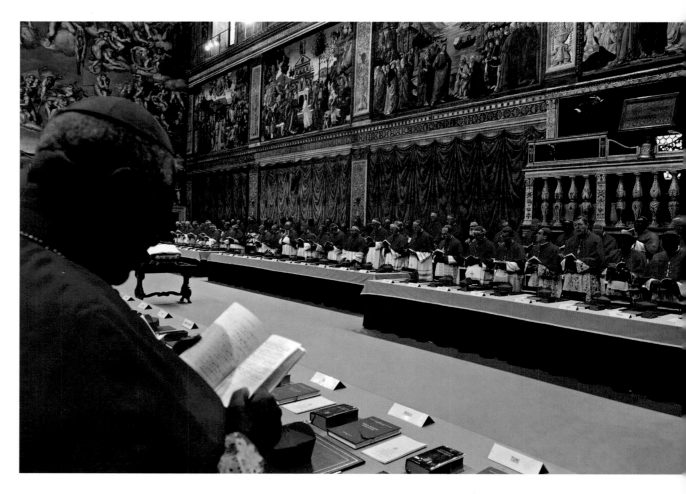

"Ave Maria." Though touched, the cardinal was noticeably fatigued, acknowledging that he was weary from all the talking he'd been required to do over the past 10 days. Two days later, on the Monday that the Conclave began, Ratzinger had one more task as the Cardinal Dean, delivering a final homily in St Peter's Basilica at the *Pro Eligendo Romano Pontifice* mass before the forced seclusion in the Sistine Chapel began. The theme was not much different from his talk two weeks earlier in Subiaco, decrying "the dictatorship of relativism" and telling his brother cardinals that the future for the Church required clear choices to be made. In a certain sense, Ratzinger was telling the College that he knew his vision of the Church – and yes, even his own candidacy – might very well be the point of departure once they gathered to begin the balloting. If nothing else, his homily was a declaration that if the Holy Spirit did in fact choose him, his beliefs would not be compromised by the new title.

Once inside the conclave, as he realized the votes were piling up for his election, Ratzinger would later say that it was like the guillotine was falling toward him. Still, by the time he came out onto the balcony overlooking 50,000 faithful in the piazza, he was beaming. Perhaps this shy man of faith was feeling a bit awkward in his robes and overwhelmed by the moment.

He nevertheless understood that his old mission was once again taking a new turn. He lifted his arms up together in the type of grandiose papal gesture that he never would have made as cardinal. His words though rung with a familiar deep sense of modesty. "The cardinals have elected me – a simple, humble worker in the vineyard of the Lord." There was indeed much work to be done.

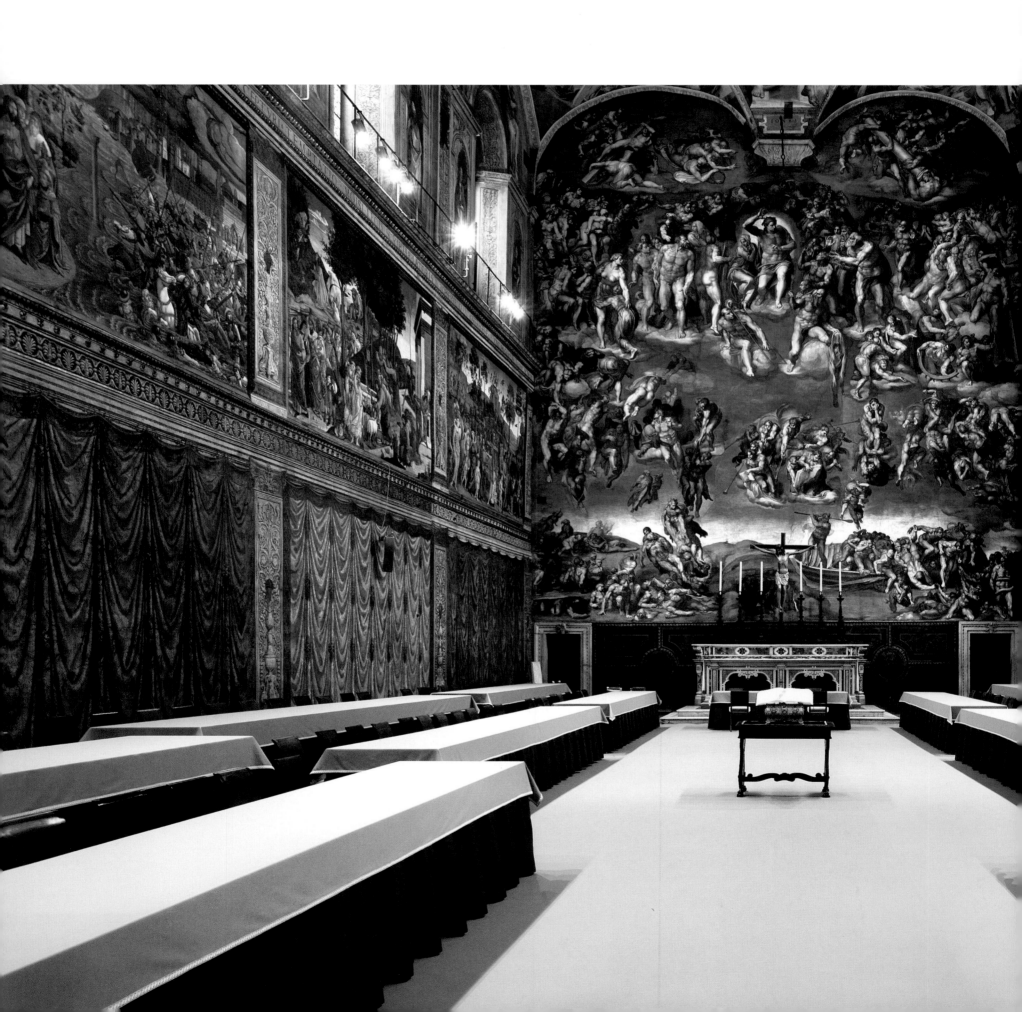

38-39 *The Sistine Chapel, where St Peter's successors have been elected since 1492, prepared for the Conclave, with special attention to the urns and the chimney that emits the black smoke. Recalling his own election, John Paul II said, "The Sistine Chapel is a place that holds a memory of a special day in every pope's life."*

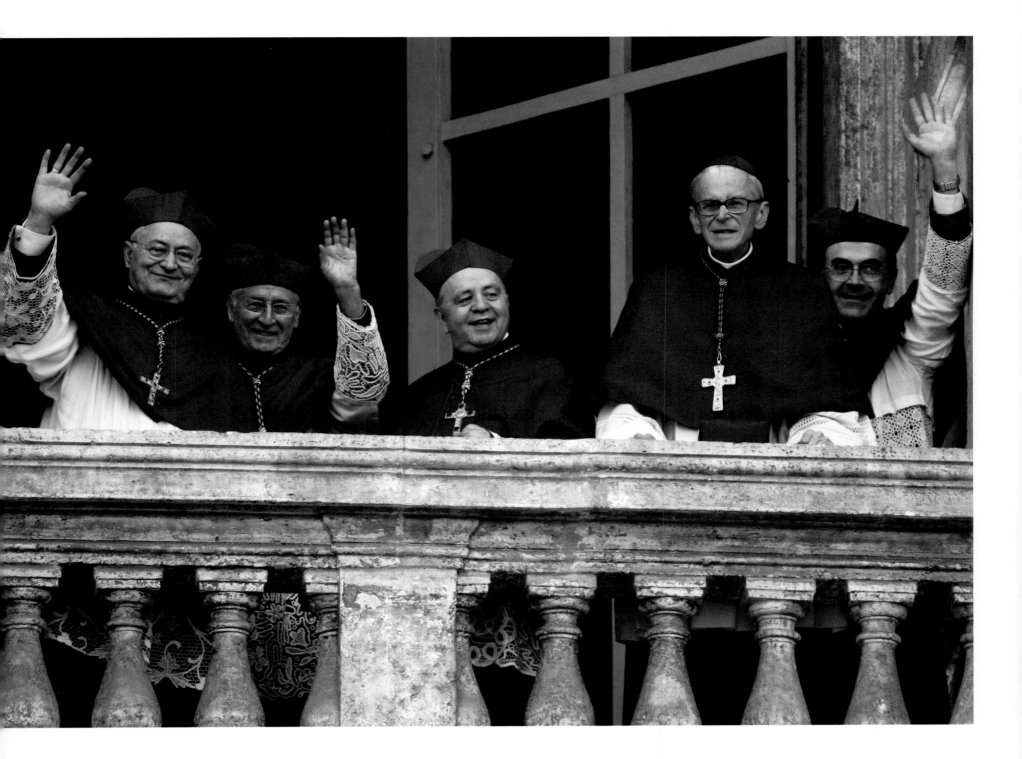

40 and 41 *After the traditional announcement made by the Proto-Deacon Cardinal Jorge Arturo Medina Estévez "Habemus Papam," a great cheer goes up in St Peter's Square, packed by one hundred thousand faithful, who share the joyous moment with the cardinals waving back down at the crowd.*

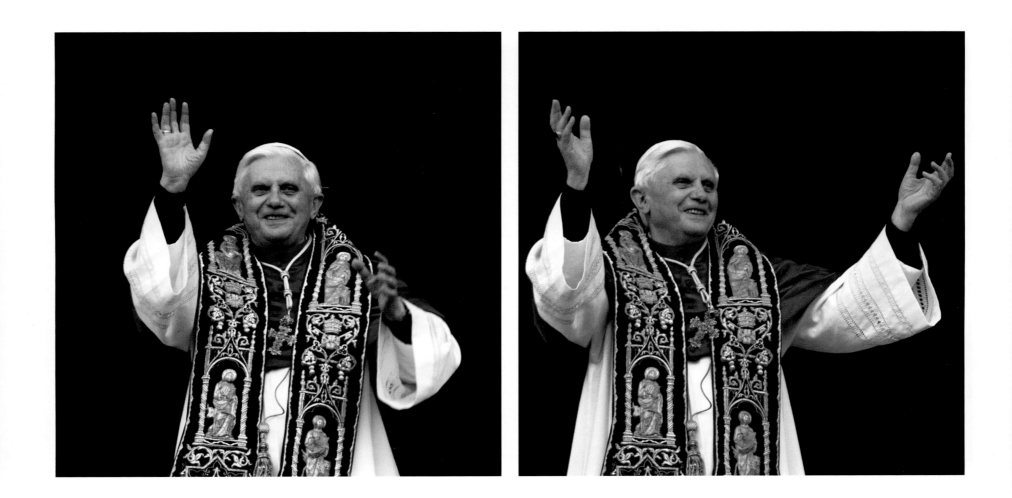

42 and 43 *Ratzinger at the main balcony of St Peter's Basilica, for the first time as pope, greeting the faithful in the square below and all those watching from around the world.*

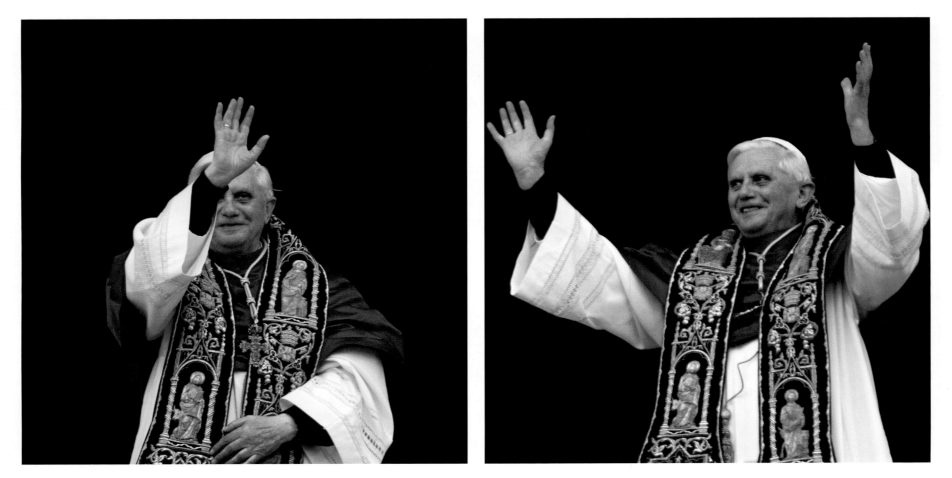

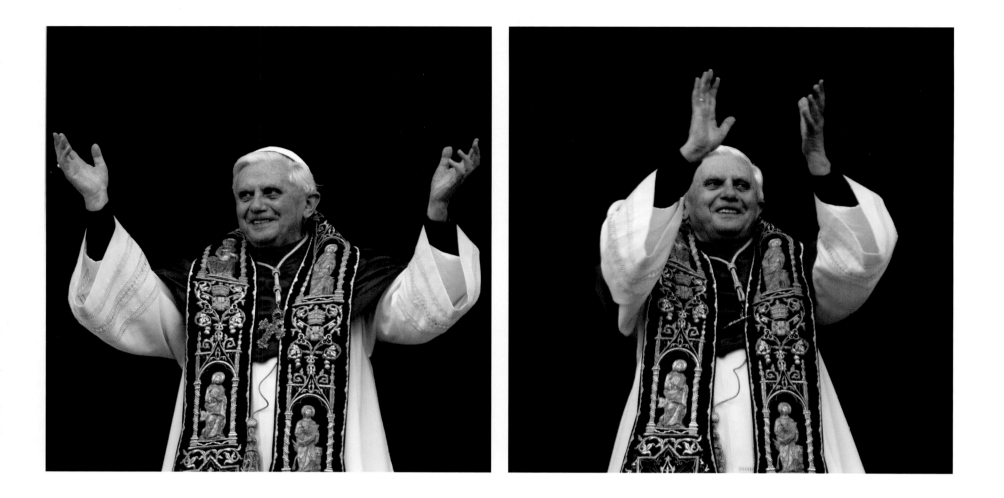

44-45 *The Mass for the Inauguration of the Pontificate of Benedict XVI was held at the Vatican on April 24th 2005. The new pope's first sermon stressed ecumenical themes, continuity with his predecessor and the need to reach out to the faithful.*

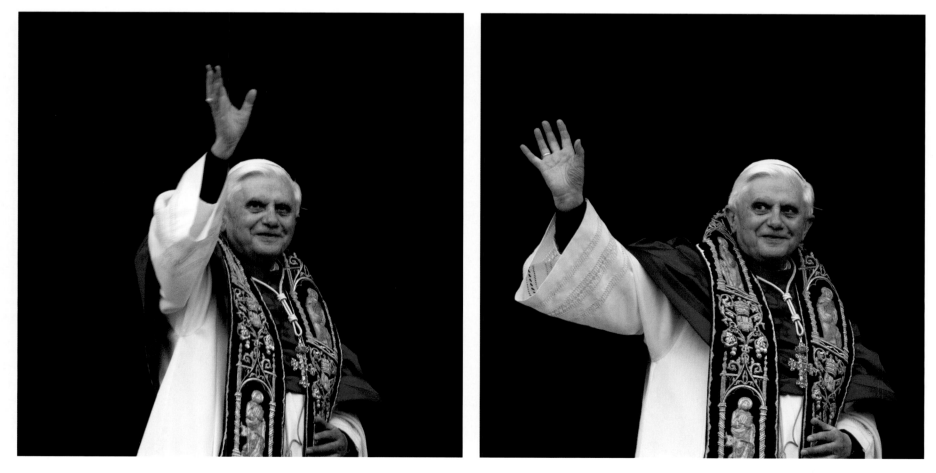

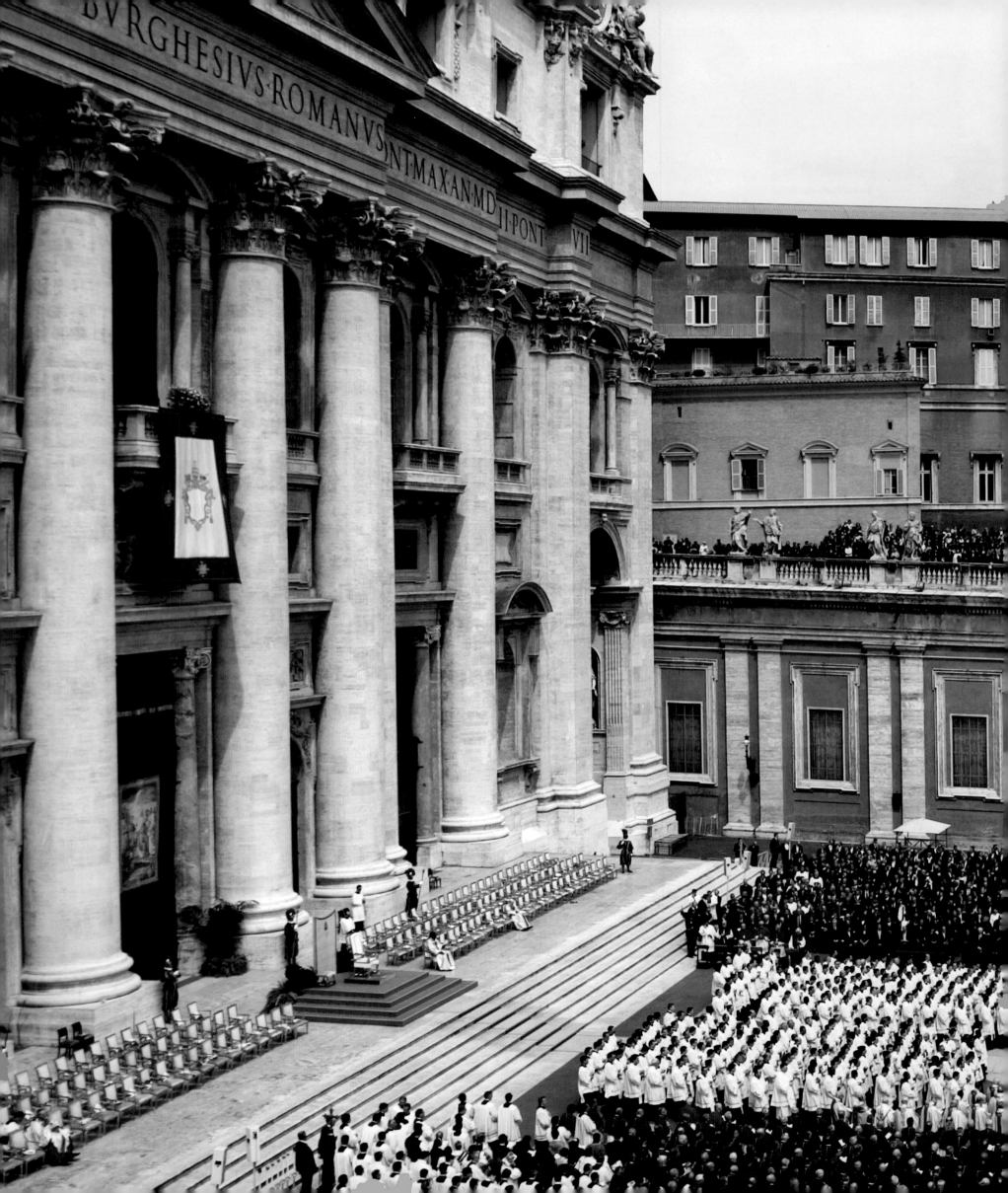

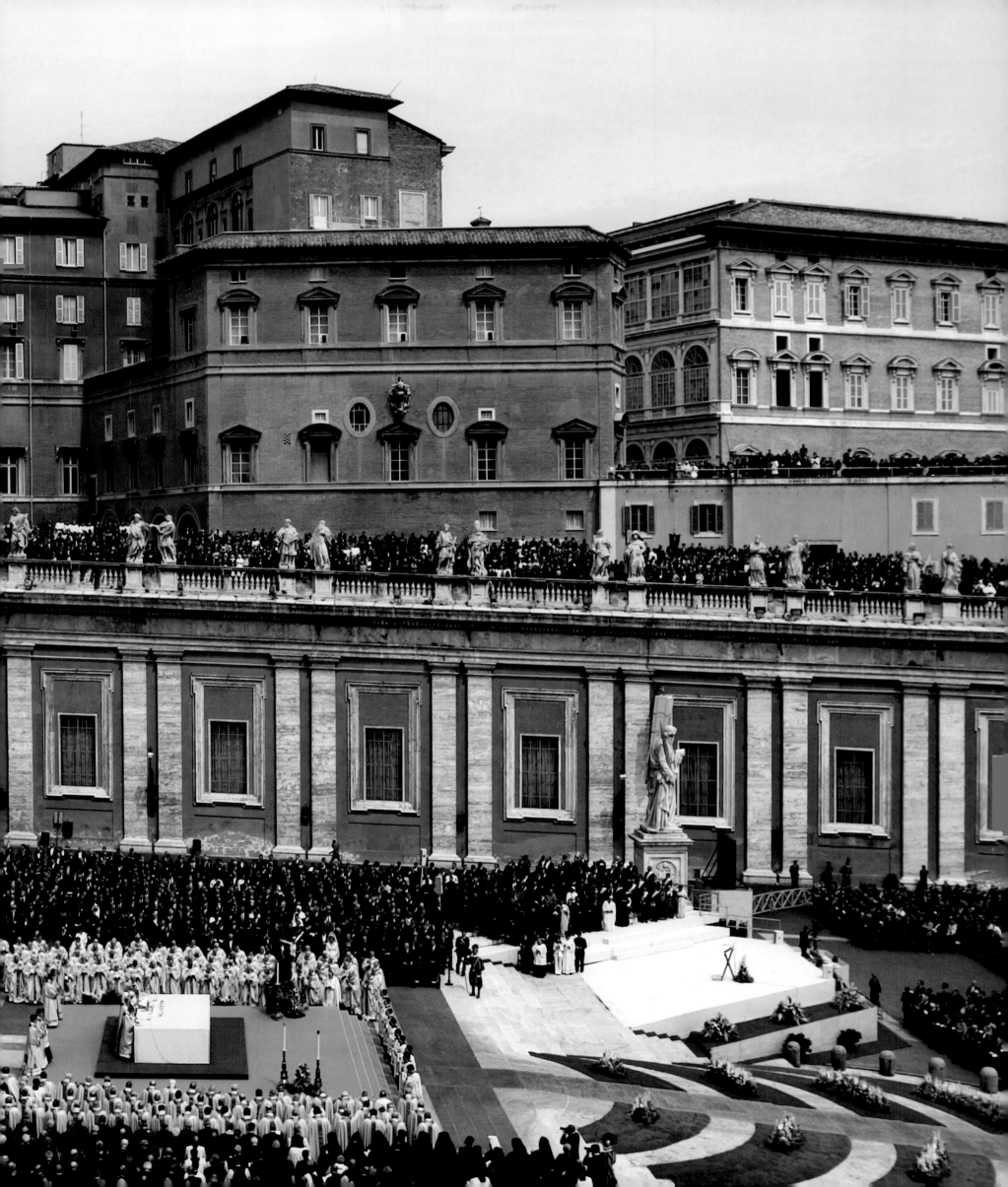

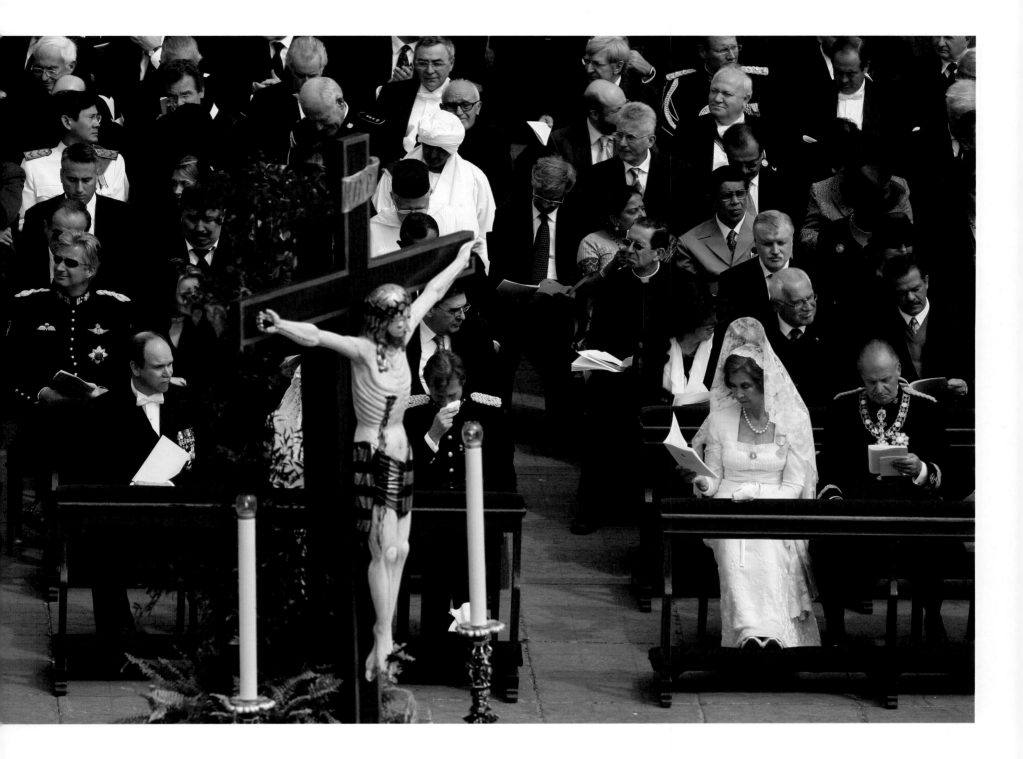

46 *The Inauguration Mass was attended by heads of state and crowned dignitaries from all over the world, and included: Prince Albert of Monaco and King Juan Carlos and Queen Sophia of Spain, who returned to Rome after being present at Pope John Paul II's funeral.*

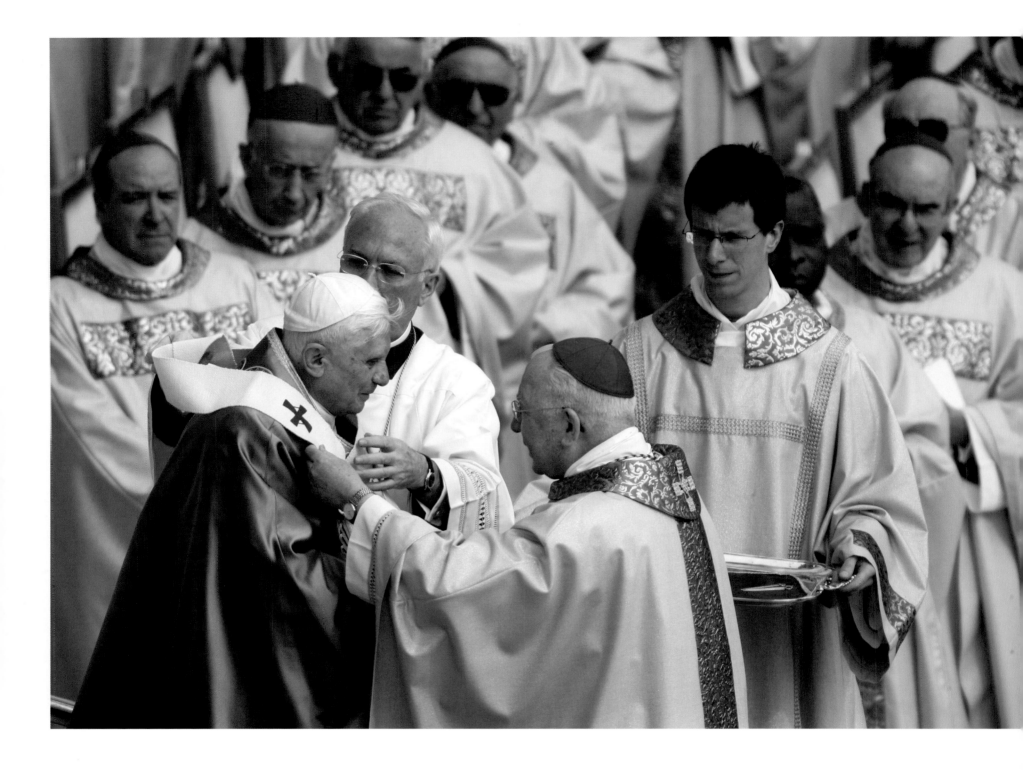

47 *Benedict XVI receives the pallium, which, together with the Fisherman's Ring, is the symbol of the papacy: it represents "Christ's yoke," the good shepherd who seeks the lost sheep, as the Pope himself was later to explain. The pallium symbolizes the unity of Pope and Church and is also present on Ratzinger's personal crest.*

48-49 *At the close of the ceremony, the pope, in his jeep, crossed St Peter's Square teeming with 400,000 people and later received various international delegations inside the basilica.*

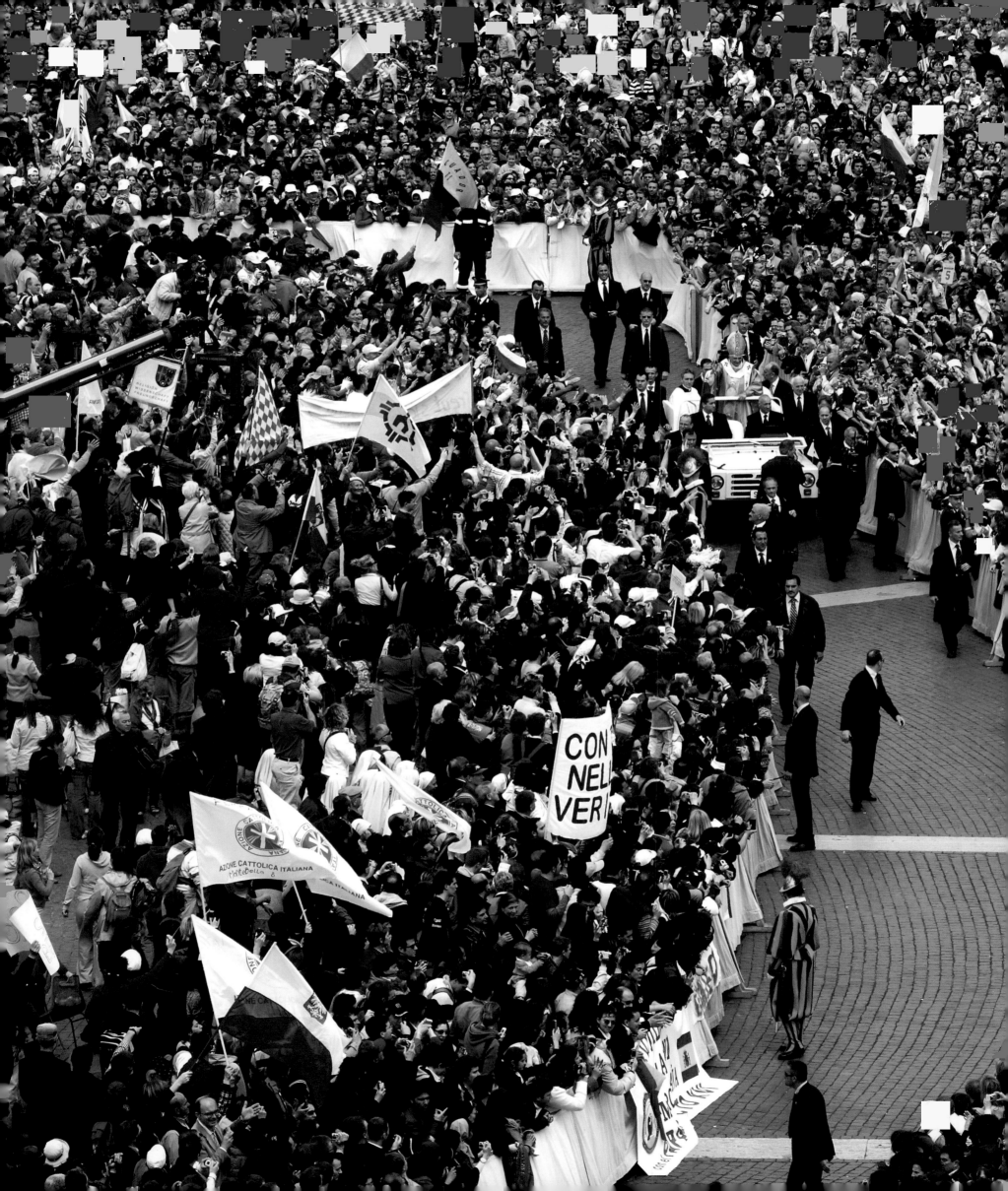

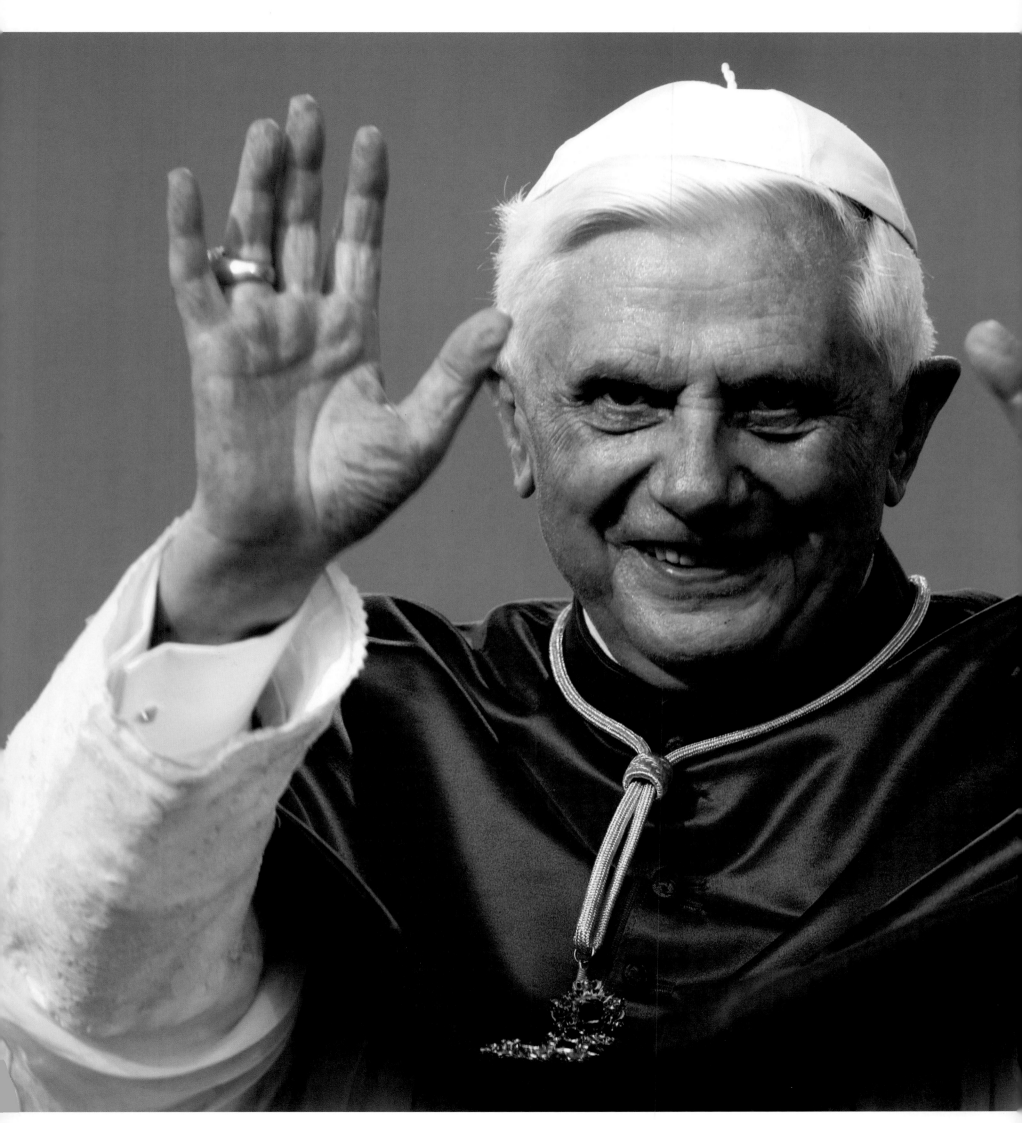

FILLING THE ROBES, FINDING HIS VOICE

The new Pope takes the stage

50-51 Week by week, Pope Benedict's smile seems to get broader and more relaxed. His two-handed wave becomes a familiar and welcome gesture to the faithful.

53 Those who have had the chance to meet Benedict XVI face to face always remark that the pope conveys through words or his eyes an attention focused solely on the person standing before him.

54 and 55 Benedict XVI's first trip "out of town" was to Bari, the capital of Puglia, which he visited in May 2005. He was joined by thousands of faithful and many Italian bishops in a celebration of the Eucharist.

56-57 A view of the Sala Regia, where Benedict comes to meet the members of the Diplomatic Corps accredited to the Holy See.

The Saturday morning encounter in the Paul VI auditorium was not just a media event, but actually an event held explicitly for the media. And it could not have gone much worse. Less than 100 hours from his election, Benedict XVI had decided – or someone decided for him – that the first public appearance since his emotional St. Peter's balcony christening should be this awkward salute to a mix of international journalists, Catholic VIPs and employees of the Holy See's communication office. From the moment he stepped out from stage left, it looked like the pontiff wanted to step right back behind the curtains. His smile was fixed somewhere well short of joyful, his waves to the crowd were less than spontaneous, his reported sweet sense of humor was absent from the script. It seemed as though somehow, at least for this odd self-imposed baptism-for-the-press, the brand new pope had wound up on this worldwide stage by mistake.

Benedict sat stiffly through effusive messages of gratitude by Church officials, winced at the sporadic chants of Ben-e-DET-to!, and spoke through a yelp of joy from a German reporter when he began to read in his native tongue. Though he recited his own prepared statements fluently in four languages, the pope was not given a text in Spanish, a language spoken by more than 45 percent of all the world's Catholics.

It was certainly a stumble out of the block, capped off the next day when Italian newspapers ran large photos of the encounter, pointing out that the hemline on Benedict's new papal robes was about three inches too high, offering an unusually clear view of his ruby slippers. A skeptical observer might have seen in those special slippers, and the rest of the majestic new wardrobe, a looming question in those very early days of the new papacy: Can a just-elected pope – even one of the most esteemed "princes of the Church" – be magically transformed into polished royalty the way Cinderella was with a wave of her fairy godmother's wand?

Fast forward from the 100th hour to the 100th day of this nascent papacy, and still no sign of magic tricks or miracles. But something – the devout would indeed call it the Holy Spirit – began to transform this timid academic into a comfortable and inarguably credible public presence before the expectant eyes of the faithful and readied pens of the Vatican press corps. There would of course be some stops and starts, and Benedict is obviously not the telegenic superstar his predecessor was. But the longtime theologian and behind-the-scenes Vatican manager stepped out of the shadows and into the role of Father to the Flock with surprising ease.

The emergence of the papal personage actually began to take root quickly, with the majestic instalment ceremony in St. Peter's Square just a day after the flop before the press corps inside the Paul VI hall. His homily on that brilliantly sunny Sunday offered the first glimpse that this was a man who was perhaps more eager to teach than preach, to guide his followers not only on a journey of faith but of deeper understanding. His words arrive in a lilting, gently accented Italian that draws his public in by highlighting the key points with a slight rise in his cadence, without ever having to raise his voice or repeat a phrase for emphasis.

Sources inside the Vatican hierarchy note the pope's insistence on writing virtually every line of all his key addresses; and this intimate bond between the sermonizer and his sermon offers an unadorned authority from the pulpit. His Angelus prayers on Sunday morning and his Wednesday general audiences have brought record crowds in this first year – outdrawing even those who came to hear John Paul during the 2000 Jubilee Year celebrations. His first trip outside of Rome, to the southern Italian city of Bari, was perhaps too brief, but nonetheless left the crowd buzzing as they waved skyward toward his departing helicopter.

Of course, it is inevitable that he would disappoint some – perhaps particularly the fist-pumping youth who had approached their faith and allegiance to John Paul as something akin to cheering for a sports hero.

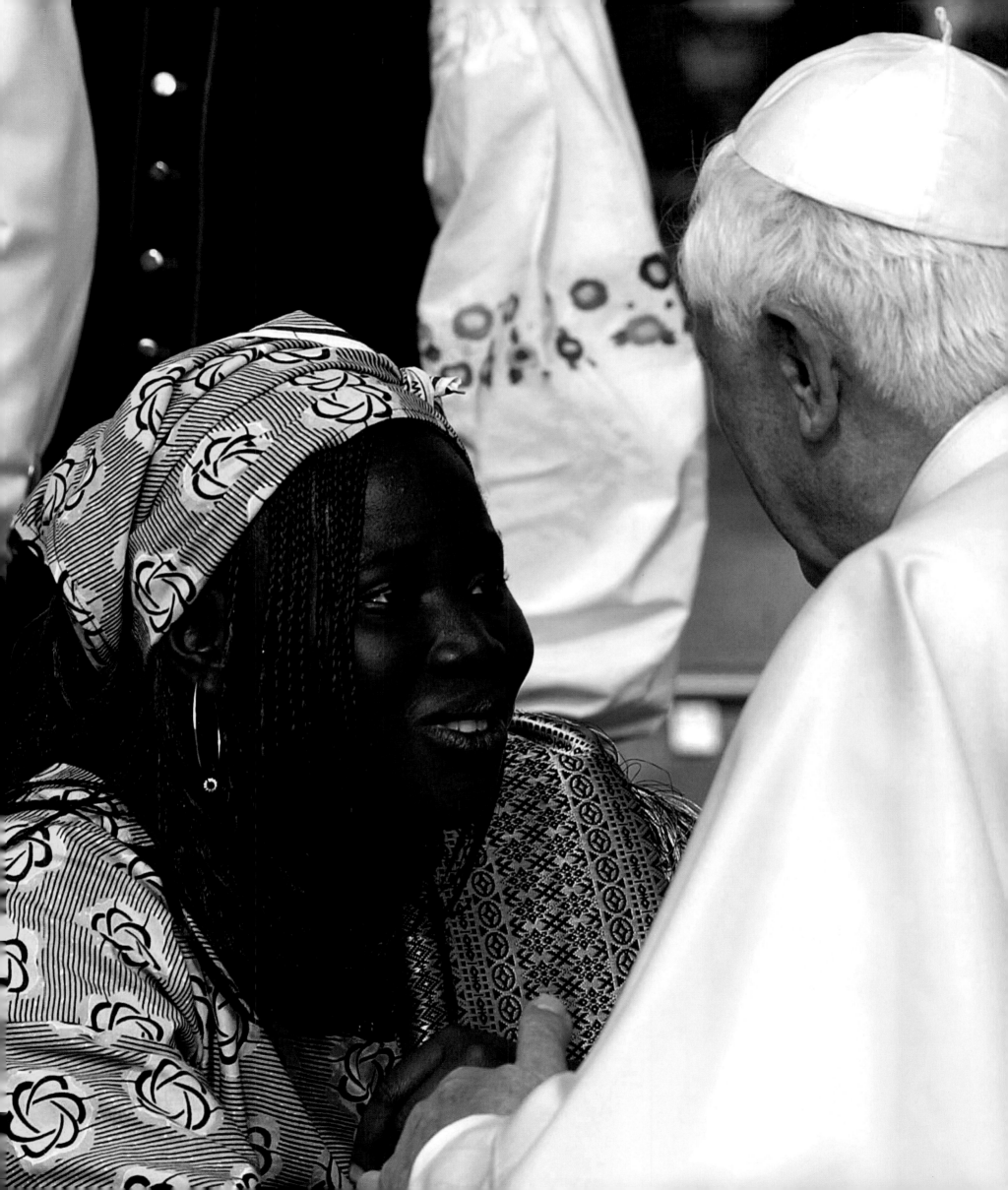

The Ben-e-DET-to (!) chanting and rhthymic clapping — inherited from the Gio-Van-ni PAO-lo (!) of the last papacy — seems to be something he accepts rather than revels in. But the new pope is all too aware that there are moments when he must in fact play to the crowd. This meant learning not to step on his applause lines. It meant finding moments to stray from his script not only for theological parentheses, but also for off-the-cuff salutes in different languages. At one general audience, he even put on a fireman's hat and later spoke to an ill nun via a cell phone

handed to him from the crowd. A long-time collaborator of Cardinal Ratzinger was downright stunned at the metamorphosis. "It's almost too good to be true. Here's a man who could well be described as 'professorial,' who suddenly has to learn to kiss babies and wave to crowds. It's a big jump. And maybe his first attempts were tentative, but he has quickly moved into the public role. He knows this is a big part of being pope."

By the time he reached his summer vacation perch in the Italian Alps hamlet of Les Combes, just a week before

he marked his 100th day in office, Papa Ratzinger was definitely hitting his stride on stage. On an overcast Sunday in late July, a crowd of a few thousand gathered in what amounts to the giant backyard of the same chalet where John Paul relaxed during 10 different summers. The sun broke through the clouds just as the new pope stepped out for his Sunday Angelus with a wide smile and waving his two-hands-at-a-time wave.

This famously private man actually seemed to be soaking up the attention. After an initial greeting, Benedict's face turned stoic, almost grim, as he segued into a reciting of the "Ave Maria." But when the final words are uttered, and one voice yells "Viva il Papa!" the white-haired man emerged from the depths of his prayer to smile again. Later, after remarks about recent terrorist attacks, he begins saluting the worshipers in various languages.

First French and English, before turning to Spanish with a bit of extra emphasis: "Saludo a los fieles de lengua espanola," prompting a loud roar from the back of the field. The pope waits for the cheers to quiet a bit, and says in Italian: "They always make sure they get heard," prompting another burst of cheers. When he arrives at his native tongue, there's the small sound of one or two German faithful cheering. "There aren't many of them," the pope quips. "But they are here!"

Afterwards, Ada Pasi, a grandmother from nearby Courmayeur, came to get a first glance of her fellow 78-year-old. She had made the same trek up the mountain for John Paul several times in the past. "Of course he's completely different. But the emotion for me is the same. You never get used to it." Asked if it was just the effect of seeing that figure in those perfect white robes, she shook that

possibility away. "No, no. I always look just at his face. Today, I saw the face of a man of generosity, but also with a touch of sadness. How could he be otherwise in these times we are living? You can see the weight of his responsibility that he carries. It is clear he is a man of great culture, an intellectual, but there is a certain determination that I hadn't expected. He has a very particular kind of charisma."

Naturally implicit in any early sizing up from the faithful is a comparison with his predecessor. But perhaps Benedict's most impressive accomplishment so far has been his charting a course – and being a man – at the same time so close to and yet so different from John Paul and his legacy. It became surprisingly easy for many faithful to accept that the time had come for a new leader, that continuity means neither a carbon copy nor forgetting about the departed pontiff. A new pope, in other words, is fundamentally a good thing.

That in fact may have be the fundamental wisdom in the cardinals' choosing him. Part of Papa Ratzinger's ability to fit so well into his new role is the natural pendulum of events, part of it is the power of the Catholic Church to adapt and

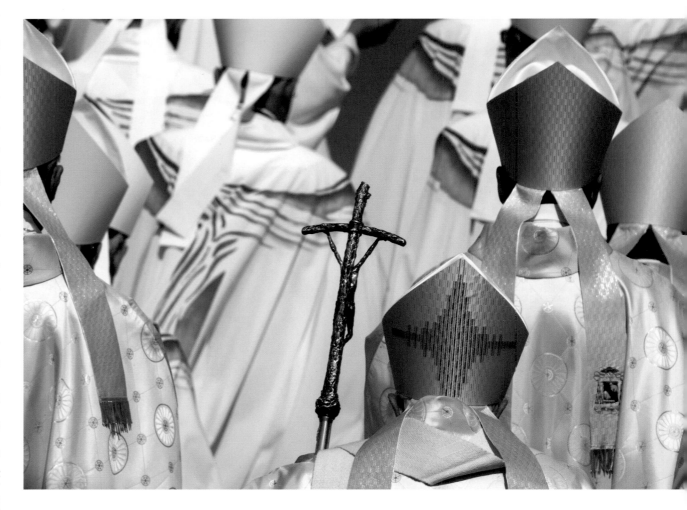

sustain itself through the convulsions of history. With his white hair and sweet smile and striking humility, it seems only he could fit so well into the pictures you see of him at the center of an elaborate Vatican ceremony or Christmas Mass or reaching out to touch some of the one million young people at World Youth Day.

Still, there are some things that stand larger than any of the pomp and yet may be hard at first to see. One such moment occurred in early August, at a general audience back in that same Paul VI auditorium where the public face

of this papacy got off to such a rocky start. After an enthusiastic ceremony with Brazilian and Mexican crowds competing for the loudest ovation, Benedict had set aside time for a long line of sick and elderly to personally greet the him on the stage as the rest of the crowd filed out of the hall. As the Vatican aides tried to keep the line moving, one could see Benedict doing his best to make each blessing count.

One girl, perhaps about nine years old, approached, holding her mother's hand and griping her favorite teddy bear with her other hand. Her hair was cut short and her face looked puffy from the medication she had to take, but her eyes were eager for this moment. When it was her turn, she'd only have a few seconds.

Benedict looked straight into her eyes, and brushed his hand with a blessing on her forehead. And then, without missing a beat, he offered the same blessing on the head of her teddy bear.

This timid academic indeed has a pastor's heart, and a father's touch.

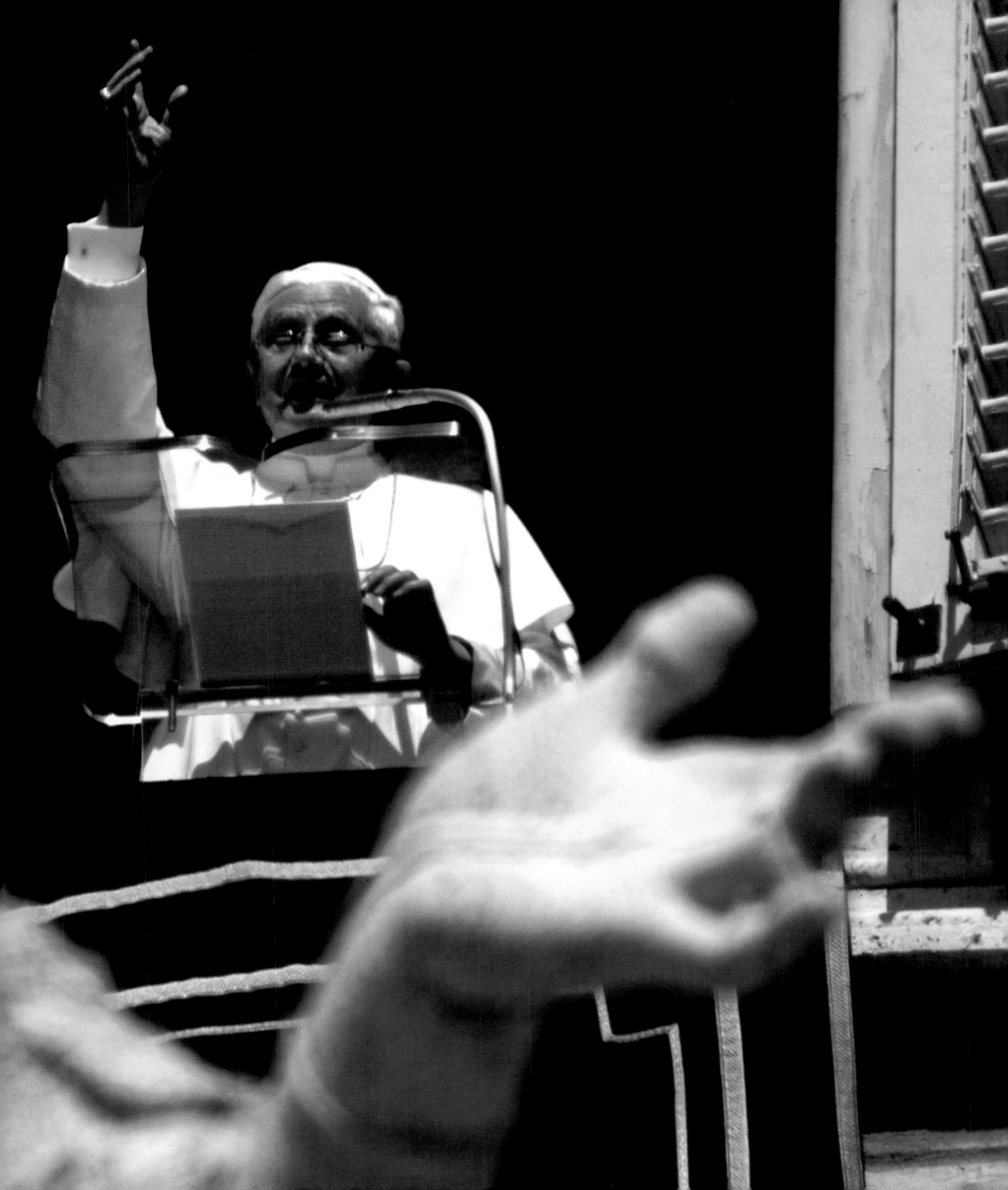

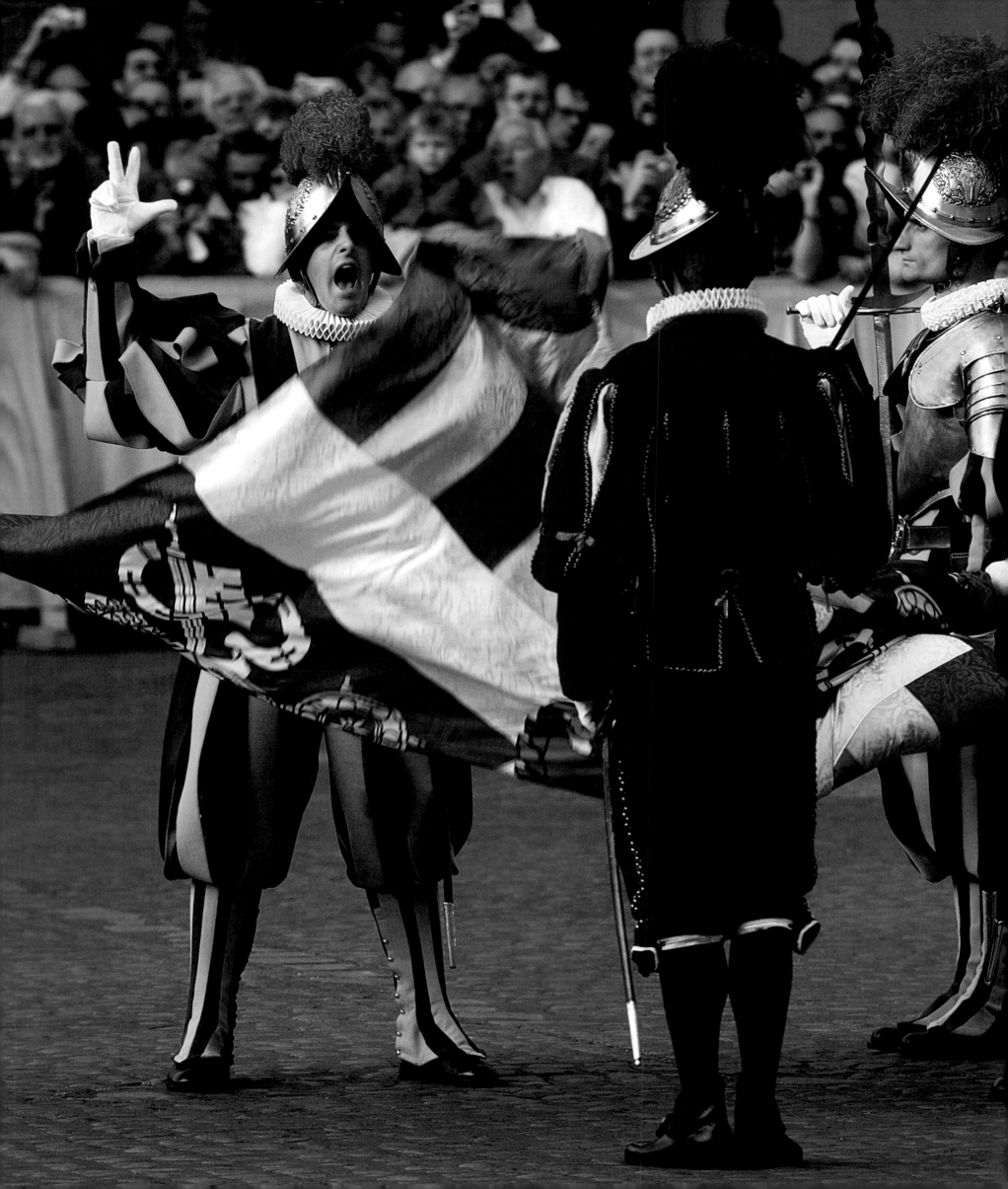

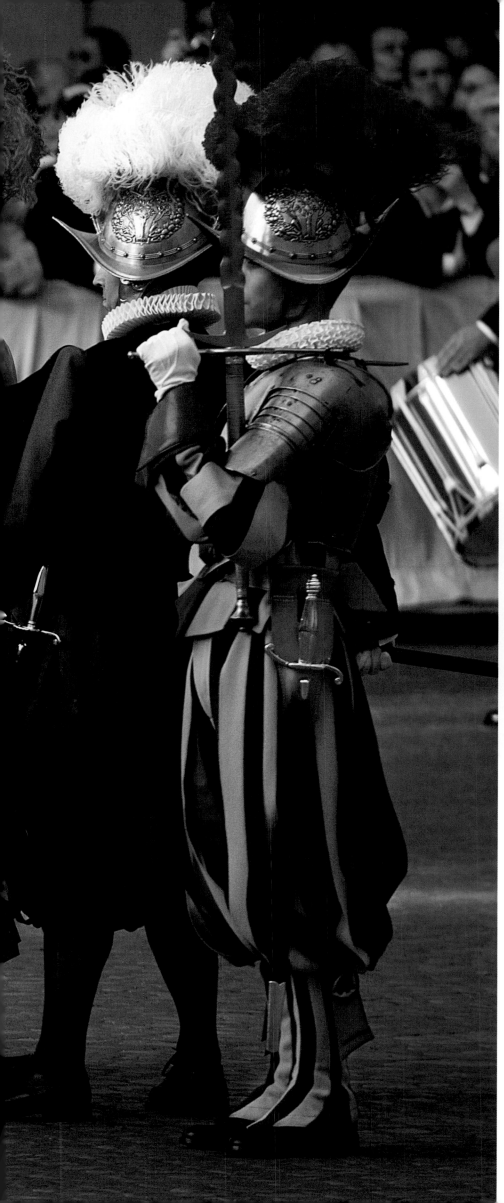

58-59 40,000 worshippers attend Benedict XVI's first
Angelus, celebrated from the window of his private study,
the same window from which only a short time before Pope
John Paul II used to look out onto the square. And indeed
Ratzinger's first words recall his predecessor, as, pointing to
the skies, he says that he senses John Paul's presence closer
than ever.

60-61 and 61 On May 6th thirty new recruits to the
Swiss Guard, the army that has protected the Pope since
1506, swear their oath in the courtyard of San Damaso.
The Pope thanked the Vatican security corps during his
private morning audience, praising its youthful vigor.

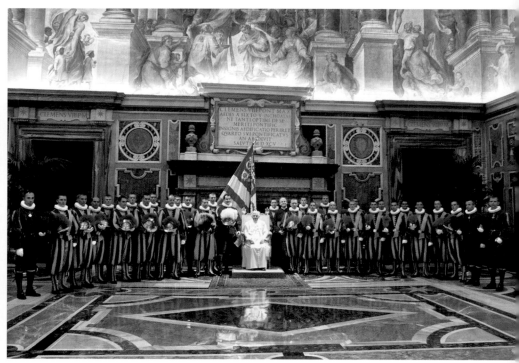

62-63 At the end of the Mass held for the swearing-in of
the new recruits, the Swiss Guard file down the nave of St
Peter's Basilica to return to their barracks, before the
afternoon ceremony in the courtyard of San Damaso.

64-65 A moment in the Mass celebrated by Benedict XVI
in the basilica of St John Lateran, the occasion when the
new pope takes formal possession of his diocese in his
capacity as Bishop of Rome.

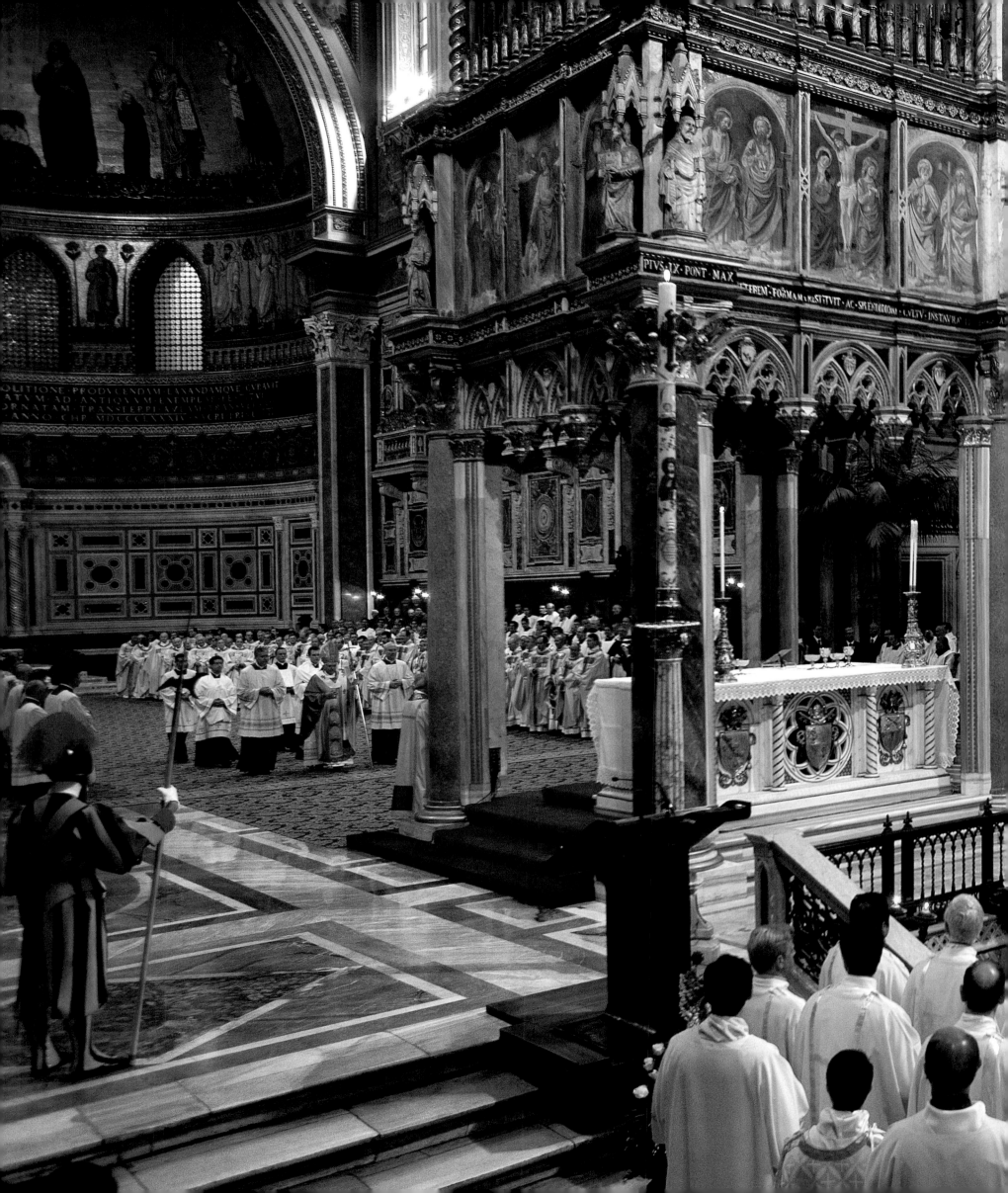

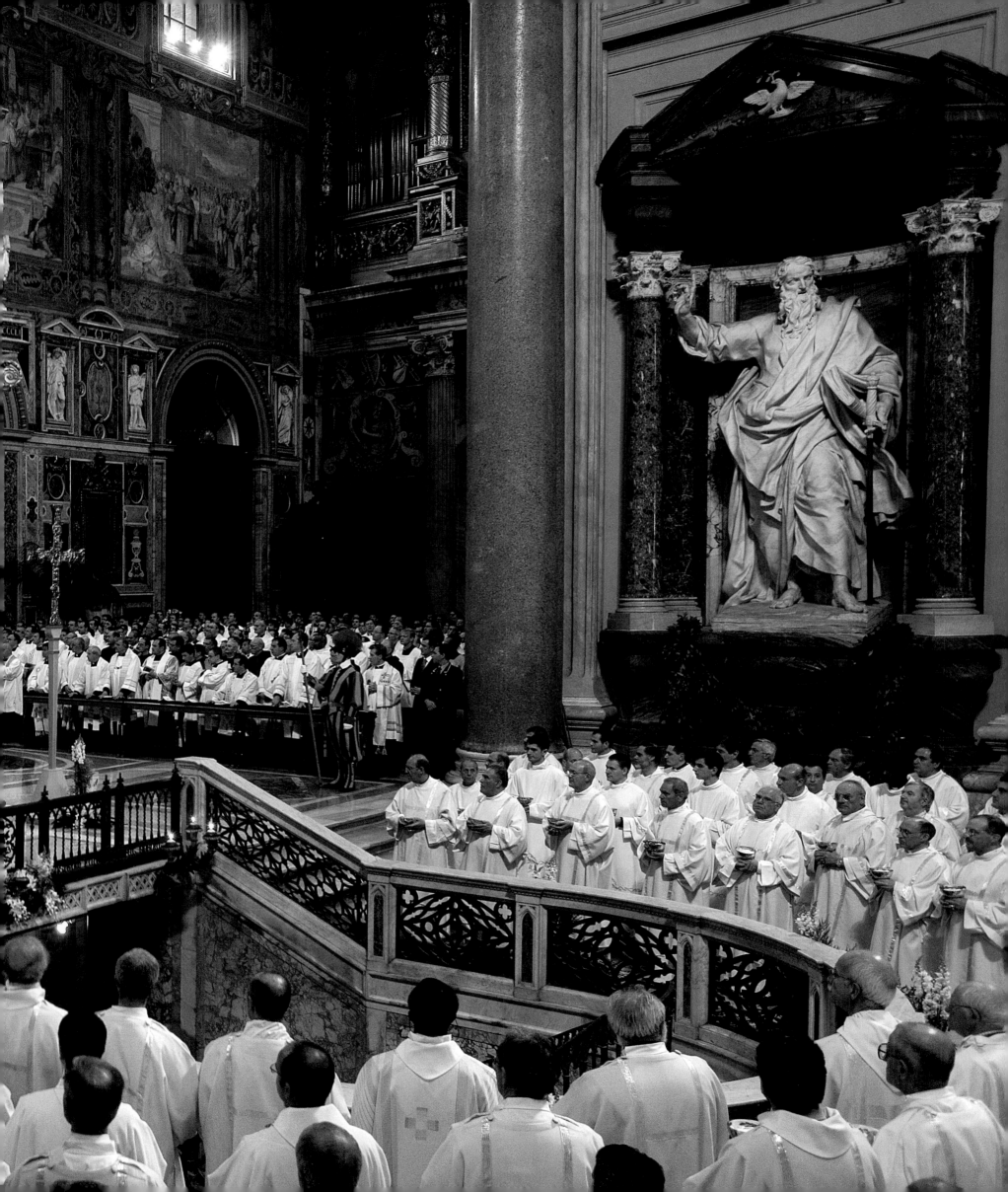

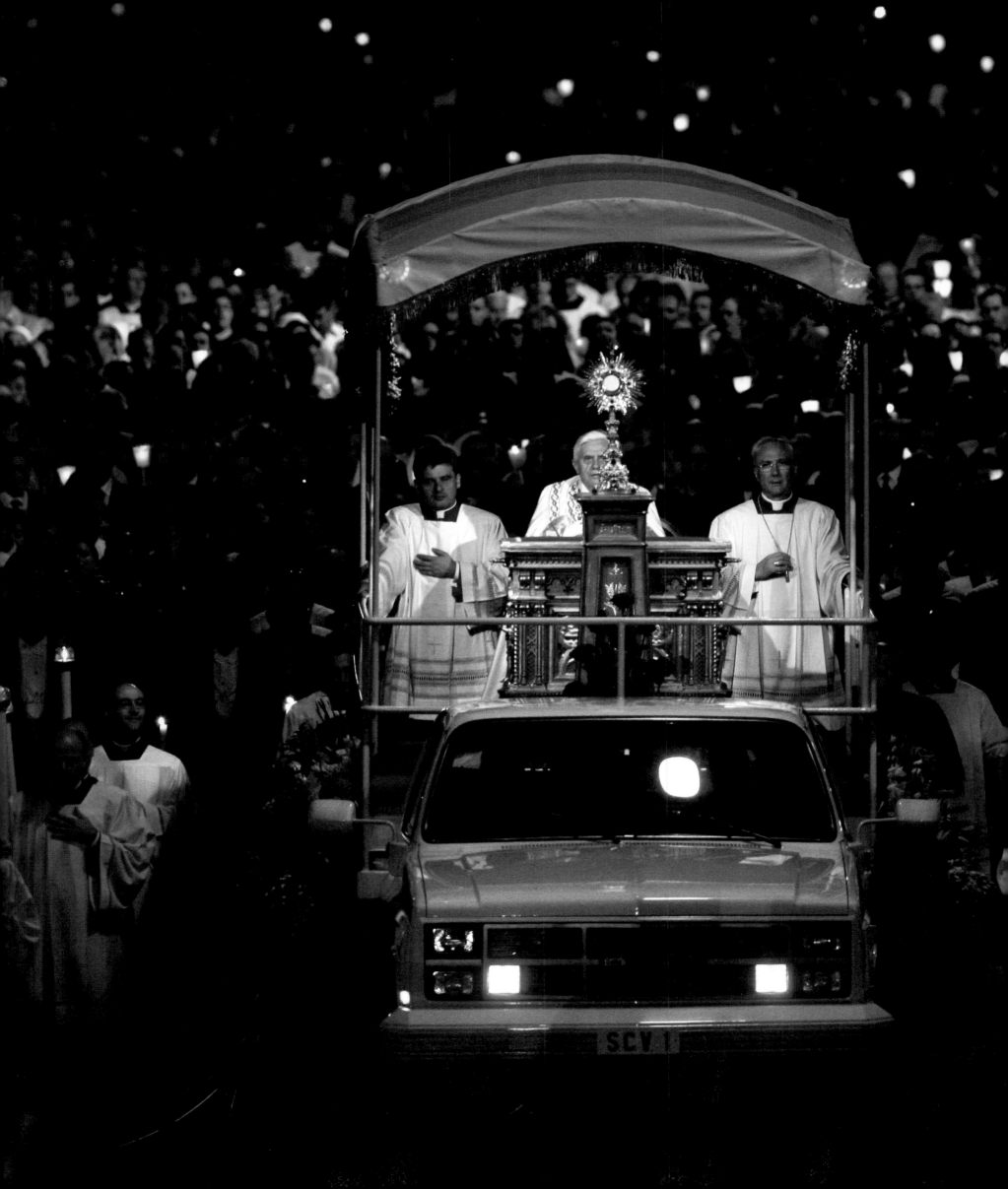

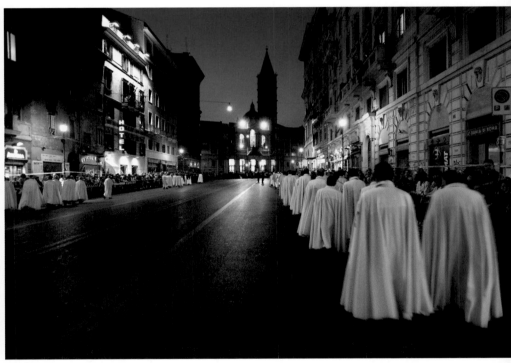

66-67 and 67 *A moving carpet of lights, a river of worshippers following the Pope in procession from the Basilica of St John Lateran to Santa Maria Maggiore, for the Solemnity of the Body and Blood of Christ.*

68-69 *A moment in the Mass celebrated on the esplanade of Santa Maria Maggiore for the Solemnity of the Body and Blood of Christ.*

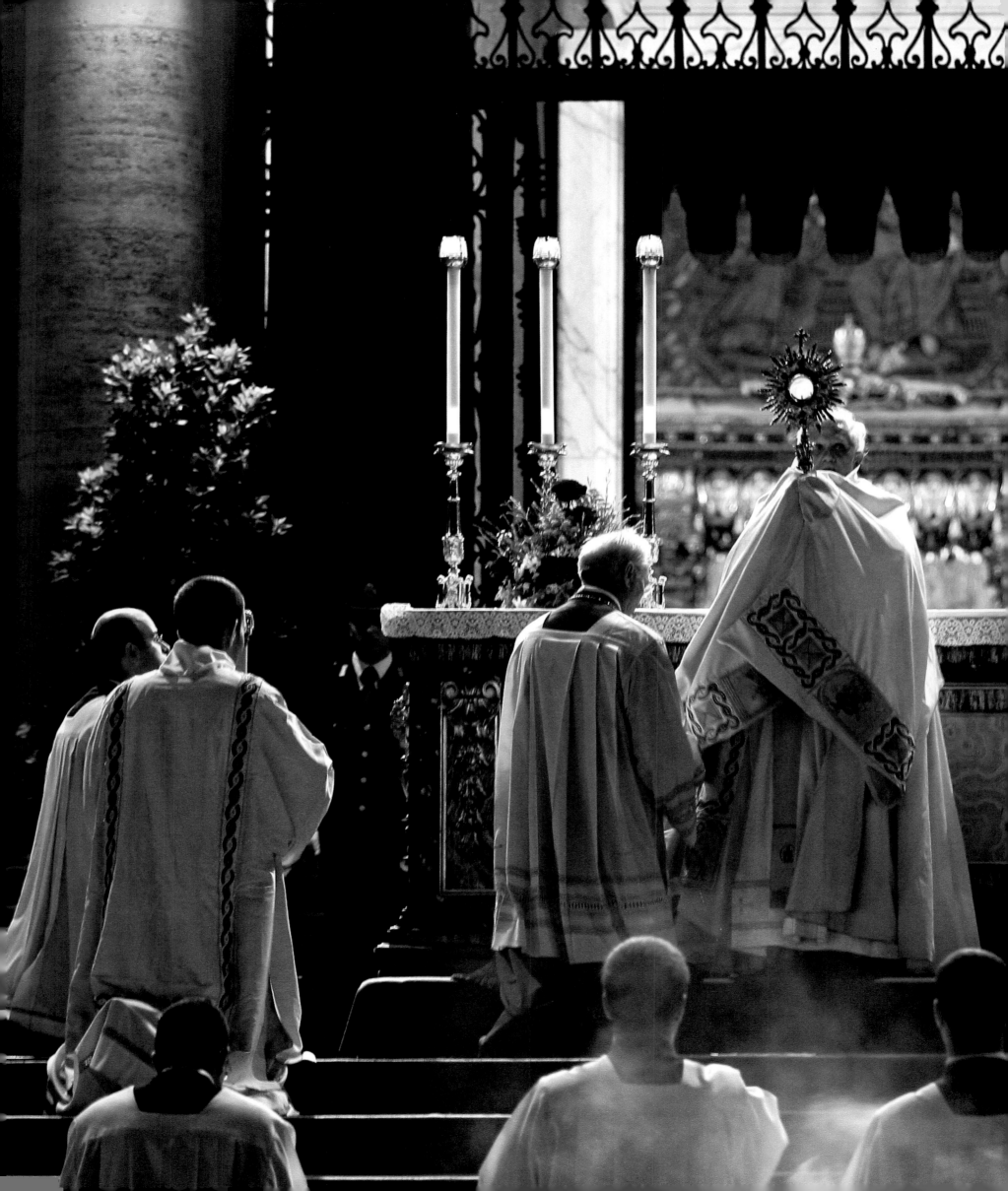

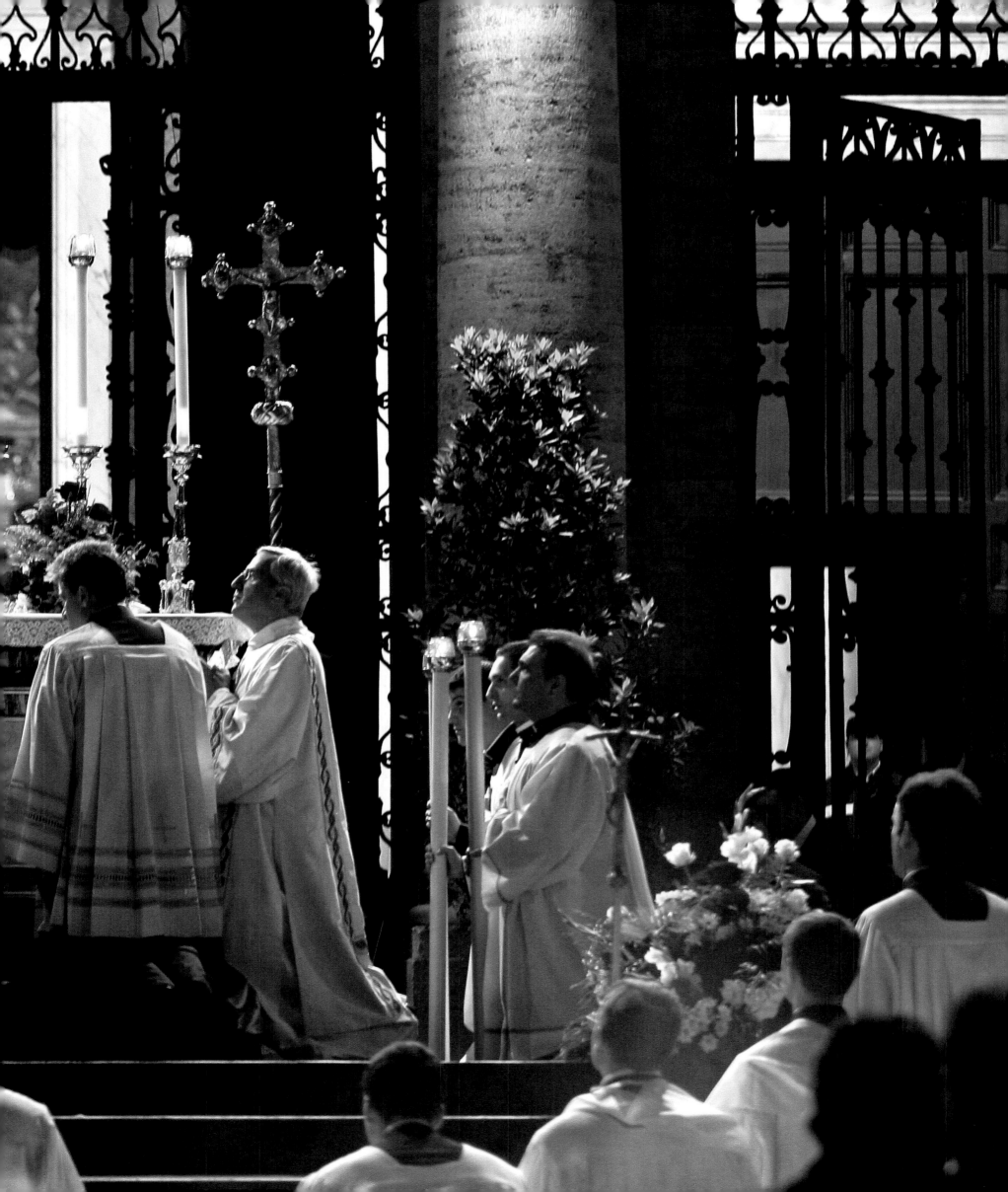

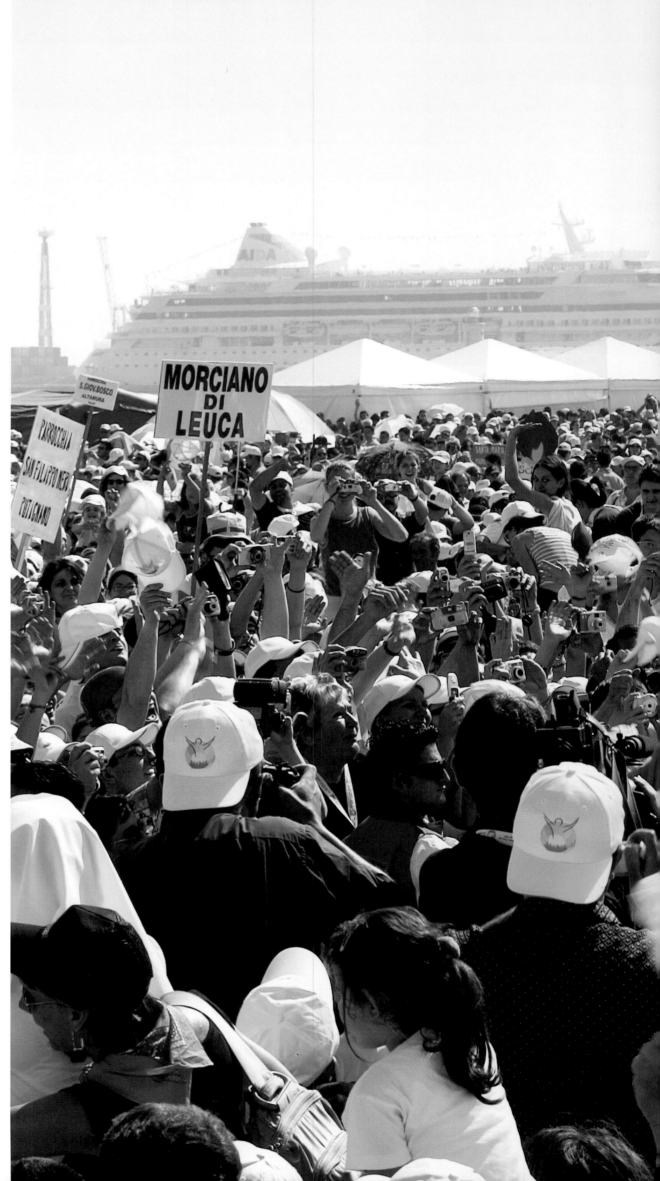

70-71 *Everyone has their cameras out and their eyes fixed on the popemobile, which has trouble squeezing through the crowd of young and old alike try to get as close as possible to Pope Benedict during his trip to Bari, his first, in which he experienced the tangible proof of the legacy of affection left by John Paul II.*

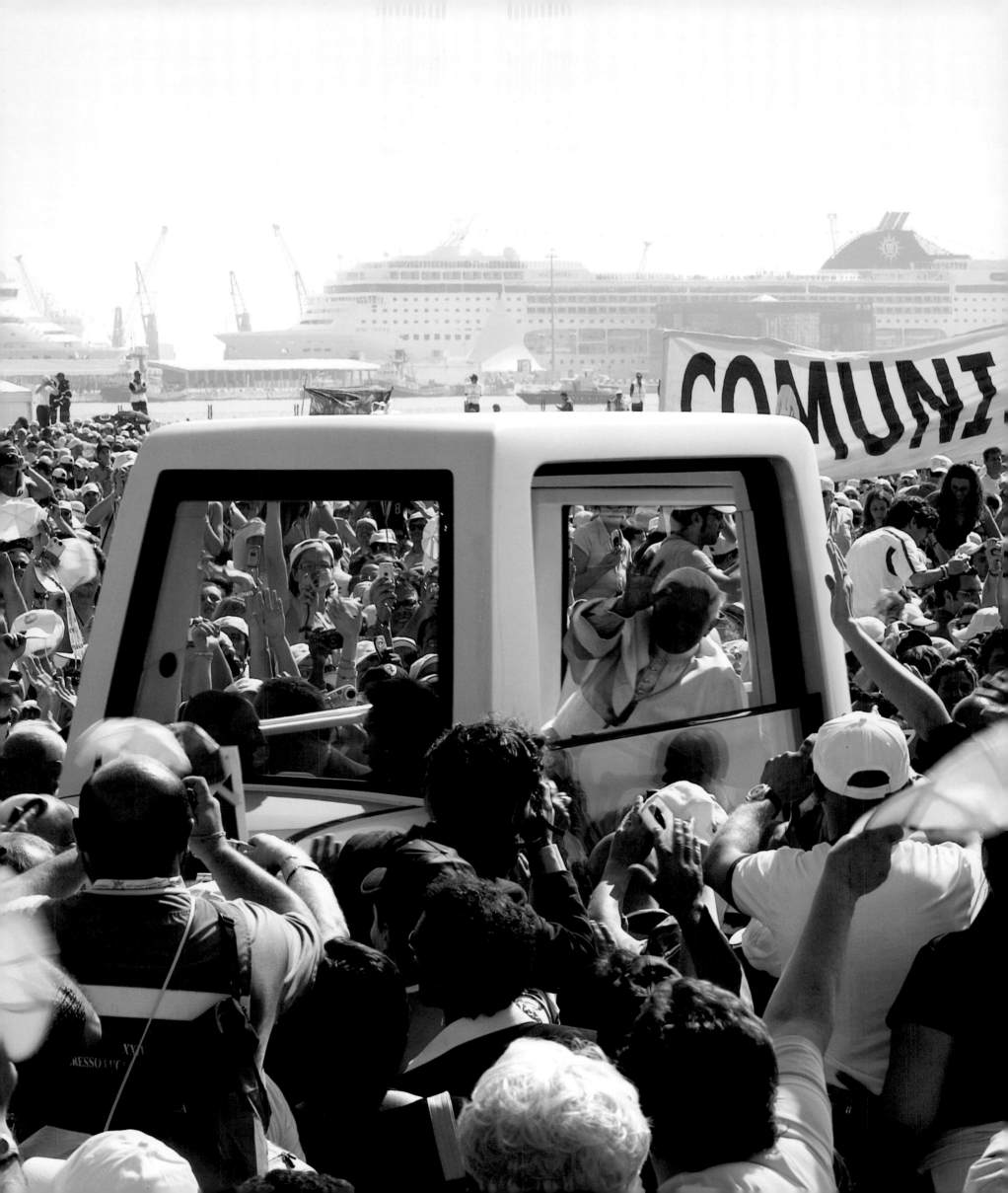

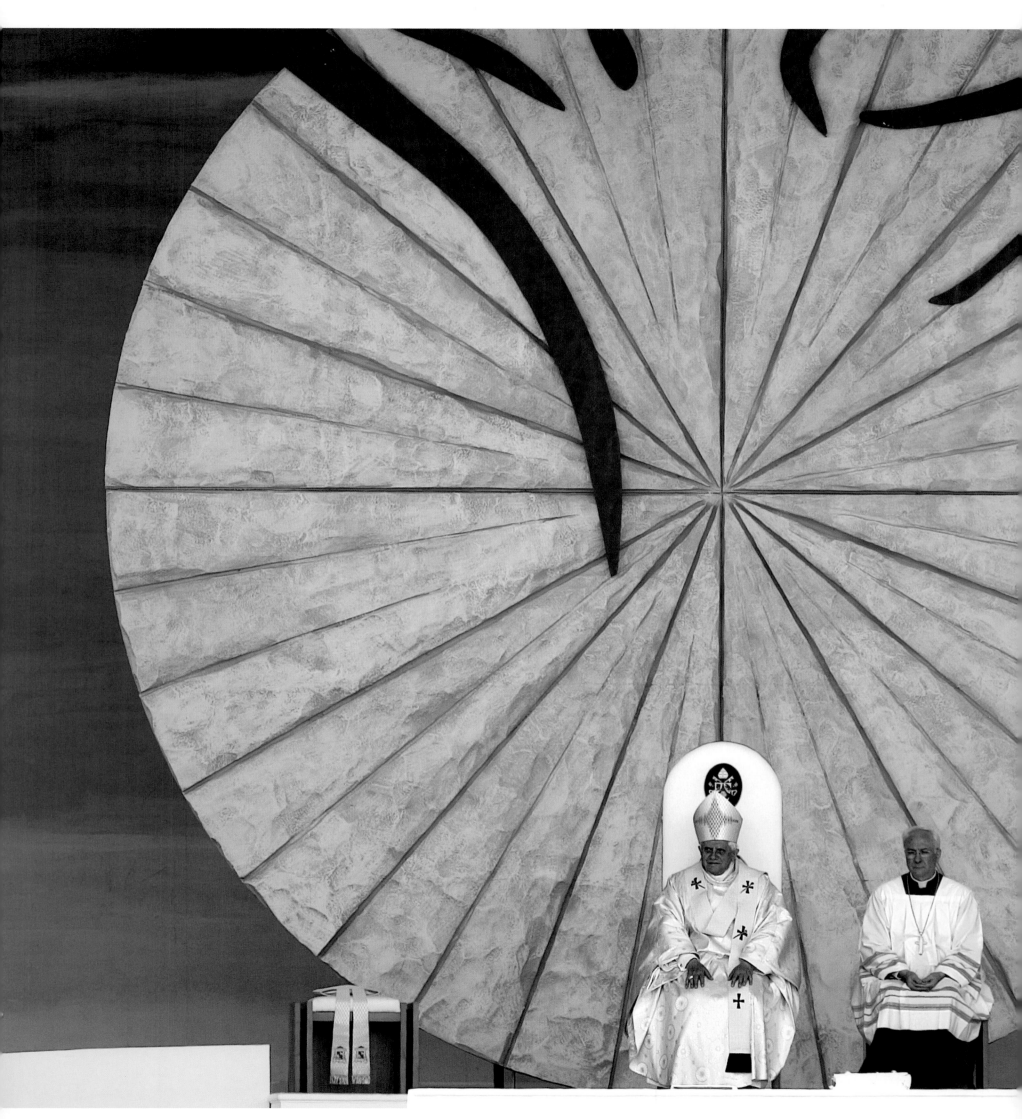

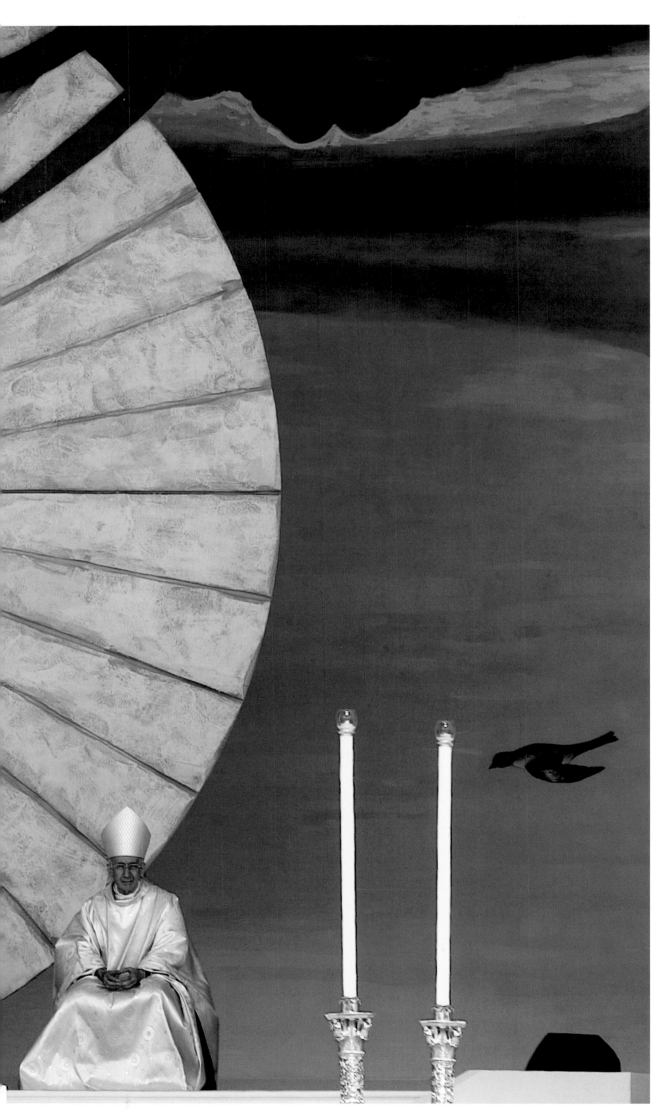

72-73 *Flanked by Monsignor Marini and Cardinal Ruini, Pope Benedict brings the 24th Congress on the Eucharist to a close with his sermon at Marisabella, in Bari, stressing that "we cannot live without Sundays".*

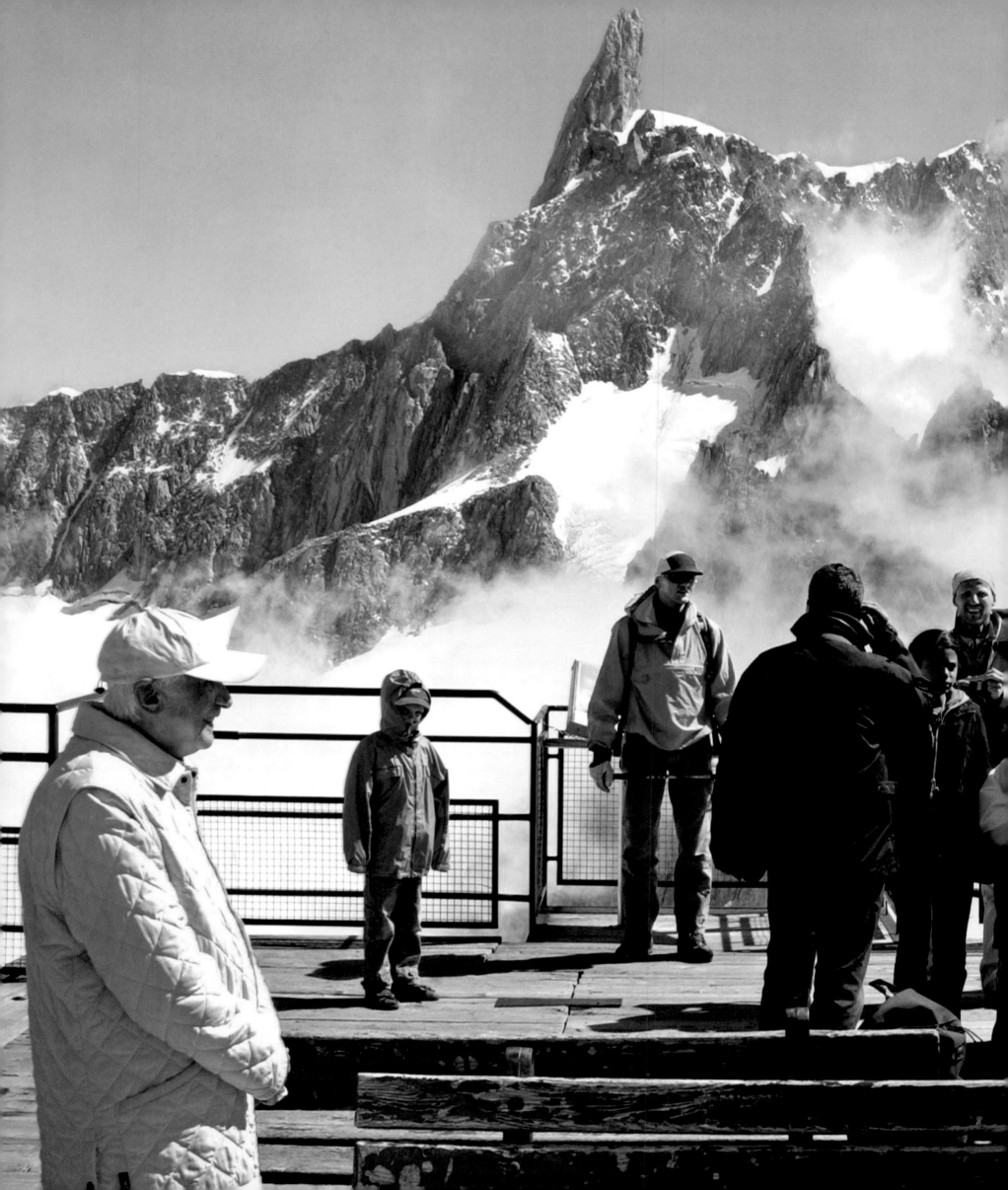

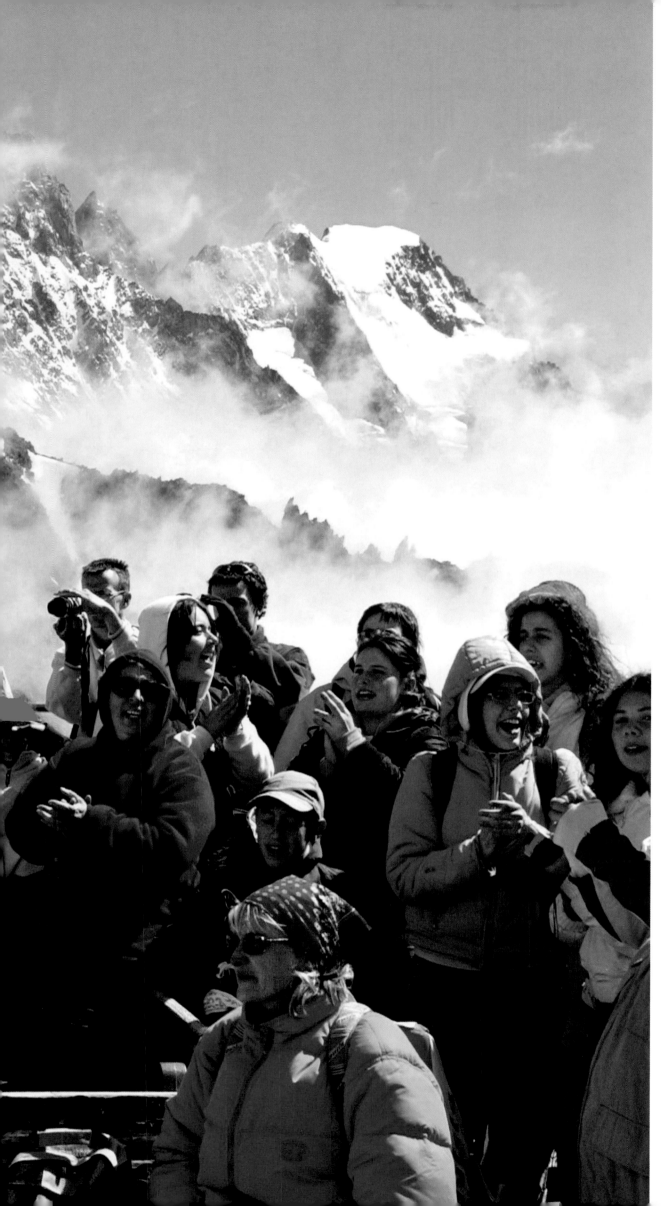

74-75 *In Courmayeur, during a trip to Mont Blanc, the pope takes by surprise a group of worshippers who were not expecting to come across such an illustrious tourist. Benedict XVI spent his summer holiday in the mountains of Val d'Aosta, as his predecessor was so fond of doing.*

76-77 *At Les Combes, surrounded by the peace and silence of the mountains, and accompanied by a handful of prelates, Benedict XVI walks the short distance from the house where he is spending his holiday to the grassy field where he is to recite the Angelus.*

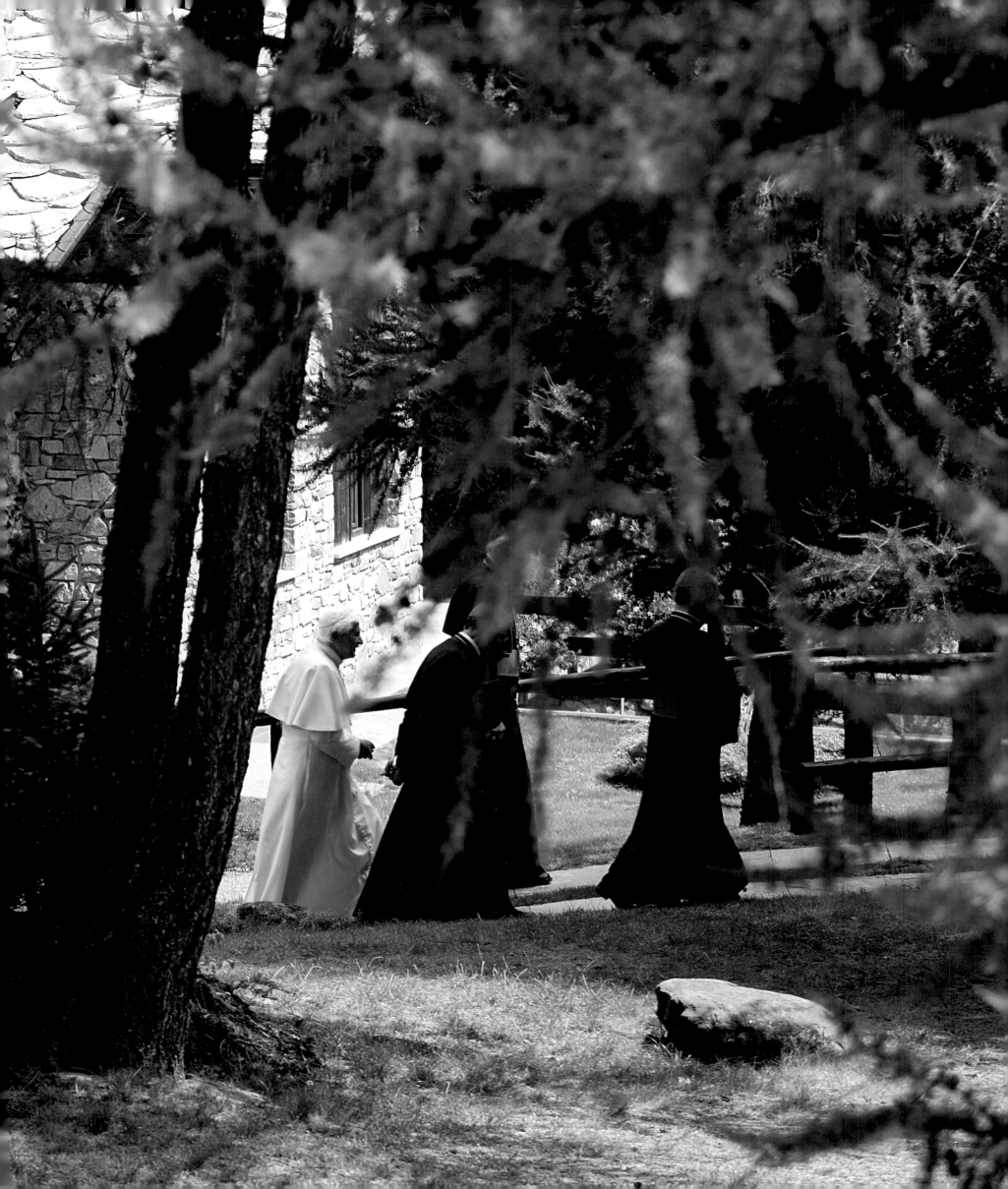

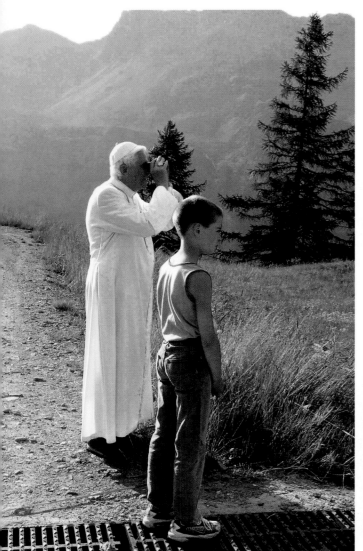

78 On a walk the pope met ten-year-old Mattia Clusaz, who showed him the most scenic paths to take, pointing out the peaks that can be seen from Les Combes.

78-79 After meeting with clerics in the diocese of Introd, a number of enthusiastic worshippers show their affection for Pope Benedict by giving gifts of mountain flowers. The pope spent two weeks of July in Val d'Aosta and devoted much of his time to writing, playing the piano and taking long walks.

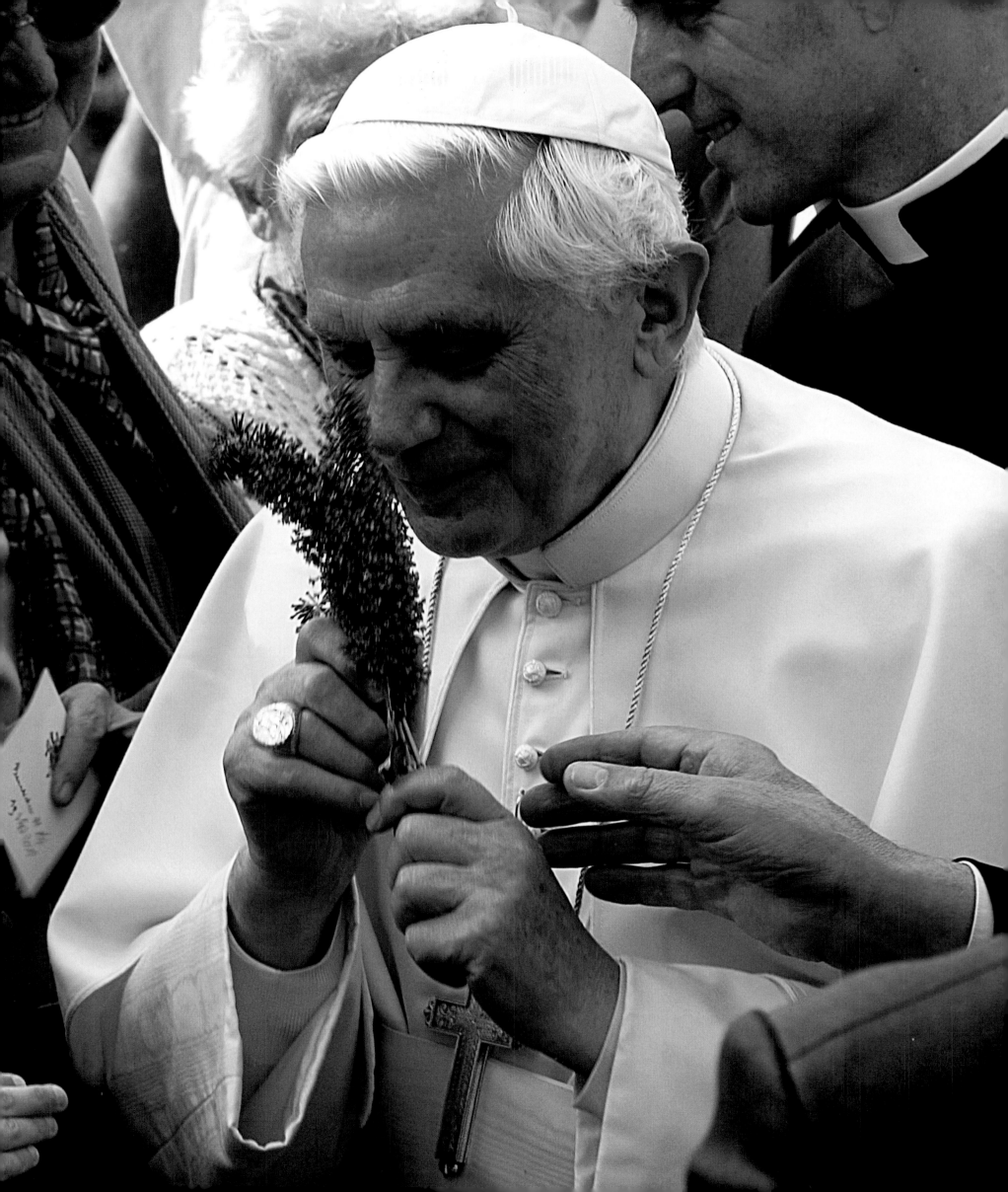

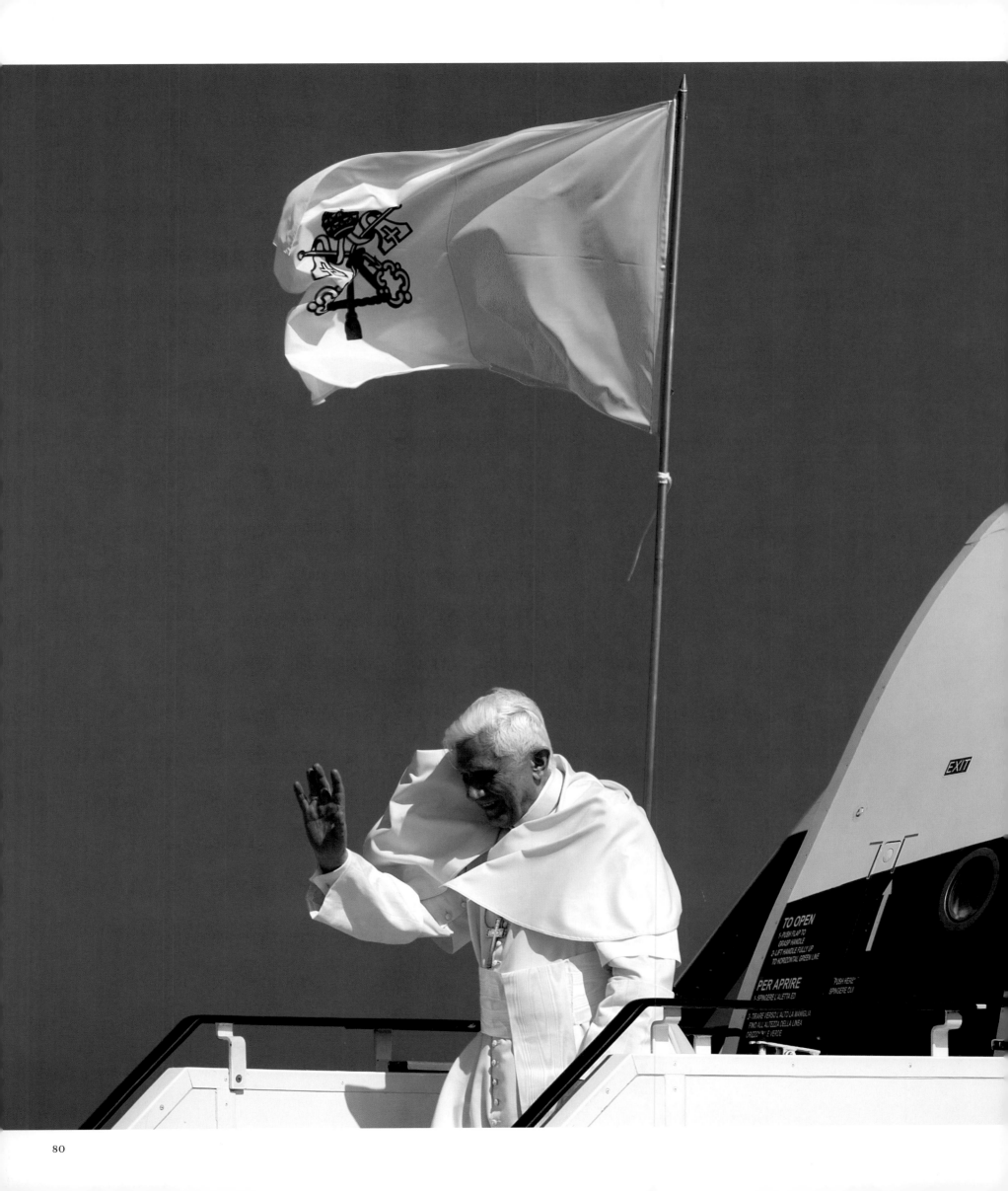

THE MAIDEN MISSION

Benedict travels to Cologne for World Youth Day

80-81 *The papal airplane arrives at Cologne International Airport and Benedict XVI receives a rapturous welcome from his homeland on his first trip abroad. Many wondered if he would continue the tradition begun by John Paul II of kissing the ground on his arrival in a foreign country, but he quickly made it plain that the procedure had changed.*

82-83 *It is a cold and misty morning when the pope celebrates Mass for the young from all over the world who have spent the night with rucksacks and sleeping bags in Marienfeld waiting for his sermon.*

84 *Benedict XVI makes his speech to the crowd of young people and believers thronging the banks of the Poller Rheinwiesen from the boat taking him to Cologne Cathedral across the Rhine.*

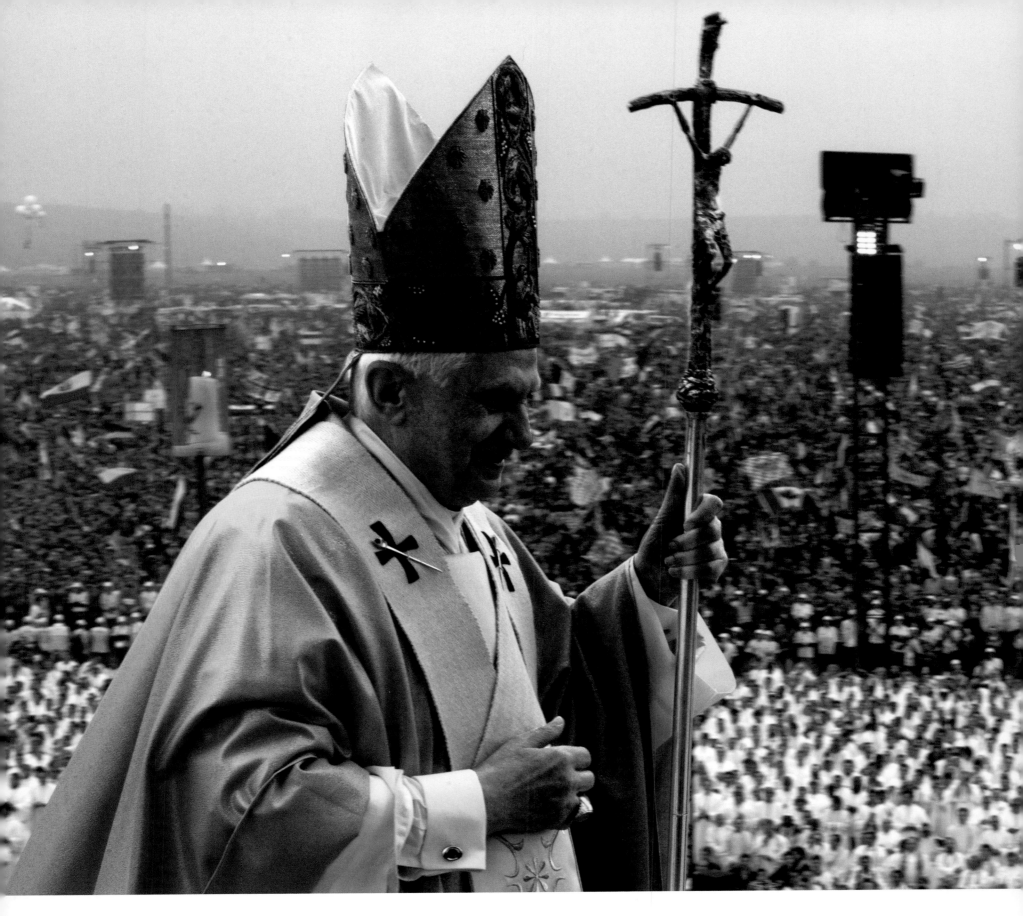

Papal trips can be many things: pastoral visit, diplomatic mission, mass media opportunity. Destiny would also make Benedict XVI's maiden journey abroad a personal homecoming for the first German pontiff in 950 years.

But with so much riding on this opening trip – and so much ground to cover – that biographical twist seemed secondary as the Alitalia jet touched down in Cologne just after noon on a sunny Thursday in August. As the cheering pilgrims and a retinue of reporters and bishops and bodyguards watched Benedict's first red-carpet steps across the airport tarmac, it was hard not to harken back to John Paul II. And hard not to wonder how anyone could fill those traveling shoes.

Not only did John Paul rack up the miles – 104 foreign trips during his 26-year papacy – he also had a natural gift

Though not the first pope to travel beyond the Vatican walls, John Paul transformed the "papal trip" into an international event simply too momentous to ignore, with every kiss of the tarmac and every open-air mass for a million, another snapshot of history.

Among the departed pontiff's favorite destinations were the World Youth Day celebrations that he created in 1985 to gather the globe's young Catholics every few years for prayer, teachings and music. Providence would beckon when he closed his last World Youth Day in Toronto in 2002 by announcing that the next edition would be in Cologne.

That meant that three years later and four months after the Vatican's German-born doctrinal chief was elected pope, the first WYD without John Paul would also be his successor's first trip home in his new robes. But most of all, this new father of the flock would get his first up-close encounter with his young followers from all over the world, and a chance to connect with millions more through four days of constant international media coverage.

The trip would also test the new pope's mettle on the political and inter-religious fronts. The most anticipated encounter was with German Jewish leaders at a ceremony at Cologne's synagogue, which had been destroyed by the Nazis on the infamous Kristallnacht rampage in 1938. The pope also scheduled meetings with German Muslim leaders and non-Catholic Christians, as well as top political leaders on the eve of what would turn out to be German Chancellor Gerhard Schroeder's unsuccessful bid for re-election. It was, in other words, a four-day papal trip with "all of the above" on the itinerary.

The jam-packed program recalled John Paul's trips before his health began to fail, and he was very much on the press corps' mind even before the 10 a.m. takeoff from Rome's Ciampino airport. Would the new pontiff follow his predecessor's old customs? Did he have any surprises up his sleeve? And first off, would he come to the back of the plane to chat with the 50 or so reporters on board? Yes, was the answer to this final question, but his salute to reporters was

for leaving both spiritual and political footprints almost anywhere he touched down. Bold but subtly calibrated words in Warsaw in 1979 would be the first domino toward the undoing of the Communist regime in his native Poland; a stern wag of his finger reined in the rebellious priests of Latin America's "liberation theology"; an old man's hand reaching out at Jerusalem's Wailing Wall carried the force of centuries of wisdom.

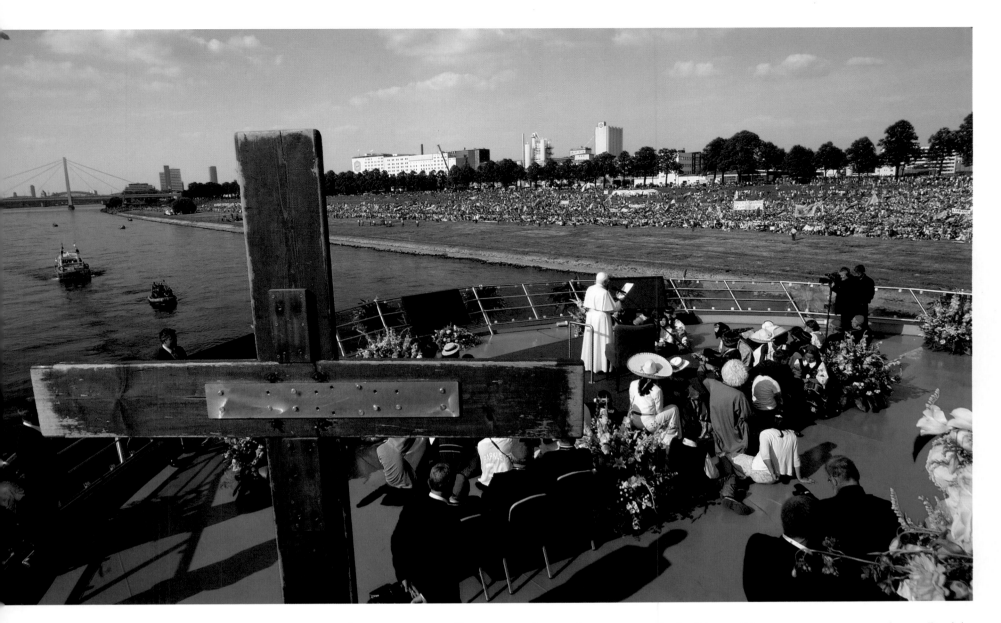

only a brief exchange before his spokesman cut off questions even though Benedict appeared ready to take more.

But there are certain decisions that only the Holy Father can make. And so two hours later, as he stepped briskly down the stairs toward the airport tarmac, the next question was about to be answered. No, Pope Benedict XVI did not follow his predecessor's custom of kissing the ground upon arrival. Having carved out a new kind of charm in Rome, the new pope would be doing things his own way on the road as well.

The view of the man in white was majestic during the trip's first major event, a ferryboat ride down the Rhine, with the pope perched on a platform at the vessel's bow, waving to the massive crowds that had turned out to line the river banks.

Dozens of young faithful even waded in up to their thighs to get closer to their Holy Father, prompting a quip

from longtime *Irish Times* Vatican correspondent Paddy Agnew: "The Rhine looks like the Ganges today!" And Benedict seemed genuinely moved, carrying a beaming smile all the way down the river and throughout a subsequent series of encounters with local authorities, and the flocks of screaming and chanting and waving young people as far as the eye could see.

He spoke, and spoke forcefully in five different languages in a message that rang out through loud speakers along the river. He recounted the pilgrimage made by the Magi, whose relics are preserved in Cologne's cathedral, and urged the young people to follow that same path. "Dear young people, the happiness you are seeking, the happiness you have a right to enjoy has a name and a face: it is Jesus of Nazareth, hidden in the Eucharist. Only he gives the fullness of life to humanity!" Listening to the crescendo of his voice around the words "a name, a face" it seemed for a

moment that this soft-spoken academic possessed a touch of riverboat preacher.

The trip's second day began with a meeting at the Presidential Palace in Bonn, but already in the morning a copy was circulating of the prepared text for Benedict's noontime visit to the synogogue. Some reporters were left cold by what he was planning to say about the Holocaust: Where were the references to how Benedict – as a German – felt about this black page of his country's history? Where was his own recollections of those dark days when he was forced into the Hitler Youth as a teenager? Where was the personal touch of John Paul? But once he arrived at the blue-domed, brown stone synogogue, the pontiff's very presence made the point clear.

With his hands humbly clasped in front of him, the pope walked into the main hall as the choir sang, "Shalom aleichem," or "Peace be with you." After two Hebrew hymns, and the blowing of the *shofar* (the ram's horn), the son of a Holocaust survivor and the synagogue's rabbi spoke. When it came time for Benedict to rise, his remarks wouldn't stray much from the original text.

But there was something happening that went beyond words. It was in the way the pope listened so intently to his hosts. It was the warm, two-hand embrace he shared with the young bearded rabbi.

It was in the somber cadence of his voice as he recounted Nazi atrocities, and the utter silence in the synagogue to hear his every breath. It was, in other words, in the German pope's heartfelt desire to come to speak out loud at the synogogue about an ugly past on what otherwise was a voyage to rejoice for Catholicism's future. And the standing ovation for Benedict was confirmation that German Jews appreciated the gesture.

Subsequent meetings with other Christian denominations and a group of German Muslims, as well as a meeting with future Prime Minister Angela Merkel, solidified the diplomatic credentials of the voyage.

Still, the real reason the pope had come to Cologne was beginning to gather in the Marienfeld, 20 miles (30 km) outside the city. Busload after busload of young people were arriving as a rainy afternoon gave way to the jagged light of a summer sunset piercing past cumulus clouds. Less than famously precise German planning meant that the pope and his aides actually had to walk through muddy patches to reach the elevated stage. The view, however, was impressive. A long way, Papa Ratzinger, from the quiet of your old studio at the Holy Office! Over the next 15 hours, Benedict delivered a pair of homilies that served as a dual lesson for the million-plus young people.

During Sunday's closing mass, the pope's explanation for how the Eucharist was born in the death of Jesus is both plain and poignant. ["What is happening? How can Jesus distribute his Body and his Blood? By making the bread into his Body and the wine into his Blood, he anticipates his death, he accepts it in his heart and he transforms it into an action of love. What on the outside is simply brutal violence, from within becomes an act of total self-giving love."] Benedict manages to be both an expert catechist and subtlely transcendent in the same turn of phrase.

Some of the young people seemed to be waiting for the new pope to sweep them off their feet. But others were happy to be planted firmly in the Marienfeld's soggy earth. Derek Smith, 23, a student at St. Thomas College in Houston, likes it that Benedict "doesn't mince words." "It's what we young people need. There are moral absolutes, and they need to be enforced, otherwise you have anarchy." Perhaps there was less cheering than at previous World Youth Days, but at least as much listening. Nine months later, his second foreign trip brought Benedict to the homeland of his predecessor. Of course it could never compare to John Paul's early journeys back behind the Iron curtain to his native Poland. But the new Pope was nevertheless again able to draw his flock closer, pay homage to a departed, special old friend, and the German pope concluded the voyage with a poignant visit to Auschwitz. Still, despite the success of his early journeys, all signs suggest that this cosmopolitan professor – and second straight "foreign" pope – will not allow any globetrotting to get in the way of his priorities as Bishop of Rome.

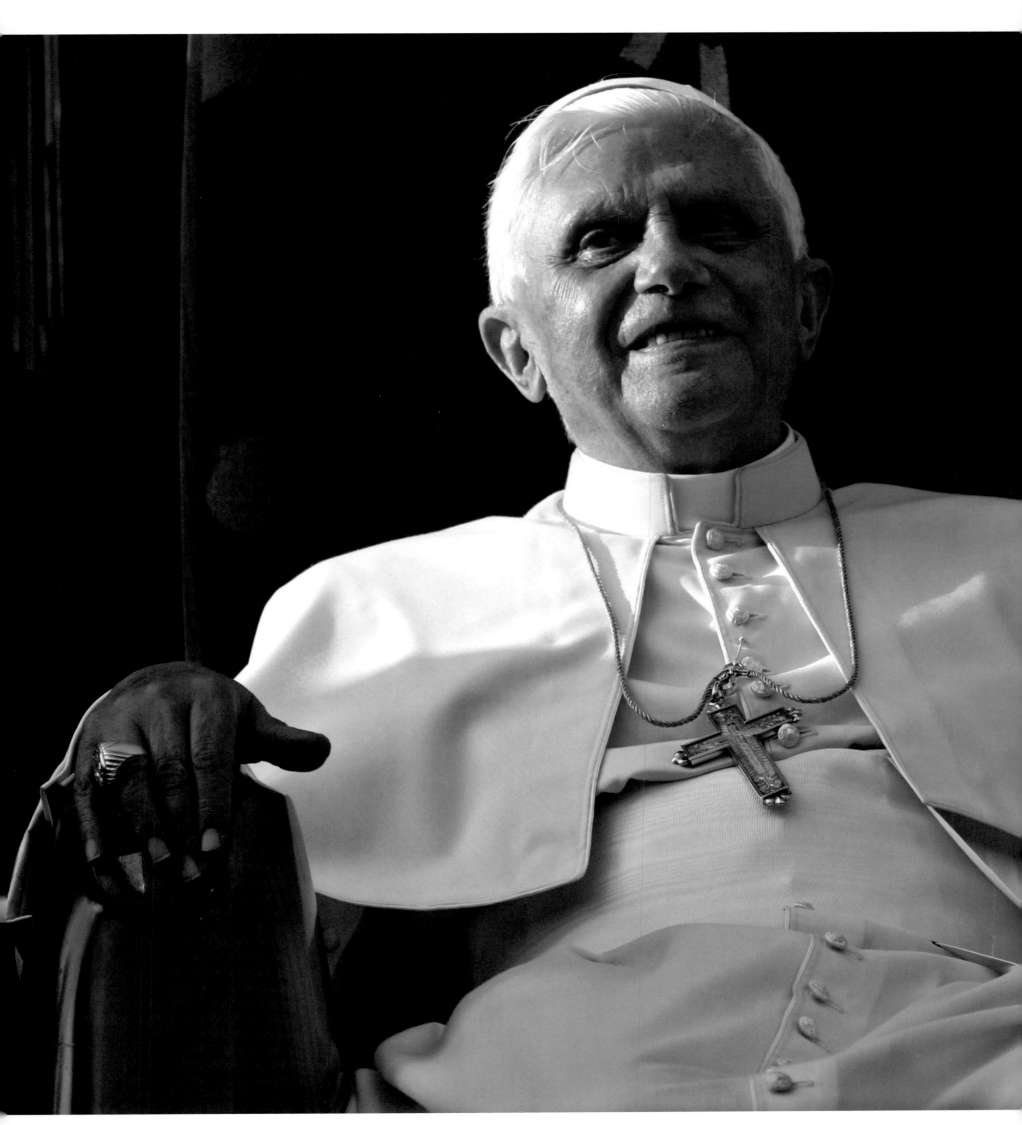

86-87 *The pope enjoys the reception he is given by the young people of Cologne, after the flight and boat trip bringing him to the cathedral.*

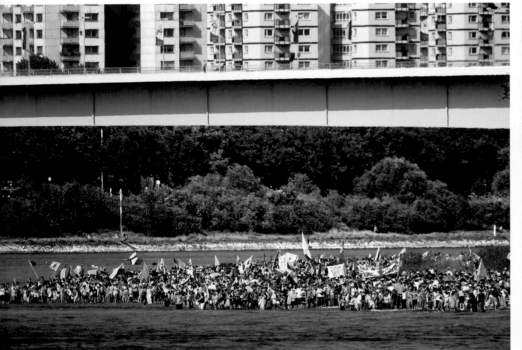

88 and 88-89 *As used to happen with John Paul II, Pope Benedict's first journey abroad to his native Germany also acted as a magnet for hordes of young people gathering to meet the new pope and hear his words.*

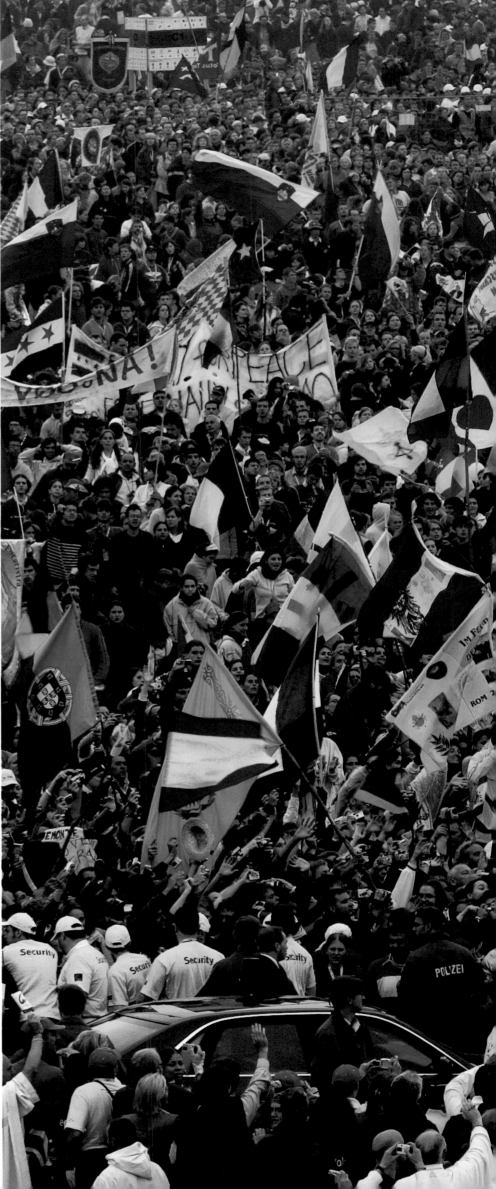

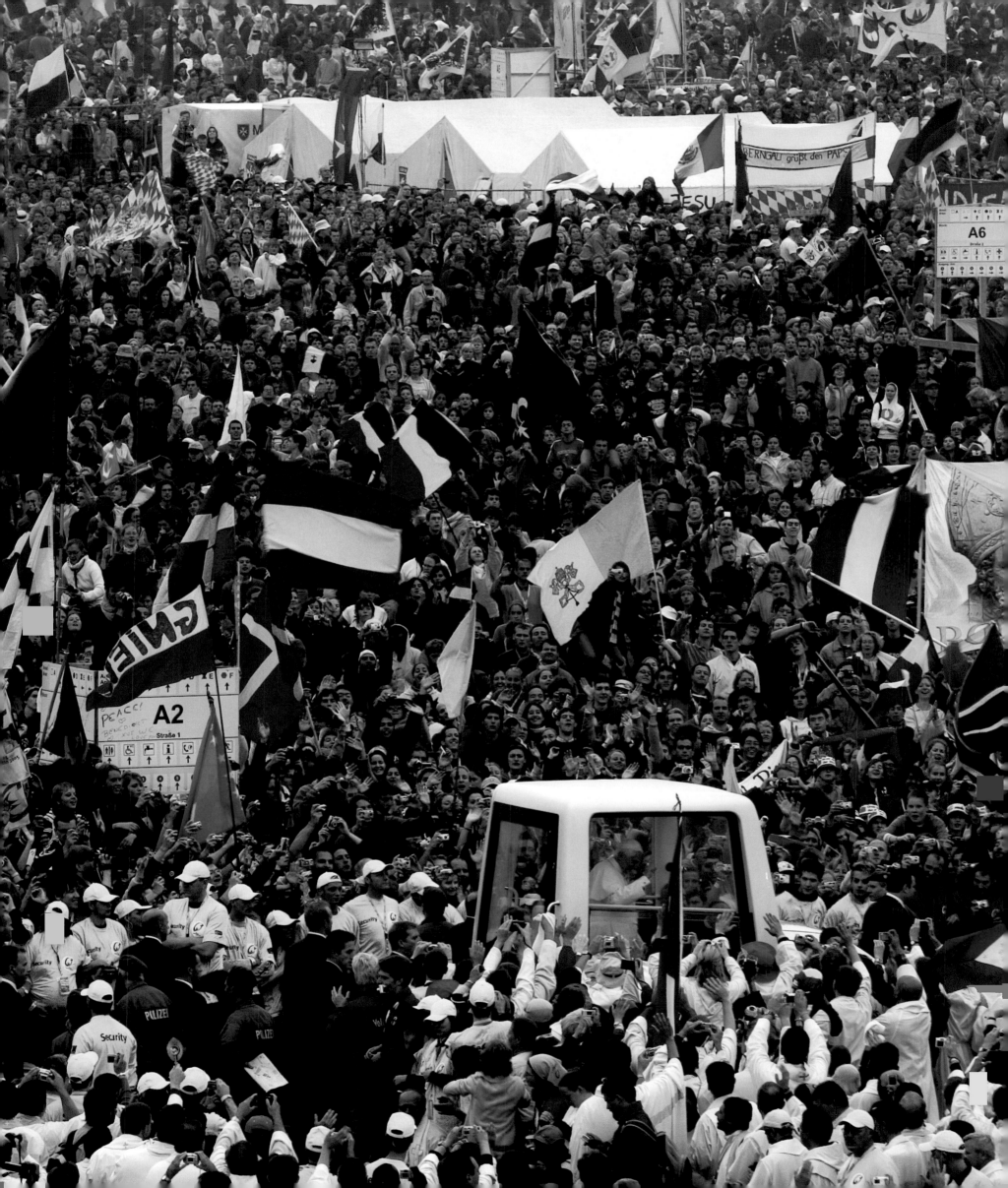

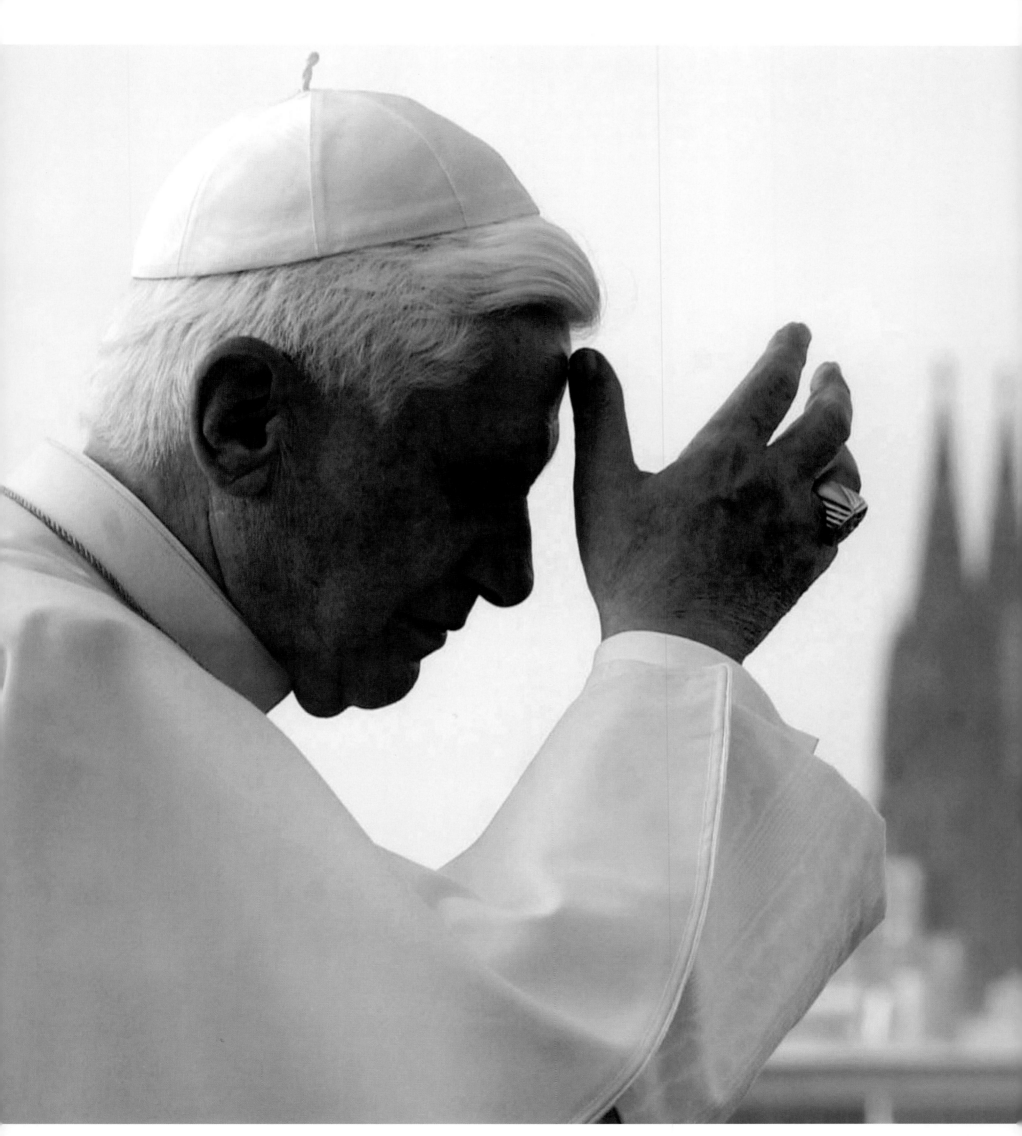

90-91 *With Cologne Cathedral in the background, Benedict XVI seems to be seeking a moment of quiet meditation during the enthusiastic welcome of the young people lining the banks of the Poller Rheinwiesen. He begins his speech by thanking John Paul II, who had the idea of gathering together young people from throughout the world. Following the example of the Magi, these young people had endured long journeys in the expression of their faith.*

92-93 *Since he was elected pope, it can be said that every gesture, every word and each little detail regarding Benedict has been put under the magnifying glass — in real time. From his red shoes up…*

94-95 *The pontiff praying in Cologne Cathedral in front of the Reliquary of the Magi. According to the pope's very words in the church, this is the most revered shrine in the whole of Christendom, upon which has been built a still greater shrine, Cologne Cathedral.*

96-97 *The Pope arrives at the Marienfeld for the vigil with the young people of the world. The date and location for the 20th World Youth Day had been set by John Paul II at the Toronto event in 2002. Now they cheerfully wave their various flags to welcome the new pope.*

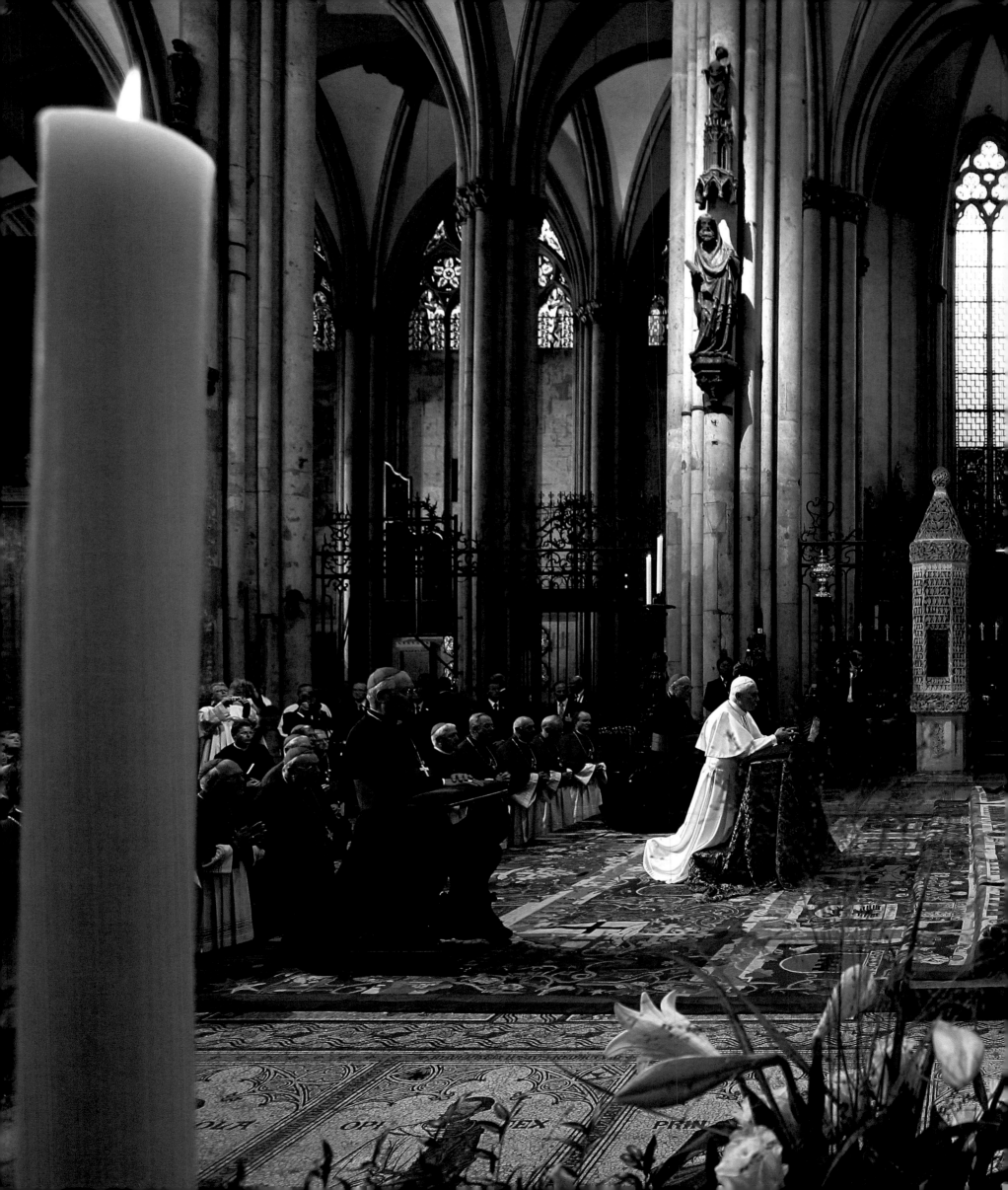

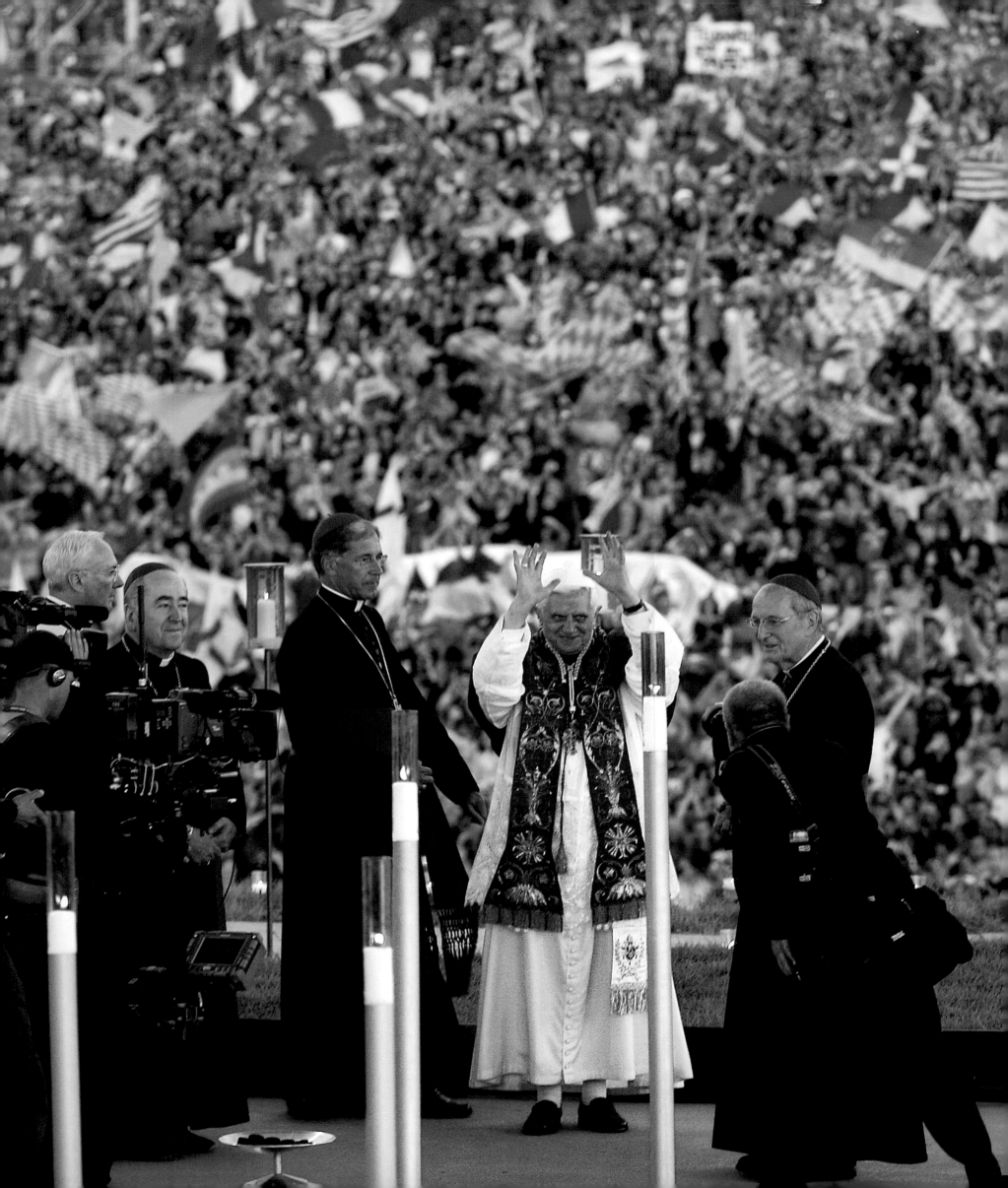

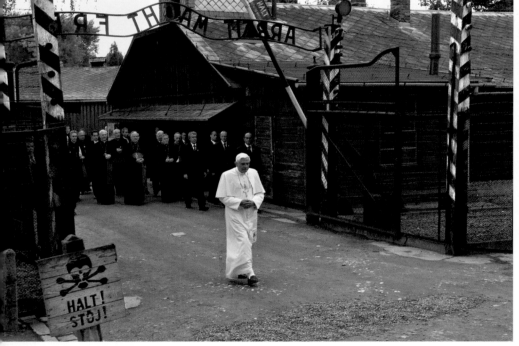

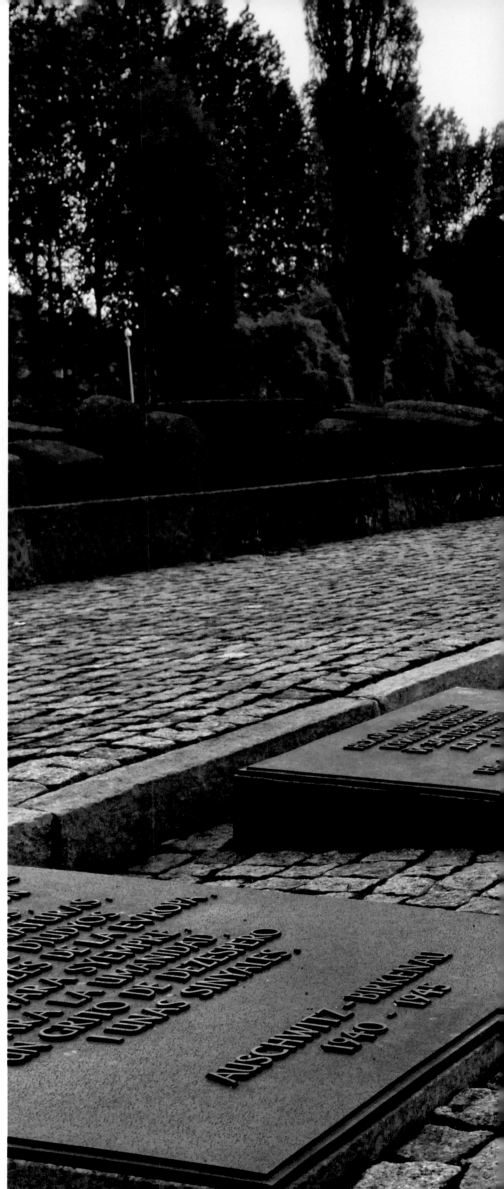

*98 left The most poignant moment of the pope's trip to
Poland was his visit to the concentration camp of
Auschwitz. Visibly emotional, Benedict XVI went through
the gate bearing the words Arbeit macht frei – "work
shall set you free" – over it. Millions of Jews walked
through this gate to their death.*

*98-99 At the concentration camp of Birkenau, the German
pope prayed before with international monument,
which has memorial tablets in 22 languages commemorating
all the victims who died at the Auschwitz-Birkenau
concentration camps.*

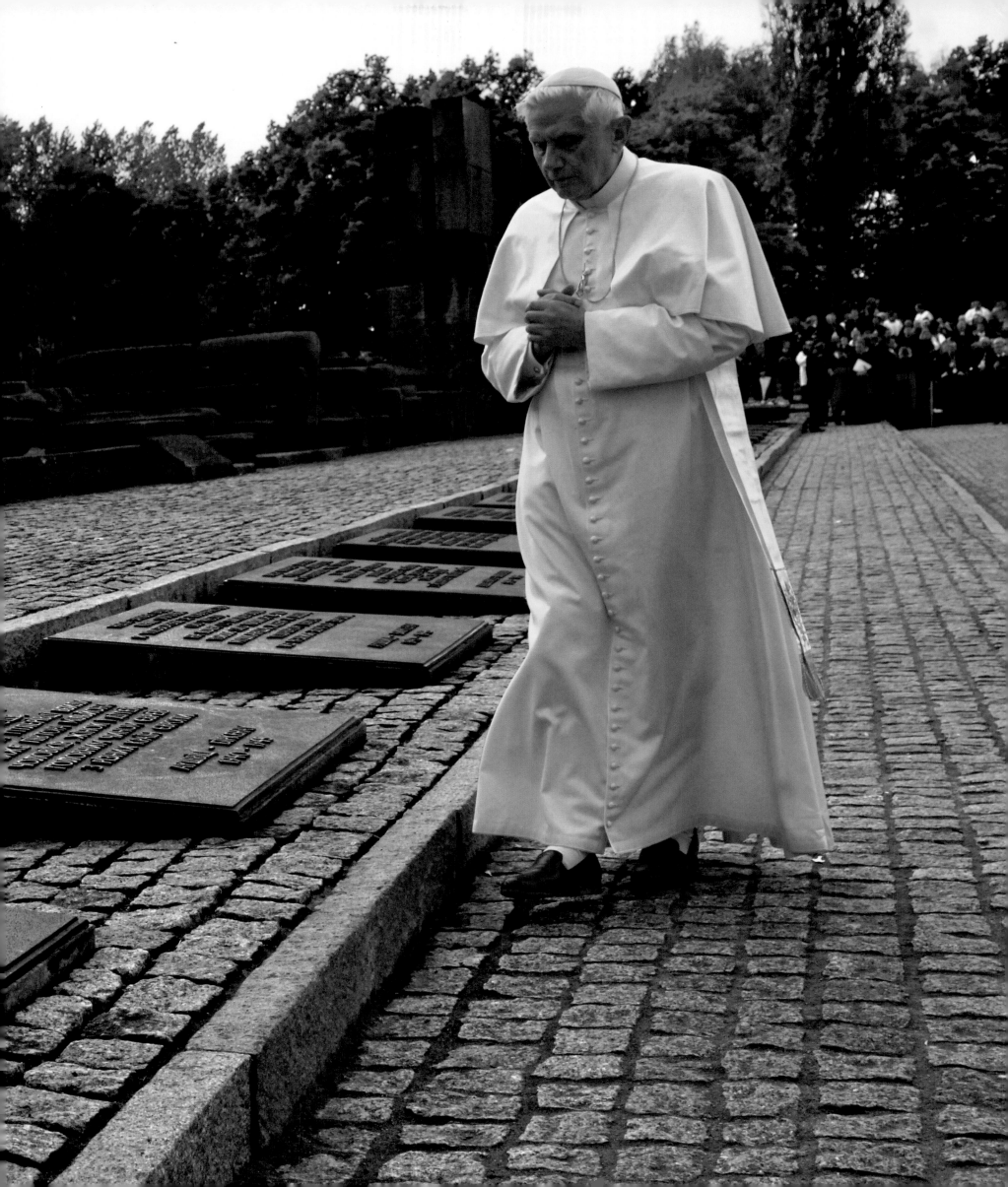

A WORLD LEADER

Challenges for the first post-September 11 pontiff

100-101 After the Inauguration Mass of 24th April 2005, Benedict XVI receives the international delegations and heads of state in St Peter's. He greets the President of the Republic of Italy, Carlo Azeglio Ciampi and his wife Franca, by Bernini's altar.

102-103 All that can be seen is the pope's small hand waving to the crowd waiting for him to pass. The Vatican vehicle is escorted to the Quirinal Palace with pomp and ceremony by the cuirassiers for the pontiff's first official visit to the President of the Republic of Italy.

104 and 105 The meetings between the pope and the heads of state visiting the Vatican are held in his private library. On the left, he is pictured with King Abdullah II of Jordan and his wife Queen Rania; on the right, he is shown in talks with President Jalal Talabani of Iraq .

106-107 During his trip to Cologne, the pope was welcomed to the synagogue to the sound of the shofar, the typical Israeli ram's horn, and met Rabbi Netanel Telitelbaum (seated) and the son of a Holocaust survivor.

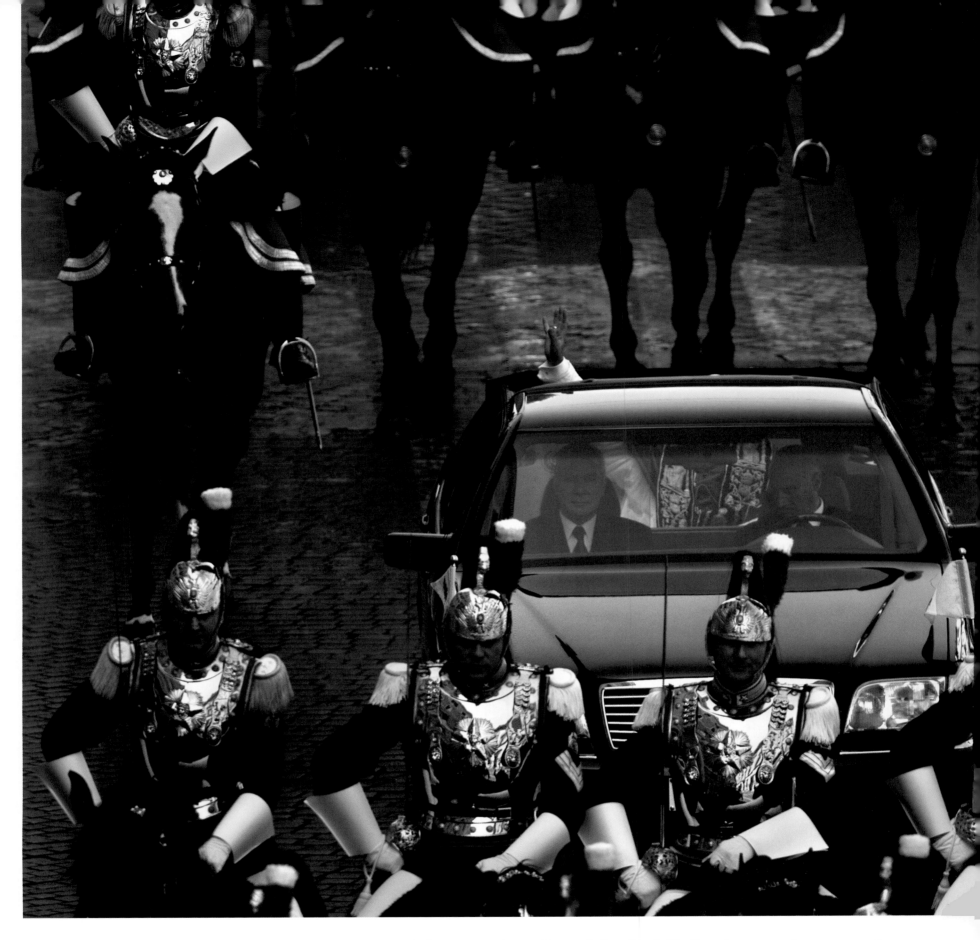

The imposing hand of the Holy See has left vast traces of both beauty and brutality across the canvas of human history for two thousand years. One small but significant detail was added at Castel Gandolfo on Sep. 13, 2001. Fate had already fixed a ceremony on that day's calendar for the newly arrived American Ambassador to the Vatican to present his diplomatic creden- tials to Pope John Paul II. Smoke was of course still rising from the suicide attacks on the World Trade Center and Pentagon, as the new envoy James Nicholson, a devout Catholic and former war hero, entered the Holy Father's summer residence. Protocol called for the pair to exchange diplomatic documents, and read aloud prepared remarks. But before the ceremony began, the Pope turned to speak

Nicholson, however, happened to be sharing this recollection of amity 16 months later, deep in the throes of the pope's steadfast opposition to the imminent American-led invasion in Iraq.

John Paul's speaking out against the drumbeat of war would turn out to be his grand finale on the stage of world diplomacy, a poignant cry from an aging warrior of international good will. But the cry turned out to be as futile as it was moving. For in the face of a new global arithmetic, John Paul's one-note message of "Peace, Peace, Peace" sounded to some more like the faint echo of a man whose battles were from a bygone era.

Benedict XVI is, for all intents and purposes, the first post-9/11 pope. With John Paul having pushed the chair of St. Peter back to the center of international political affairs, his successor has been handed both immense worlwide influence and the gravest of burdens. Pope Benedict instantly became the world's most recognizable and influential religious leader, coming precisely at a moment in history when sectarian-driven radicalism has overtaken ideology as the most incendiary planetary threat, and a lone Western superpower flirts with a dangerous unilateralism. What exactly can the chief of Catholicism do to combat the threat of Islamic terrorism? How loudly can the Vatican defend its values without providing ammunition to those who seek an all-out "Clash of Civilizations?" And in face of Joseph Stalin's snide question: "How many divisions has the pope?," can Benedict ultimately do much more than just hunker down and protect his flock?

Unlike with John Paul's three decades of life behind the Iron Curtain, the new pope does not benefit from first-hand experience with the new ideological nemesis. Benedict, moreover, had spent virtually all of his energies since coming to Rome in 1981 on internal Church matters. But ultimately, the great challenge the new pope faces is one shared with countless other people of good will – politicians, police, everyday citizens, in both the First and Third Worlds – in learning how to respond forthrightly to this emerging evil, without making it worse.

quietly to his American guest. Nicholson recalled later: "He said to me that this wasn't just an attack against America, but against all of humanity." Though whispered in just one man's ear, the legendary touch of John Paul the Statesman had once again arrived right on time. The attacks of 9/11, the pontiff understood immediately, had launched a new existential battle for the third millennium.

With so much uncertainty, and a relative foreign policy newcomer at the helm, Vatican diplomacy has had its stumbles early in Benedict's papacy. On the morning of July 7th, British-born Islamic radicals carried out four simultaneous suicide attacks within the London transportation system, killing 52. Outrage was voiced immediately across the globe, and the wheels quickly began to turn at the highest levels of the Holy See. The Vatican press corps began what turned into a relatively long wait for the official papal response. Finally, around 1:45 p.m., the Italian news wire ANSA flashed a scoop: Benedict's message to the world fol-

lowing the London bombings would condemn the attack as not only anti-human, but also "anti-Christian." Naturally the world's attention was focused on London, but Church watchers knew there was something afoot. Never before had the Vatican contended that the al Qaeda-inspired campaign was directed specifically at Christians. It looked as though the Vatican was ready to raise the ante, even at the risk of a potential head-to-head religious clash. Furthermore, the "anti-Christian" characterization of an attack in multicultural London, where no doubt some of the victims would turn out not to be Christian, seemed to strike an odd chord. As it turned out, when the pope's official message eventually did come out around 2:30 p.m., there was no sign whatsoev-

er of the "anti-Christian" language. Apparently, ANSA had been shown a draft document, which Benedict did not approve, and perhaps hadn't even seen.

The confusion over the first key public response to a worldwide emergency showed that there were some serious administrative kinks that needed ironing out under the new pope. But it wasn't solely a bureaucratic or communication policy question. The fact that such a linguistic leap was even considered by top Church officials seemed to be a sign that the Vatican was in fact looking to take on the threat of terrorism with a new forcefulness.

Already just two weeks later, Benedict's message was crystalizing. Talking with reporters during his summer retreat in the Italian Alps, he explicitly stated that the London attacks were not anti-Christian per se; and that a clash of civilizations must be avoided. But when asked by a reporter if Islam was "a religion of peace," Benedict's response was also interesting for what it left out: "Islam? I wouldn't want to label it with big, general words. Certainly it does have elements that can favor peace, and other elements." It was a nuanced message, a gentle way of acknowledging that in fact something had gone seriously awry among certain groups in another major world religion. One might have imagined an instinctive first response from John Paul along the lines of: "Yes! Of course, Islam is a religion of peace…" But perhaps Benedict knows that mere friendly words are no longer enough.

The interfaith dialogue that John Paul championed nevertheless remains high on the agenda, and a key ingredient in the recipe for Catholic action in response to the current world dynamic. The Vatican will likewise continue to be careful about what possibile effects its policies could have on Christian minorities around the world. But Pope Benedict knows that the question of radical Islam requires a firm response, and geopolitical vision. That approach was confirmed in his meeting the following month with German Muslim leaders on his Cologne trip. His prepared remarks were almost entirely focused on terrorism, though his counterparts were virtually all Turkish, and obviously not connected in any way to terror groups. But they were in fact

there to represent Islam. For this pope there could be no more alibis, no excuses – bloody attacks cannot be contextualized ad infinitum. "You have a great responsibility for the formation of the younger generation," he told his Muslim counterparts. "We Christians and Muslims must together face the many challenges of our time." These attacks must be stopped, and it is above all up to Muslims of good will (with the support of their allies of other faiths) to try to stop them.

Still, in light of some of his own previous writings on Islam (including his stated opposition to Turkey's joining the European Union) and a reputation as the Vatican's chief cheerleader for the theological supremacy of Catholicism, Pope Benedict may be surprising those who considered Cardinal Ratzinger an opponent of dialogue. Efforts to heal the millennial rift with the Orthodox churches is a clear priority. Benedict made this clear on his first trip as Pope outside of Rome. He traveled for a Eucharist celebration in Bari, a city where the remains of St. Nicholas, a cherished patron of the Eastern churches, are buried. "We can only receive Him in unity," he said. "We cannot communicate with the Lord if we do not communicate with one another." And on the front where John Paul carved out yet another slice of history – relation with Jews – Benedict has shown that he wants to maintain the momentum.

Still, as the first post-9/11 and post-Communism pope, the deck he's been dealt is largely reshuffled. He must still figure out how to make his voice heard, and the weight of his followers felt, without pushing too hard. Already his opposition (as the Dean Cardinal) to Turkey's EU membership may have scuttled plans in his first year as pope to join the Patriarch of Constantinople for the Feast of St. Andrew. Hopes for a historic voyage to Moscow remain slim. Another prickly question has been China, where the pope has expressed optimism that the so-called "patriotic Church" handpicked by Beijing, can come into communion with Rome. But Chinese church authorities' subsequent surprise naming of bishops without consulting Rome has dimmed hopes at the Vatican for an early papal visit to China.

The Church's foreign policy front – that is, both its geopolitical diplomacy and its rapport with other religions – was a source for both frustration and historical achievements for John Paul. He healed wounds with other religions, and used the force of his faith and an uncommon diplomatic acumen to help liberate millions from the oppression of Communism. Still, Benedict has what may be an even more delicate challenge. He must reaffirm the papacy as a singular voice for peace. But in the face of new challenges, this convinced Augustinian will look to apply that message with a sharpened precision.

Standing on the shifting sands of world affairs, the pope has said "no justice without freedom, and no freedom without truth."

He told the Vatican Diplomatic Corps: "Those who are committed to truth cannot fail to reject the law of might, which is based on a lie and has so frequently marked human history, nationally and internationally, with tragedy." His great diplomatic challenge is to use Christian morality to help make secular society strong enough to stare down the threats inspired by radicals of another faith.

The interfaith dialogue launched by John Paul helped right the religious wrongs of yesterday. Benedict must turn it into a tool to prevent future political calamities.

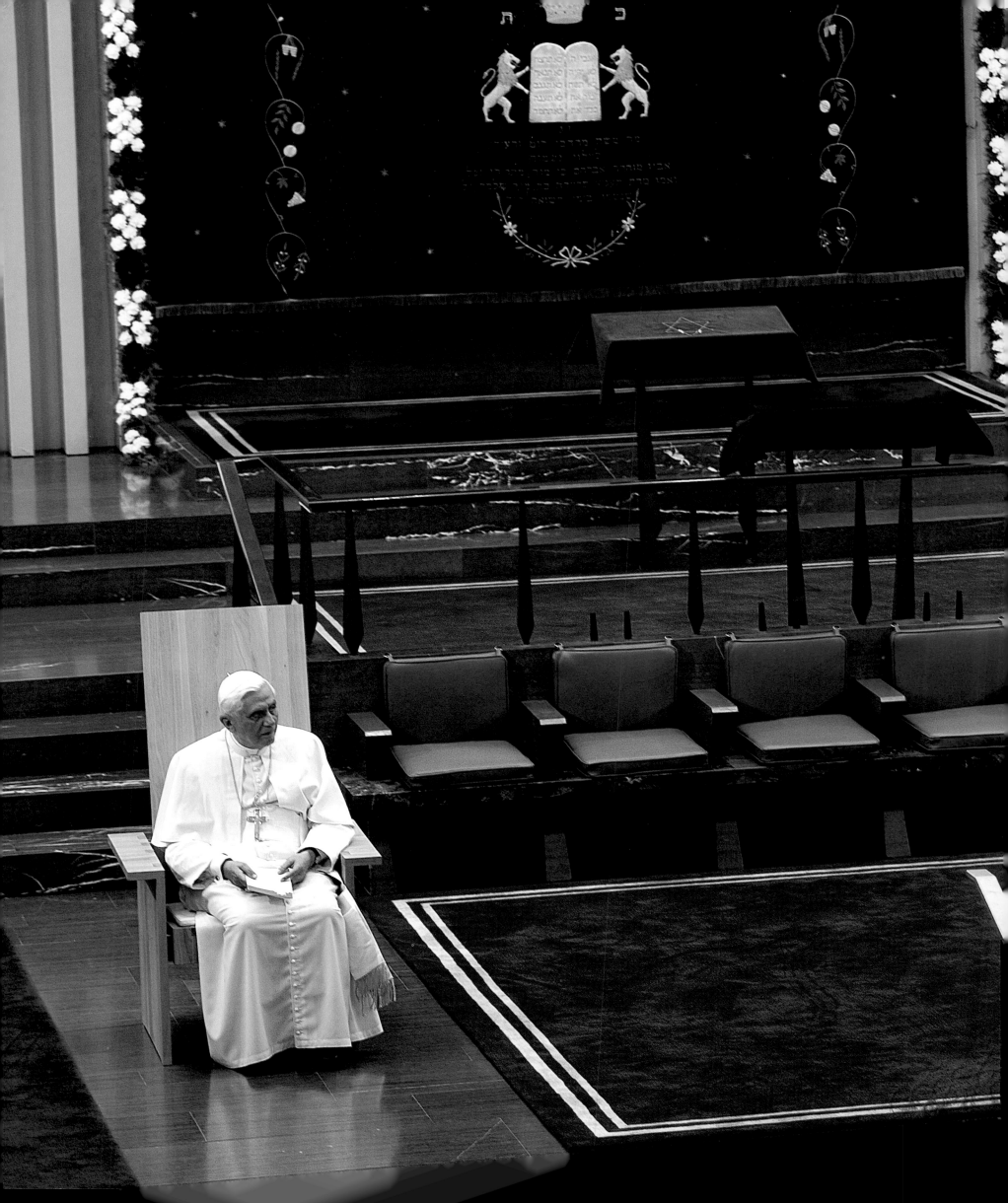

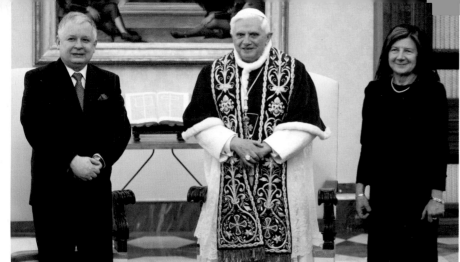

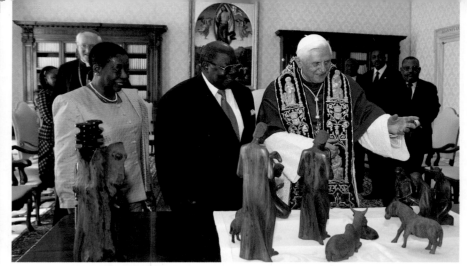

108 and 108-109 *A meeting in the library with Lech Kacynski, President of Poland (top left) and his wife, and a traditional exchange of gifts with Benjamin William Mkapa, President of the Republic of Tanzania and his wife. In the center, the pope receives King Juan Carlos and Queen Sofia of Spain, during a brief rest at the Papal Summer Residence of Castel Gandolfo.*

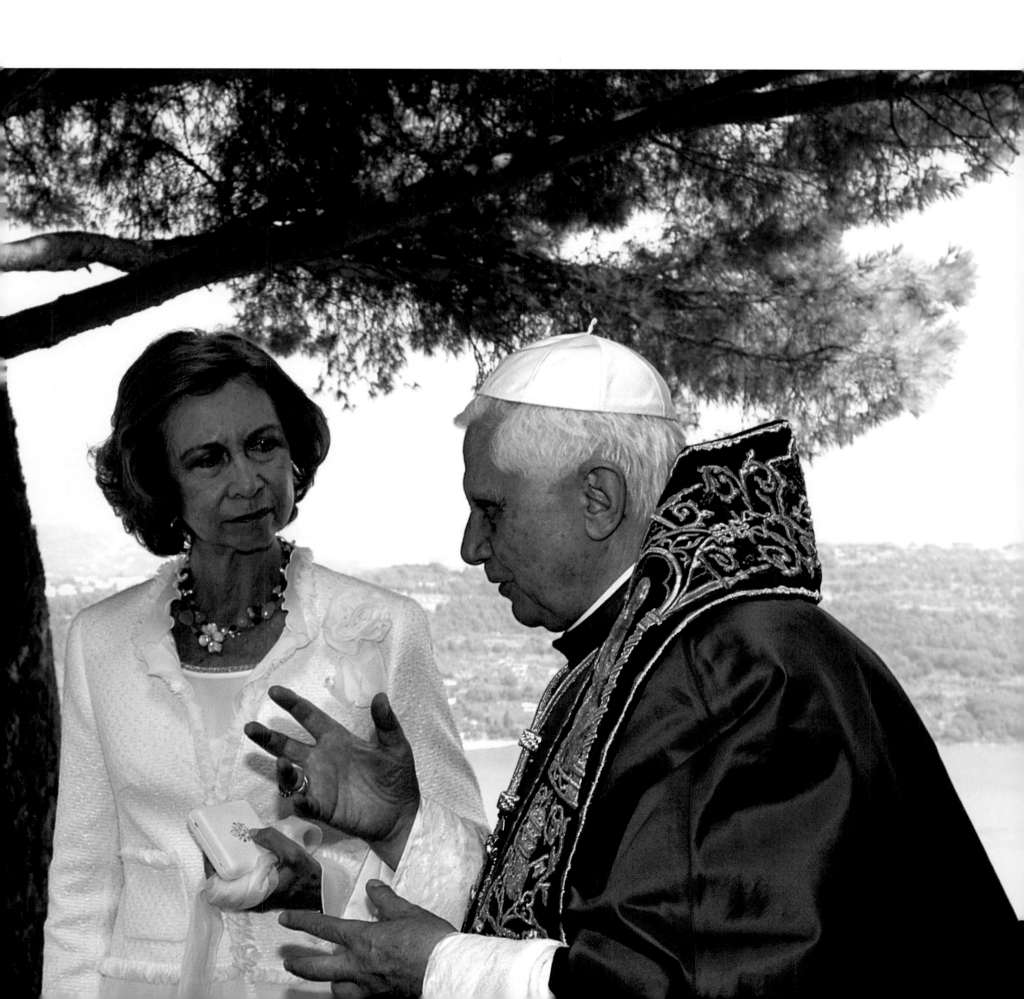

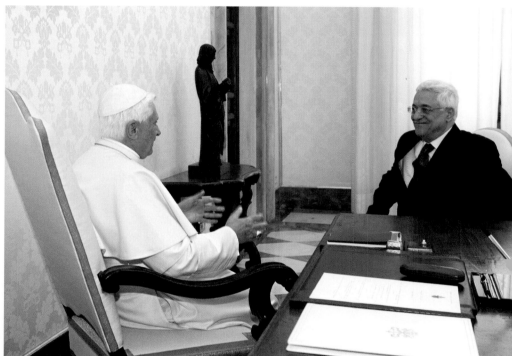

110-111 and 111 *Two more meetings in the library: with Prince Albert of Monaco, the new sovereign of the Principality following the death of his father Rainier, and with Mahmoud Abbas, President of the Palestinian Authority (right). Vatican etiquette requires that only heads of state may sit directly in front of the pope, while government representatives sit beside him.*

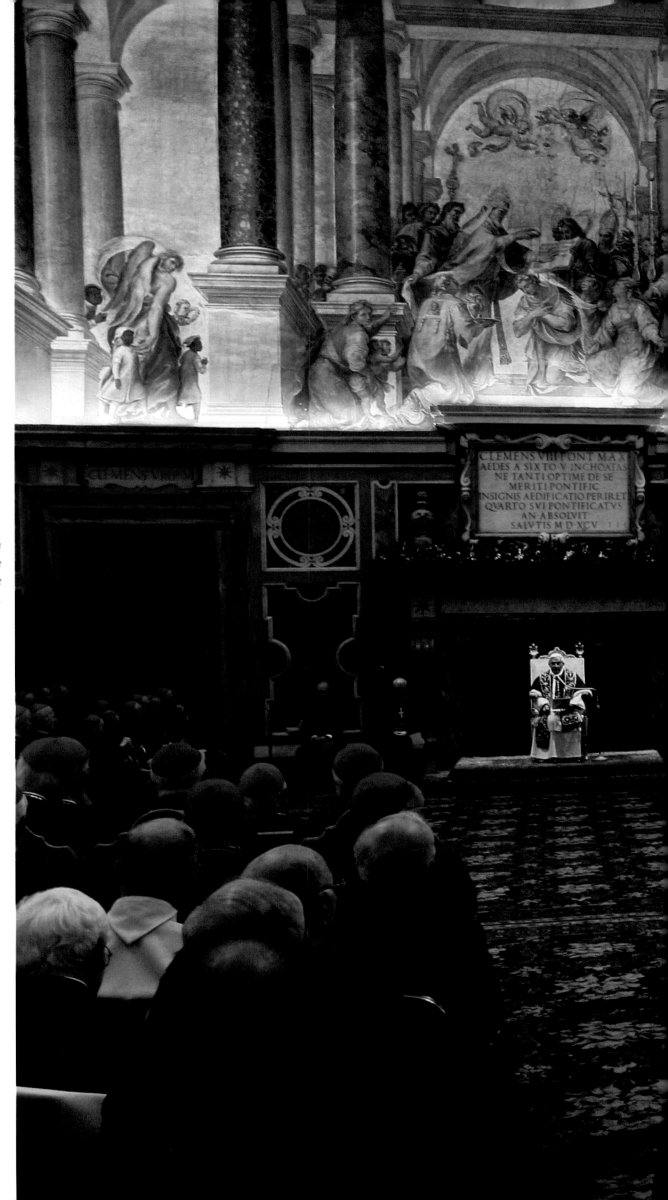

112-113 Broadcast non-stop by the Vatican Television Centre, the pope receives the Christmas greetings of the members of the Roman Curia and Papal Family in the splendid setting of the Sala Clementina.

DEFENDER OF THE DOCTRINE

A recipe for strengthening the Catholic Church

114-115 Work begins in the Sala Nervi for the 11th General Assembly of the Synod of Bishops, called by John Paul II and presided over by Pope Benedict XVI.

116-117 and 119 Two moments from the opening ceremony of Synod of Bishops: dressed in green and holding his crook, the pontiff makes his way to the altar to celebrate Holy Mass among his brother bishops.

118 A well-known gesture recalling the age-old tradition of the Church: Benedict XVI casts incense during the Mass marking his first visit as pope to a local parish. His choice was the church of Santa Maria Consolatrice, in the Roman nieghborhood of Casal Bertone, where he often celebrated Mass as a cardinal.

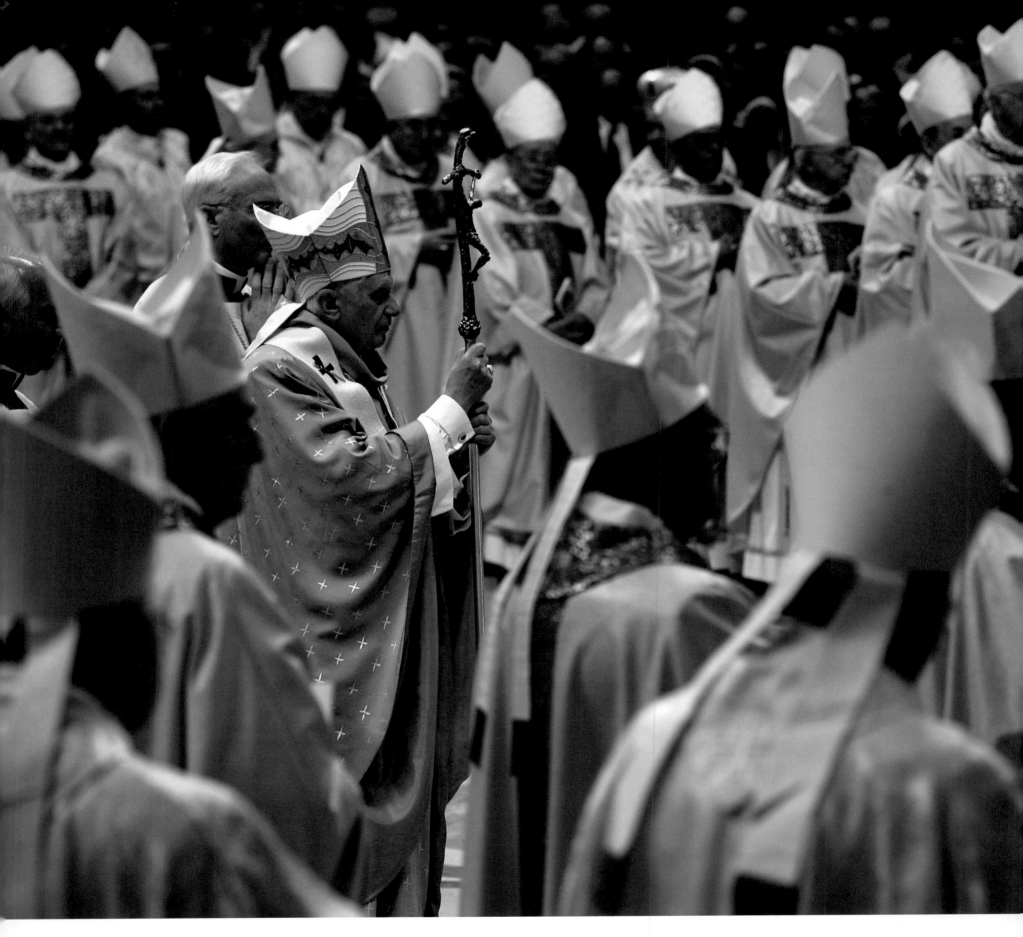

"Not one comma." That, according to Comunità di Sant'Egidio founder Andrea Riccardi, was exactly how much Church doctrine would change under John Paul's successor. The forecast, offered the day before the old pope died, was not a Conclave prediction, but a matter-of-fact observation on the state of the Church and its hierarchy after a quarter-century-long pontificate committed to orthodoxy. And of course, there could be no more certain guarantee of Riccardi's prognosis than the ballots piling up inside the Sistine Chapel for the very architect of John Paul's doctrinal policy.

That the new pope has no plans to tinker with Catholic teaching, however, does not mean that Benedict is laying low with regard to moral values. Quite the contrary. After John

2005 by Pope Benedict XVI, with an introduction dated March 20th, 2005 by Joseph Cardinal Ratzinger, who, as Prefect for the Congregation for the Doctrine of the Faith, shepherded through the volume.

While the question-answer format of the compendium may help explain the teachings, the questions alone are enough to comprehend Benedict's unyielding allegiance to tradition: Item 230: Why are the sacraments necessary for salvation? Item 472: Why should society protect every embryo? Item 502: What are the affronts to the dignity of marriage? The answer to this final query is a simple list: "Adultery, divorce, polygamy, incest, free union (cohabitation, concubinage), sexual congress before or outside marriage." That pre-marital sex is listed alongside polygamy and incest makes clear that the Church's age-old — some would say, outdated — pursuit of piety is still very much the order of the day in Rome.

Europe marks the front line in this culture war. The continent that gave rise to Christianity is most vulnerable to what Benedict has defined as the "dictatorship of relativism." The most direct challenge to the Church is in the once fiercely Catholic country of Spain, where Prime Minister Jose' Luis Rodriguez Zapatero has pushed through laws that make divorce easier, expand embryonic stem cell research, and allow gay marriage and adoption. But whether such legislation is the cause or the effect of secularism is not altogether clear.

Church attendance has fallen just about everywhere: down 30 percent in Ireland over the past quarter century, and 11 percent in Italy, while only five percent of French Catholics still attend weekly Mass. Across all of Europe, young men entering the priesthood across is down 20 percent since 1978.

In his role as John Paul's doctrinal watchdog, Cardinal Ratzinger was the singular symbol of the Vatican's hard line on the hard choices that modernity poses to the faithful. With his ascension to the papacy, common wisdom said that Benedict was prepared to accept a "smaller Church" that abided by tradition, rather than a Church satisfied by the masses that follow a diluted form of Catholicism. A sort of pruning away of the dead branches of the faith, this thinking holds, is the only way to prepare Catholicism for a new era of true vitality and growth. But

Paul's twilight, there is a renewed impulse in Rome to confront the rise of secularism and reaffirm the tenets of the faith. And having the longtime doctrinal chief as pope means a boss who knows the material — and knows what he wants.

The commitment to tradition is spelled out clearly and concisely in the new "Compendium of the Catechism of the Catholic Church," which just so happens was signed June 28,

to the surprise of some, Benedict is not satisfied with simply reaffirming the teachings of Catholicism, internally, but of taking on the challenge within the society at large. Just before Zapatero's gay marriage proposal became law in Spain, Benedict decried: "the erosion of marriage, such as free unions and trial marriage, and even pseudo-marriages between people of the same sex." In Italy, Benedict repeatedly and publicly praised the country's bishops for their well-organized campaign to defeat a national referendum by supporters of assisted fertil-

an inseparable part of the Church. And it is precisely with the shrinking of Christian congregations we are experiencing that we shall have to consider looking for openness … I have nothing against it, then if people who all year long never visit a church go there at least on Christmas."

Still, ultimately, the pope's guiding principles remain passion and purity. Just a month before his election, Ratzinger wrote the Good Friday meditations for the Way of the Cross ceremony, using a phrase whose bluntness caught many in Rome that

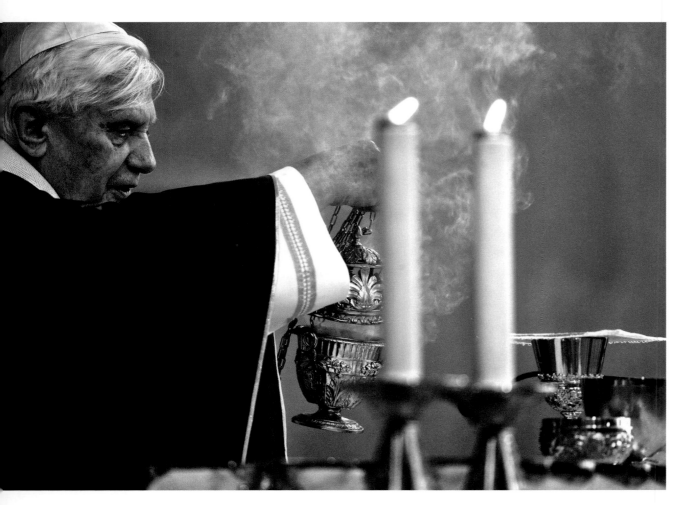

evening off guard: "How much filth there is in the Church," he wrote, "and even among those who, in the priesthood, ought to belong entirely to him!" Benedict has not yet explained the nature of the "filth" to which he referred. But we may be finding out. As head of the Vatican doctrinal office, Ratzinger had been apprised of some of the most heinous cases of clerical sex abuse – and many believe the filth was indeed a reference to the scandals that have shaken the Church in the United States and elsewhere in recent years.

The new Church "instruction" in November reaffirming a Vatican ban on gays from joining the priesthood may be an indication that the new pope is making a priority of putting the priestly

ity and stem cell research. That electoral victory was perhaps a sign to the traditionalists that there were battles even in Western Europe that could still be won – and Benedict was indeed prepared to look for ways to spread the faith deeper – and wider. But by not resigning himself to a smaller Church, does Benedict also require a dose of flexibility – or even a touch of relativism? As doctrinal prefect, Cardinal Ratzinger was surprisingly open to those who fall well short of complete commitment to the faith. He told the German journalist Peter Seewald in 2000: "This consciousness of not being a closed club, but of always being open to everyone and everything, is

house in order. Gay priests and others argue that there is no direct link between homosexuality and pedophilia, noting that the majority of offenders are hetereosexuals. Some Catholics also fear the document may debilitate a Church already facing a shortage of priests, and might even spark a witch hunt for already ordained gay priests, though they are technically not affected by the seminary guidelines. But conservative Catholics point out that the vast majority of victims of abusive priests are boys, and complain that the prevalence of gay seminarians is creating an environment that turns heterosexuals away from the priesthood. The fact that Benedict made it a priority to

publish the Congregation of Catholic Education document, which had languished in John Paul II's final years, was a clear sign that it was a papal priority. A Vatican official said that with reports of a rising percentage of homosexual priests, the pope believed something must be done. "He's is in a position that if nothing new was said, it would be a tacit acceptance of what is going on in some places."

The same approach was behind Benedict's decision to effectively end the ministry of Legionaries of Christ founder Father Marcial Maciel Degollado – who'd long been sustained under John Paul – after an internal Vatican investigation of sex abuse allegations agains the 86-year-old Mexican leader.

Though moving from top doctrinal bureaucrat to Holy Father may not have changed what Ratzinger believes, it has changed whom he sees. In the span of two weeks, Benedict met dissident Swiss theologian Hans Küng, who had long been denied his request for an audience with John Paul II, and Bishop Bernard Fellay, the excommunicated head of the ultraconservative movement founded by the late Archbishop Marcel Lefebvre. The pope's meeting with the Lefebvrites gave new impetus to ongoing negotiations to bring them back into the fold, though they insist on maintaining the old Latin Mass and reject other Second Vatican Council reforms, and are cold to the Church's emphasis on inter-religious dialogue.

Benedict is no doubt sympathetic to the traditionalist leanings of the group, but cannot risk ceding Rome's (and his own) authority to determine what are the standards of Catholicism. Küng, instead, has for decades been viewed as a kind of "anti-Ratzinger" because of his liberal views on doctrine. In fact, as Archbishop of Munich, Ratzinger had a role in stripping Küng of the right to teach Catholic theology in 1979, because he had challenged the doctrine of papal infallibility.

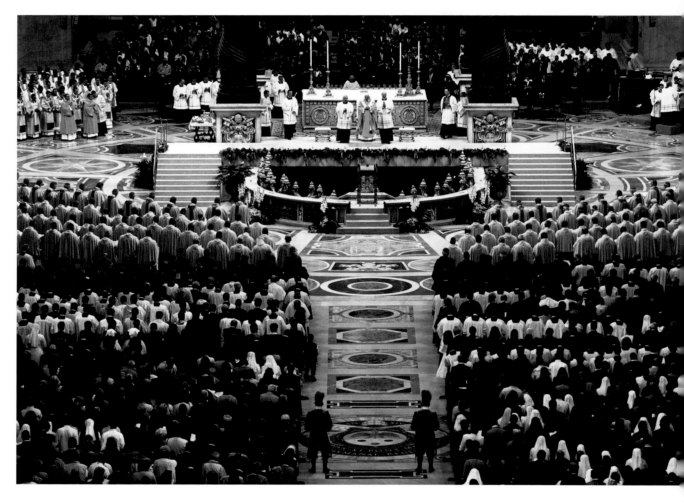

So why did Benedict open his doors to Küng ? The first answer may be as simple as the desire to catch up with an old friend and colleague: the two men had taught together at the University of Tübingen, and both had served as theological advisers during the Second Vatican Council.

The dinner they shared at Castel Gandolfo, in fact, was the first time the old companions had seen each other in more than two decades. A Vatican statement said that the pair's standing doctrinal disputes were not broached. Instead they spoke about the relationship between faith and science, and inter-faith dialogue. It's hard to know the specific motivation behind Benedict's desire to meet with each of these surprise visitors. But it is by now clear that the new pope is conscious that his job description has radically changed. As Prefect for the Congregation for the Doctrine of the Faith for 20 years, Cardinal Ratzinger had been responsible for keeping certain arguments on theological lock-down. But when you become father to a flock of 1 billion, your doors must be kept as open as possible. No one, however, can have any doubt about what the man behind those doors holds to be eternally sacred.

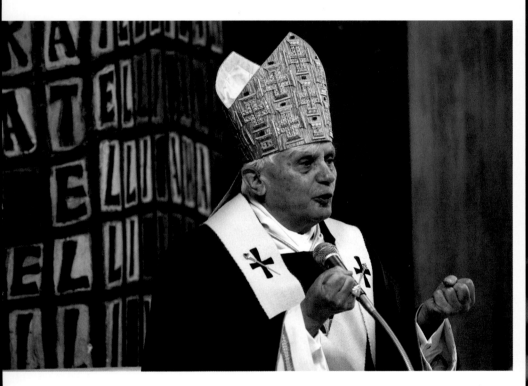

120 and 120-121 *Pope Benedict in the church of Santa Maria Consolatrice. His gestures clearly reveal his fervor and desire to drive his message home to the hearts of the faithful.*

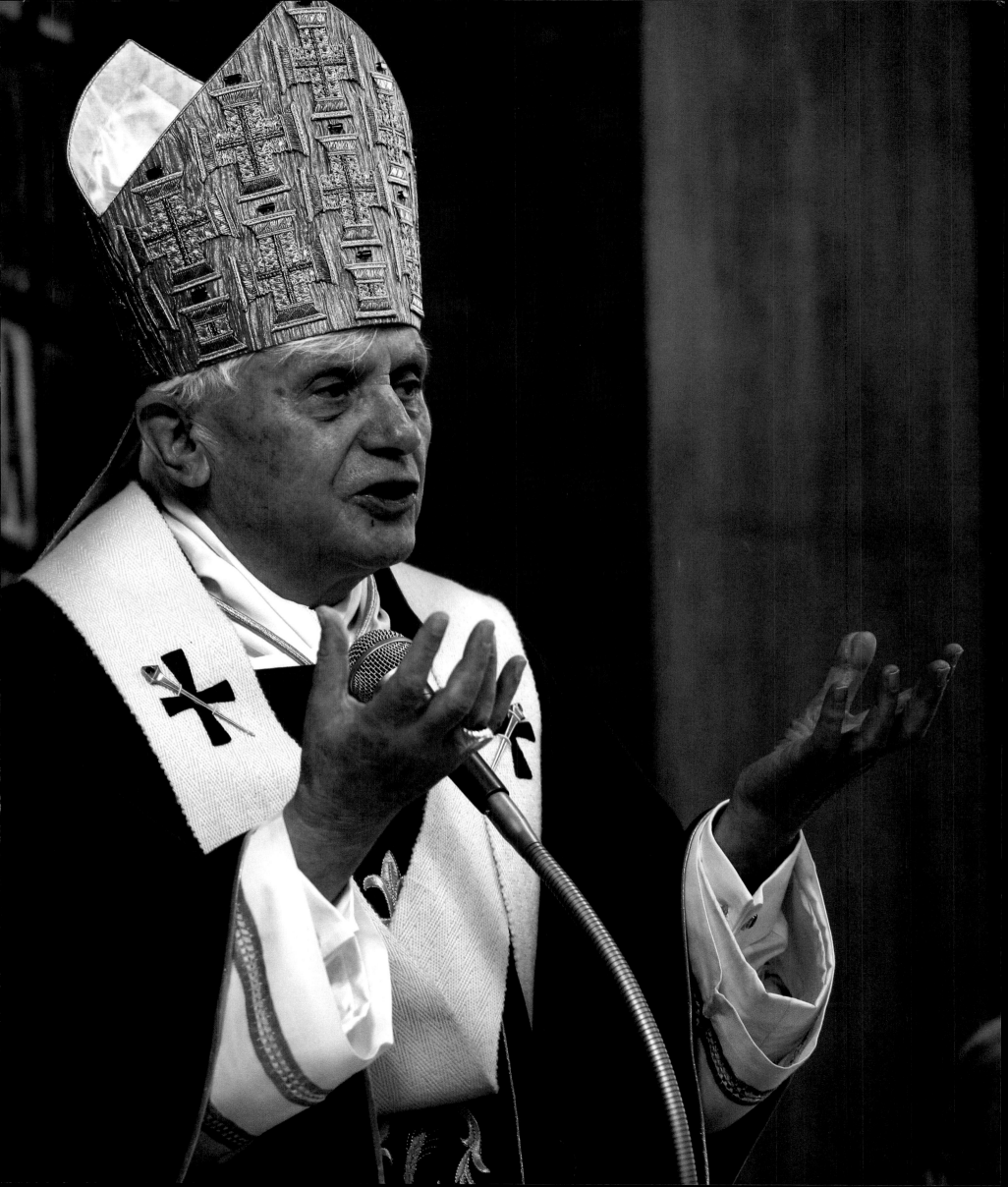

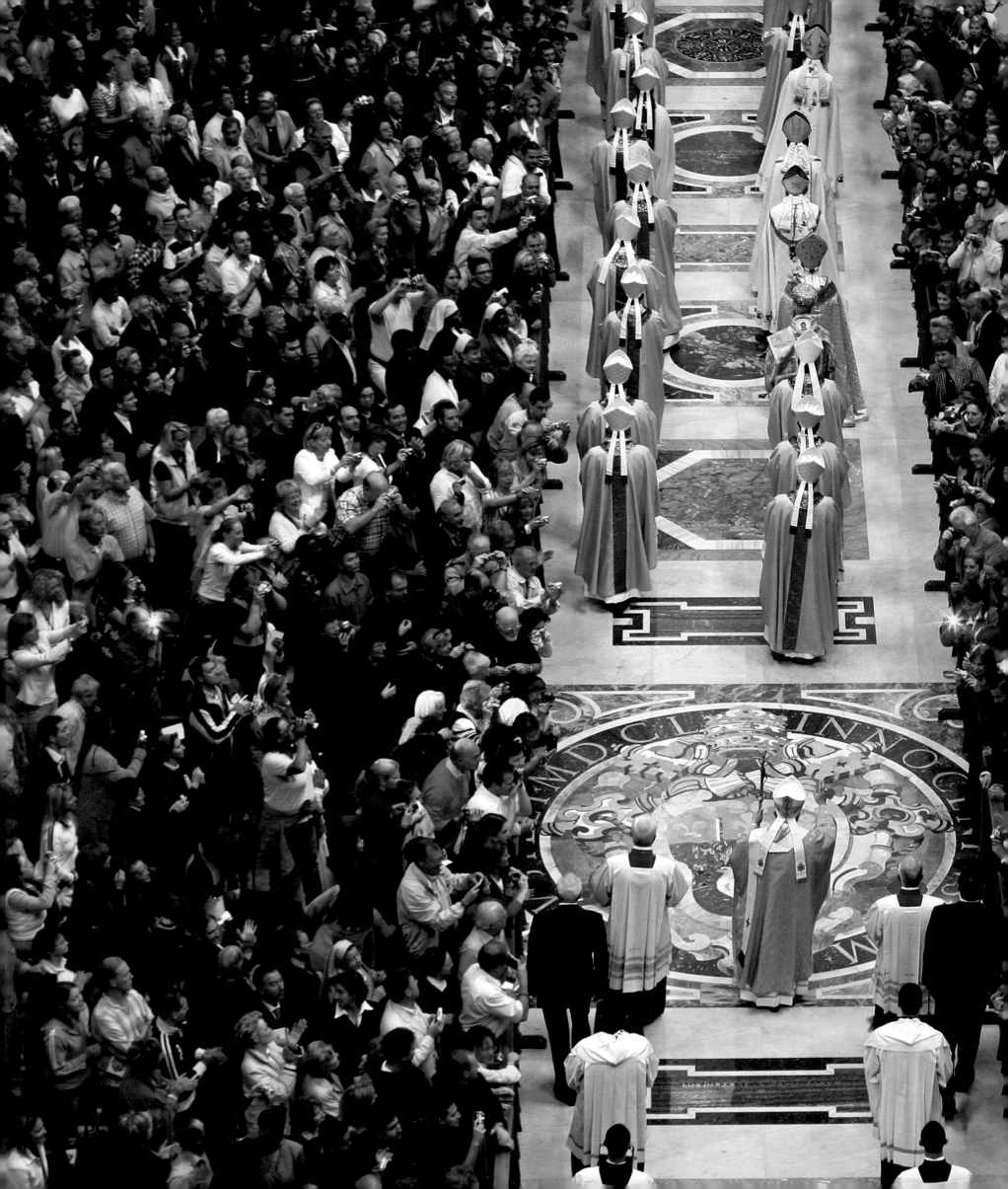

122-123 *Benedict XVI makes his way down the nave of St Peter's Basilica greeted by thousands of flashes as worshippers snap pictures. The pope's opening sermon at the inauguration of the Synod refers repeatedly to the image of the vine, one of his favorite metaphors since his election.*

124-125 *A solemn moment during the pope's celebration of Mass at Pentecost in St Peter's Basilica, during which he performs the presbyterial ordination of twenty-one deacons of the Diocese of Rome.*

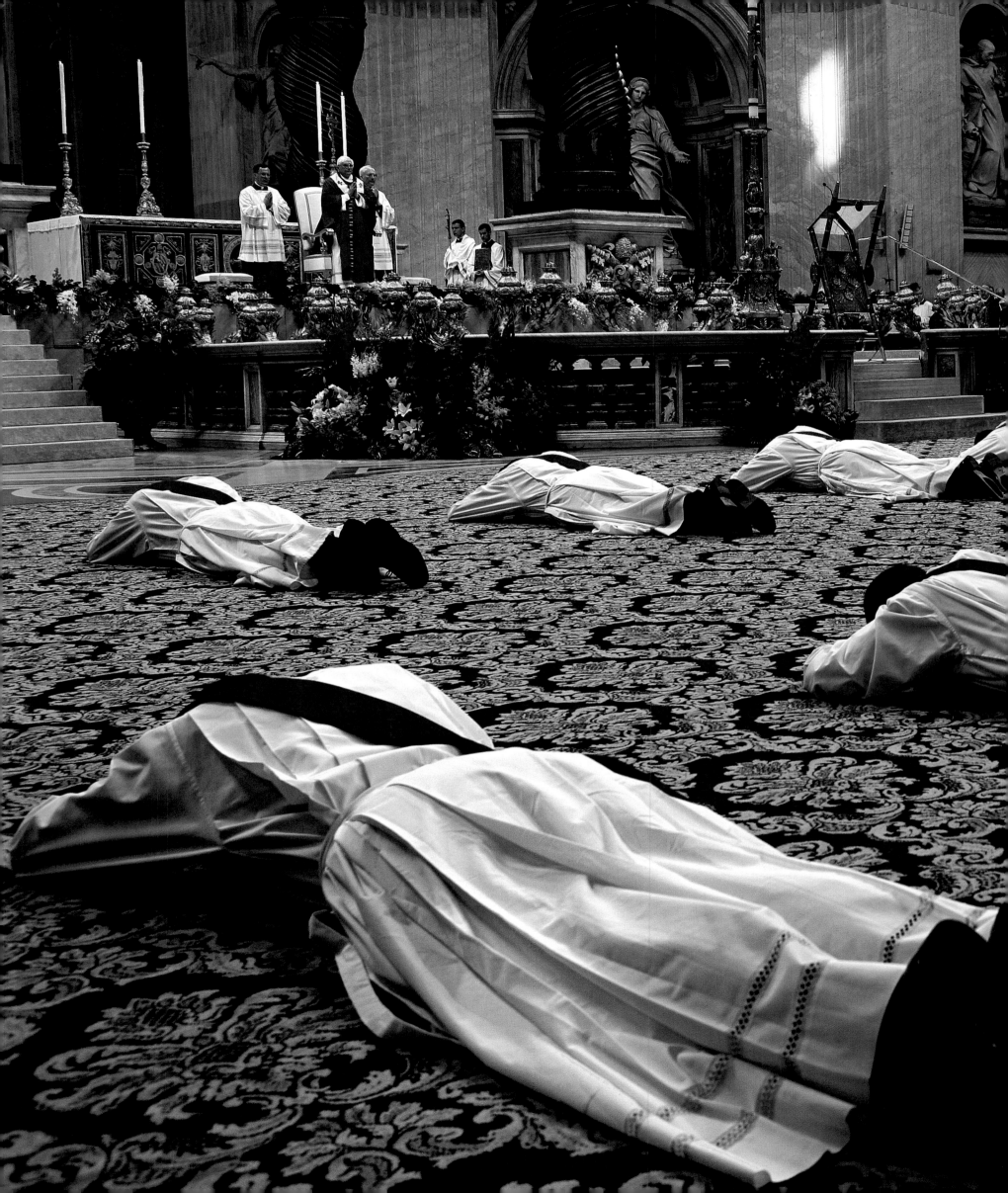

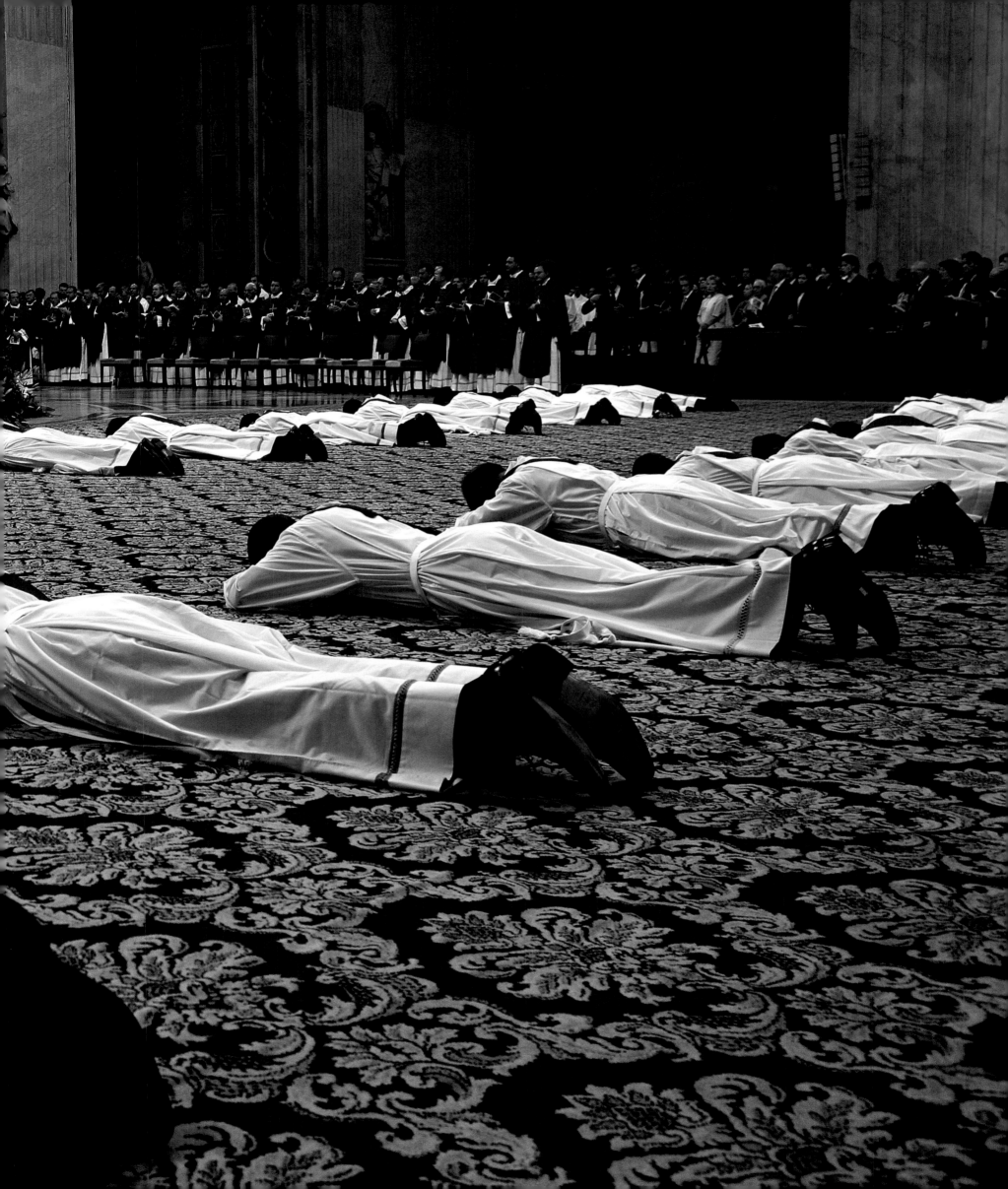

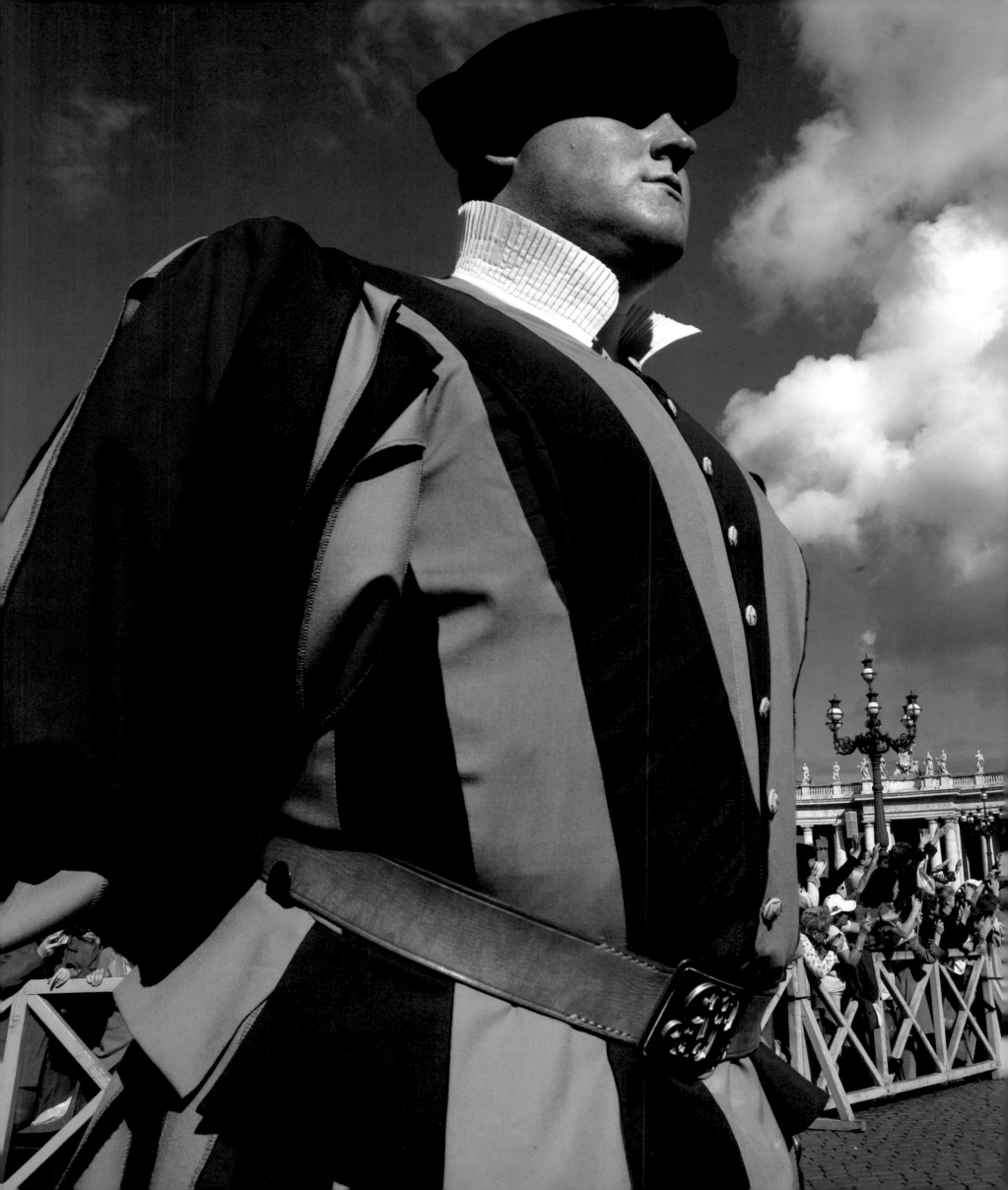

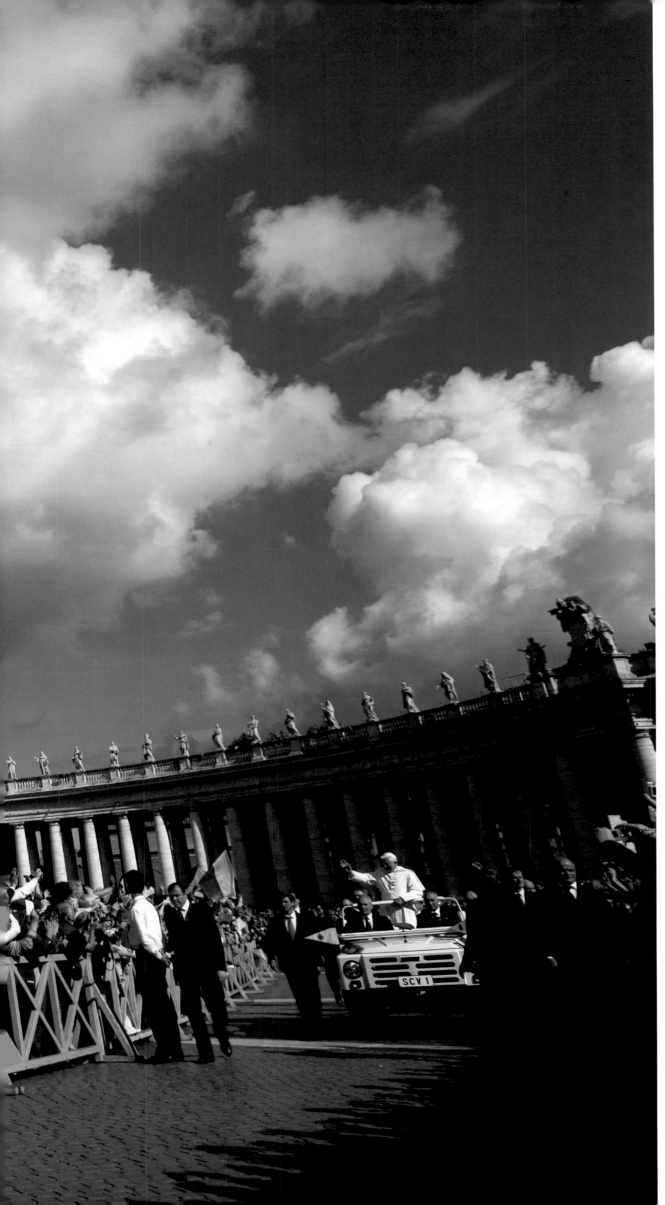

126-127 *A Swiss Guard watches the popemobile pass as it ferries the Holy Father across a packed St Peter's Square, where he is to welcome the faithful to a Wednesday general audience.*

128 and 129 Benedict XVI grasps the hand a boy who
had come to attend the general audience in St Peter's Square,
while a group of altar boys set their cameras to immortalize
the moment when the Holy Father passes in his popemobile.

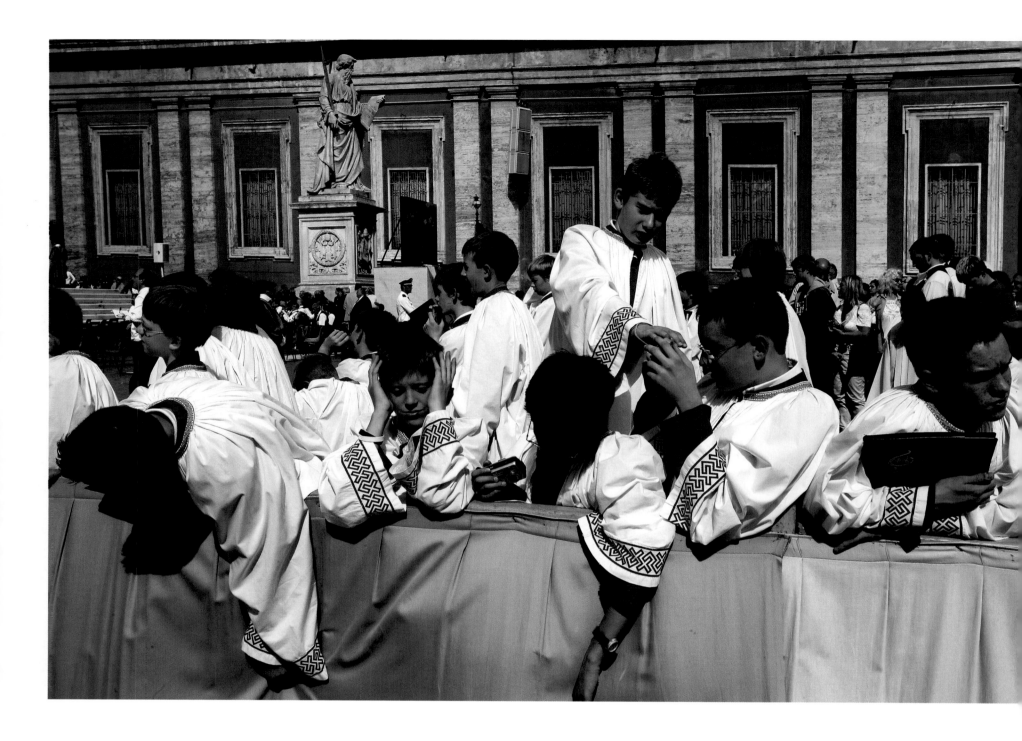

130 and 130-131 *The main theme of the 11th Assembly of the Synod of Bishops, presided over by the Holy Father, was the Eucharist, although other important topics were aired, such as the loss of faith, objections to the ordination of married men and the need for dialogue with the Protestant and Orthodox Churches.*

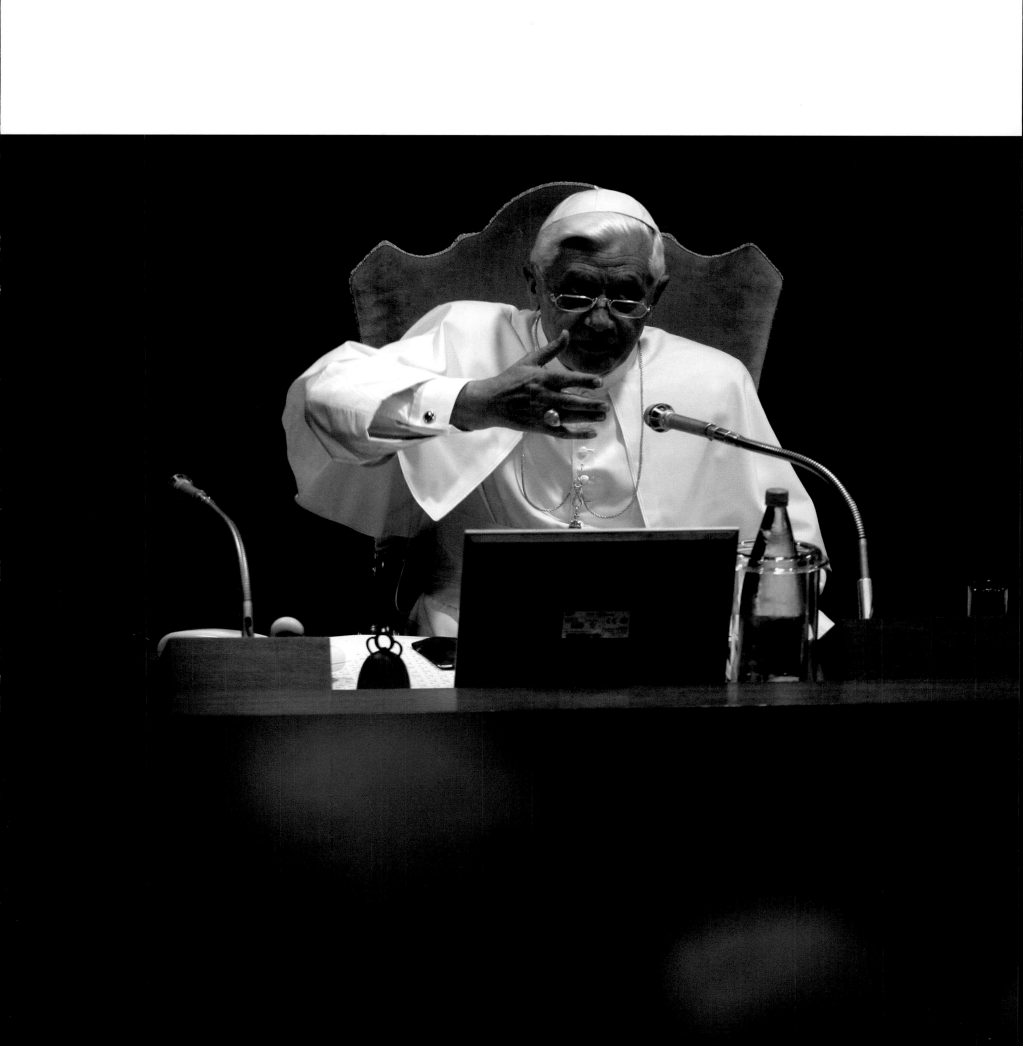

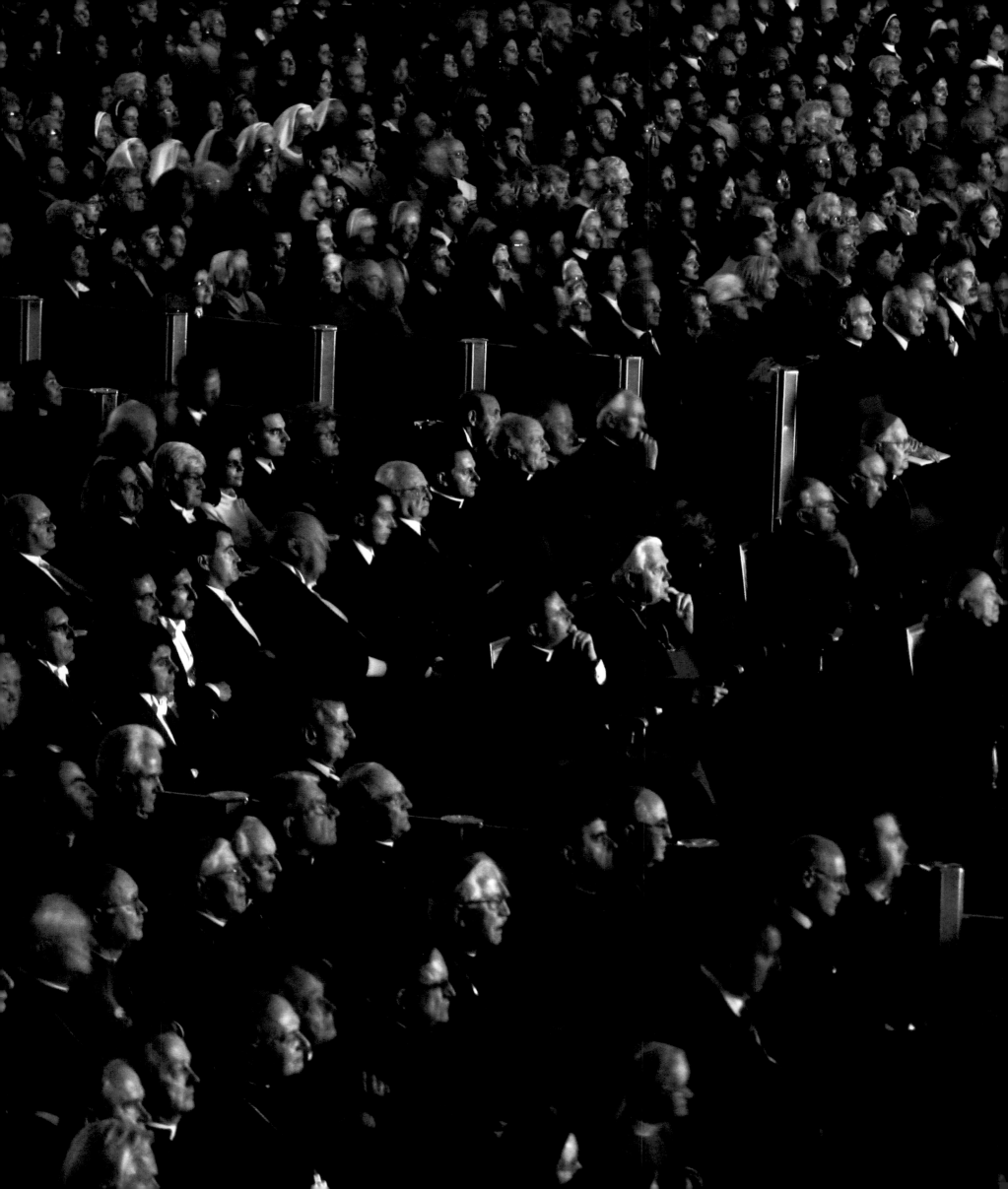

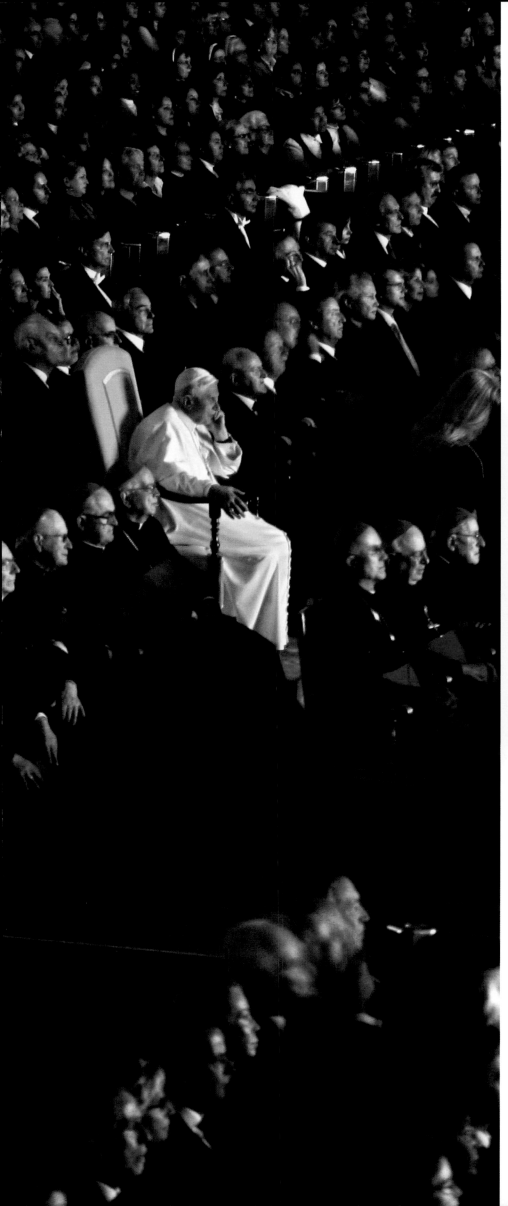

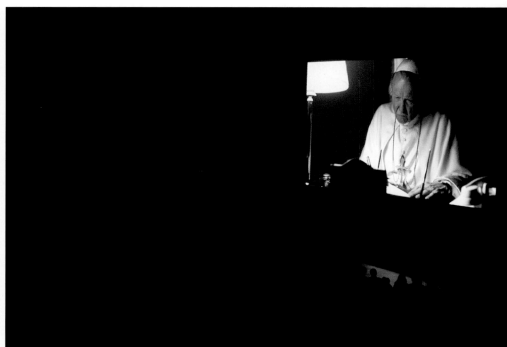

132-133 and 133 *The pope enjoys a preview of the TV film on the life of John Paul II in the Paul VI auditorium. The mini-series revealed some of the lesser known aspects of John Paul's life, thanks to the close collaboration of the Vatican's spokesman Joaquin Navarro-Valls and the Special Secretary, Monsignor Stanislaw Dziwisz. After the screening, Benedict spoke for a few minutes with its star Jon Voight, who was present along with the other actors.*

134-135 Cheered by thousands lining Via Condotti and packing Piazza di Spagna, Benedict XVI makes his way to the square to pay the customary homage to the statue of the Virgin, escorted by the Special Secretary, Monsignor Georg Gänswein, sheltering him from the rain with his umbrella. Before praying, the pope paid homage to the Virgin with a basket of roses.

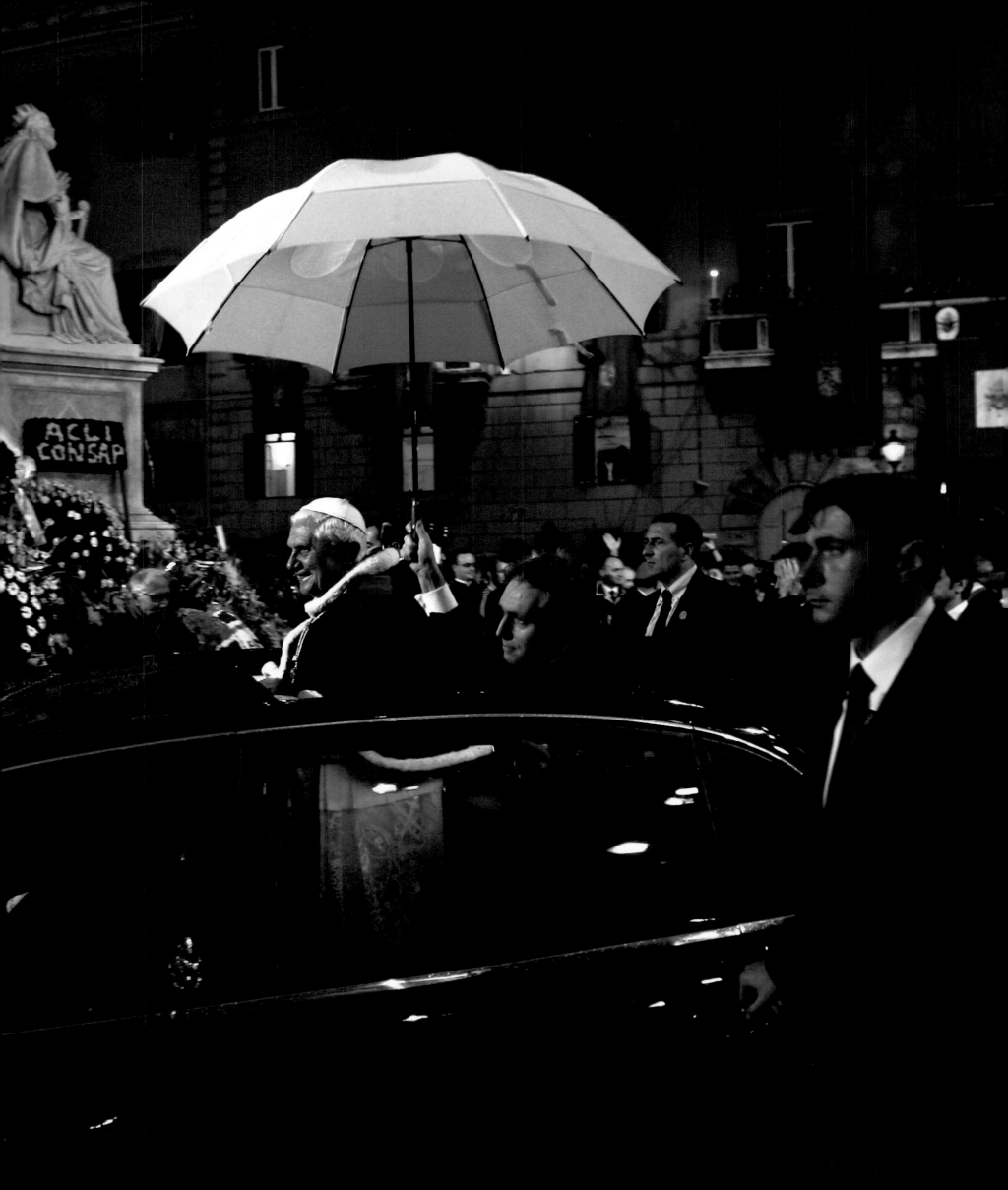

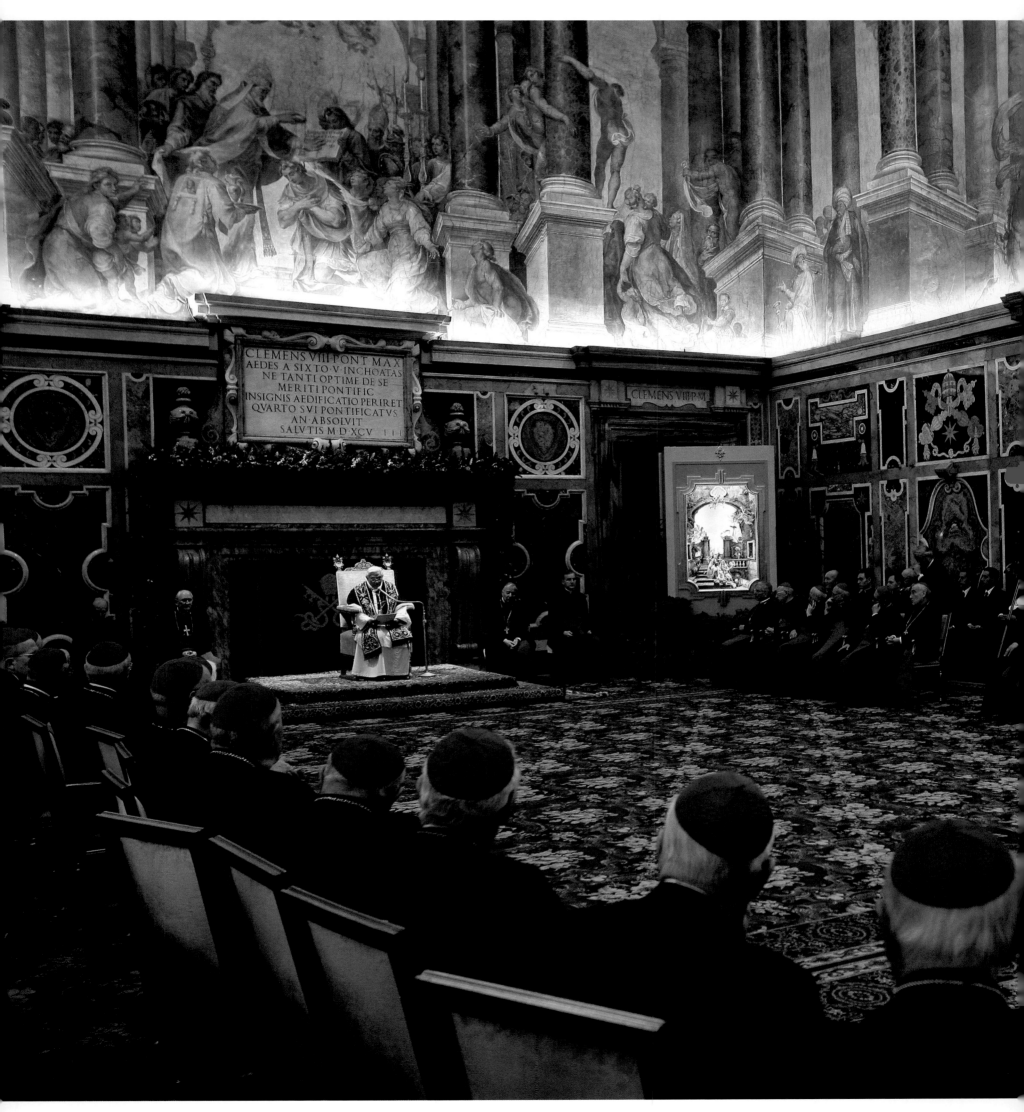

THE MEN
OF THE POPE

*Cardinals, bishops
and simple prelates in
the service of Benedict XVI*

136-137 *and* 138-139 *Pope Benedict XVI receives the
Roman Curia in the Sala Clementina a few days before
Christmas for the traditional exchange of greetings.*

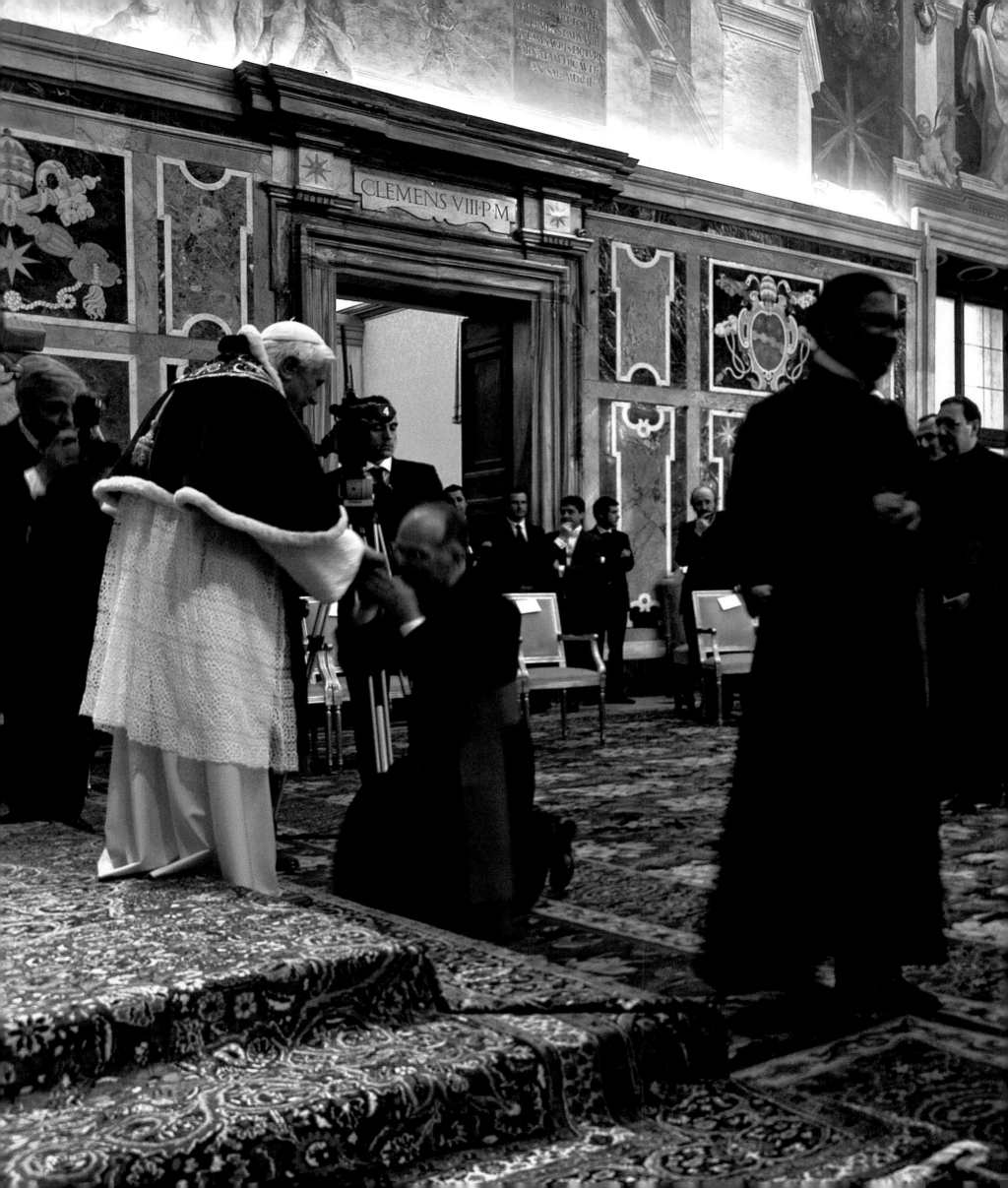

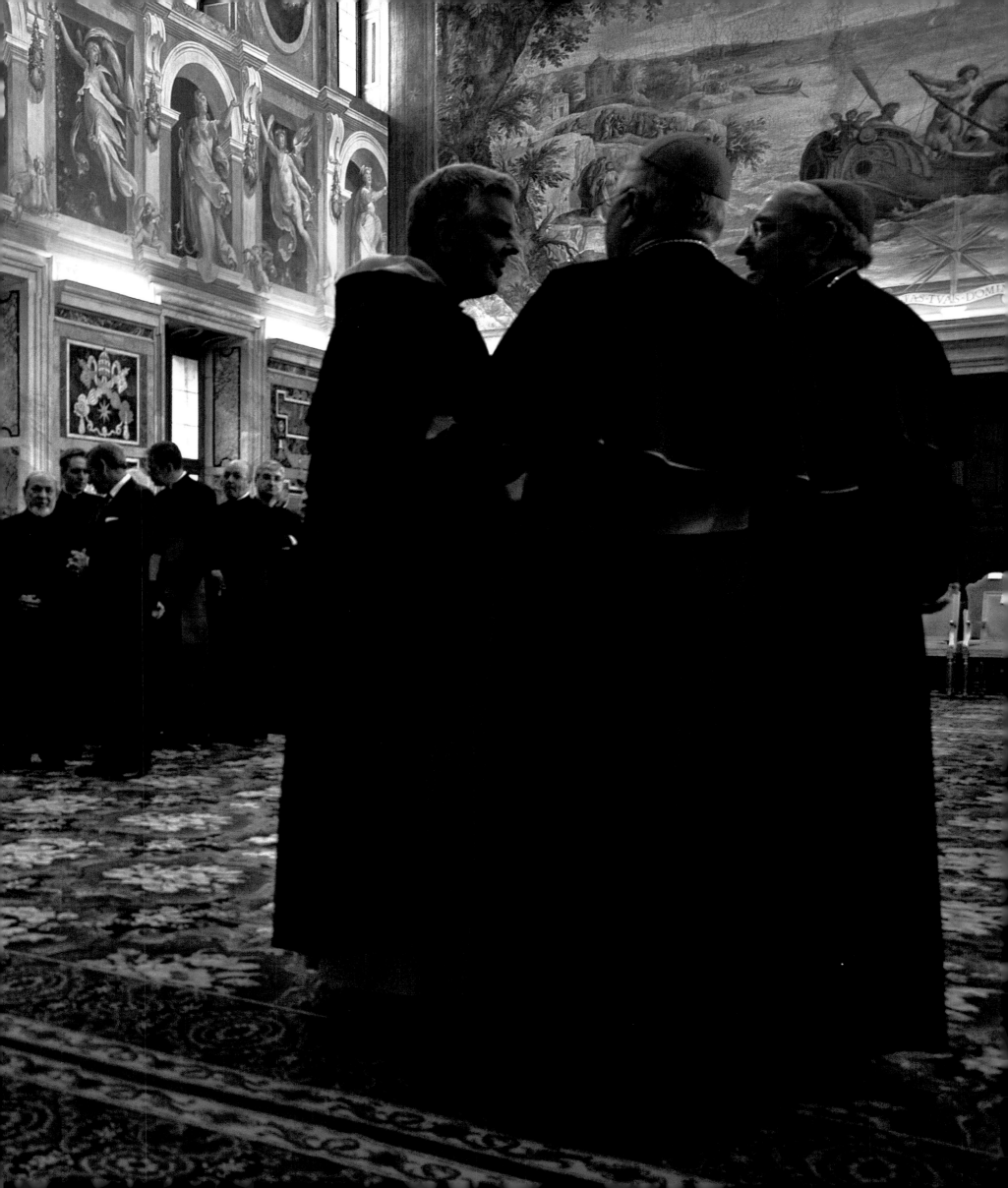

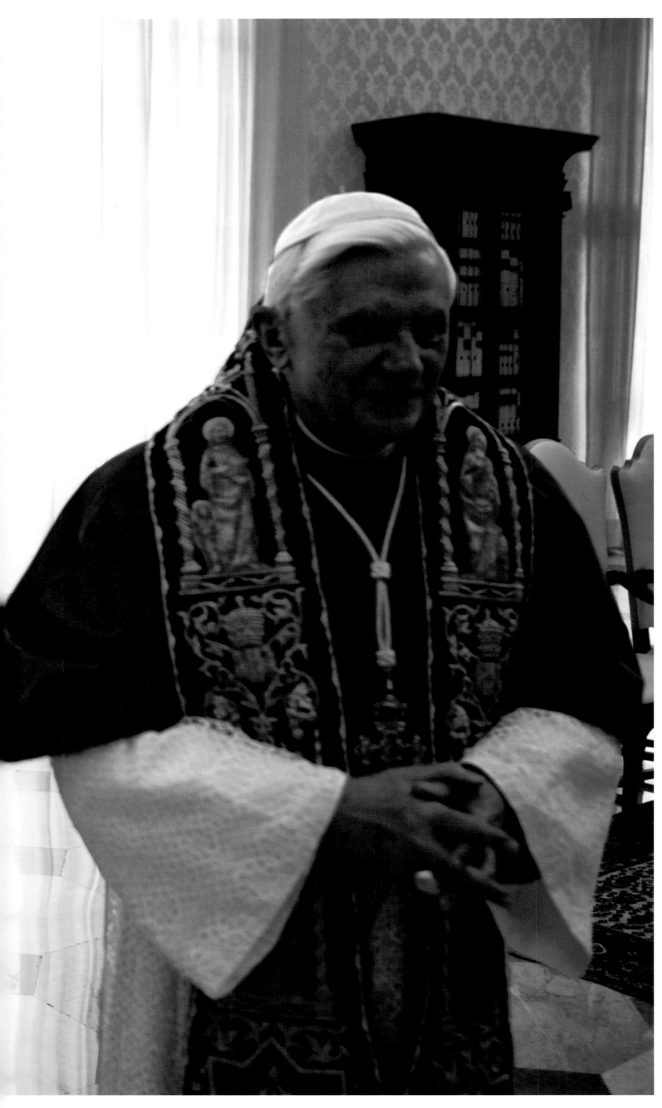

MONSIGNOR GEORG GÄNSWEIN

Personal secretary to the Holy Father

A composed and graceful shadow to the pontiff, this former theology professor moved over to the apostolic palace after serving as Cardinal Ratzinger's right-hand man at the Congregation for the Doctrine of the Faith. Gänswein, a German with a sharp sense of humor, is the singular point of reference in the management of Benedict's time and the list of visitors he receives.

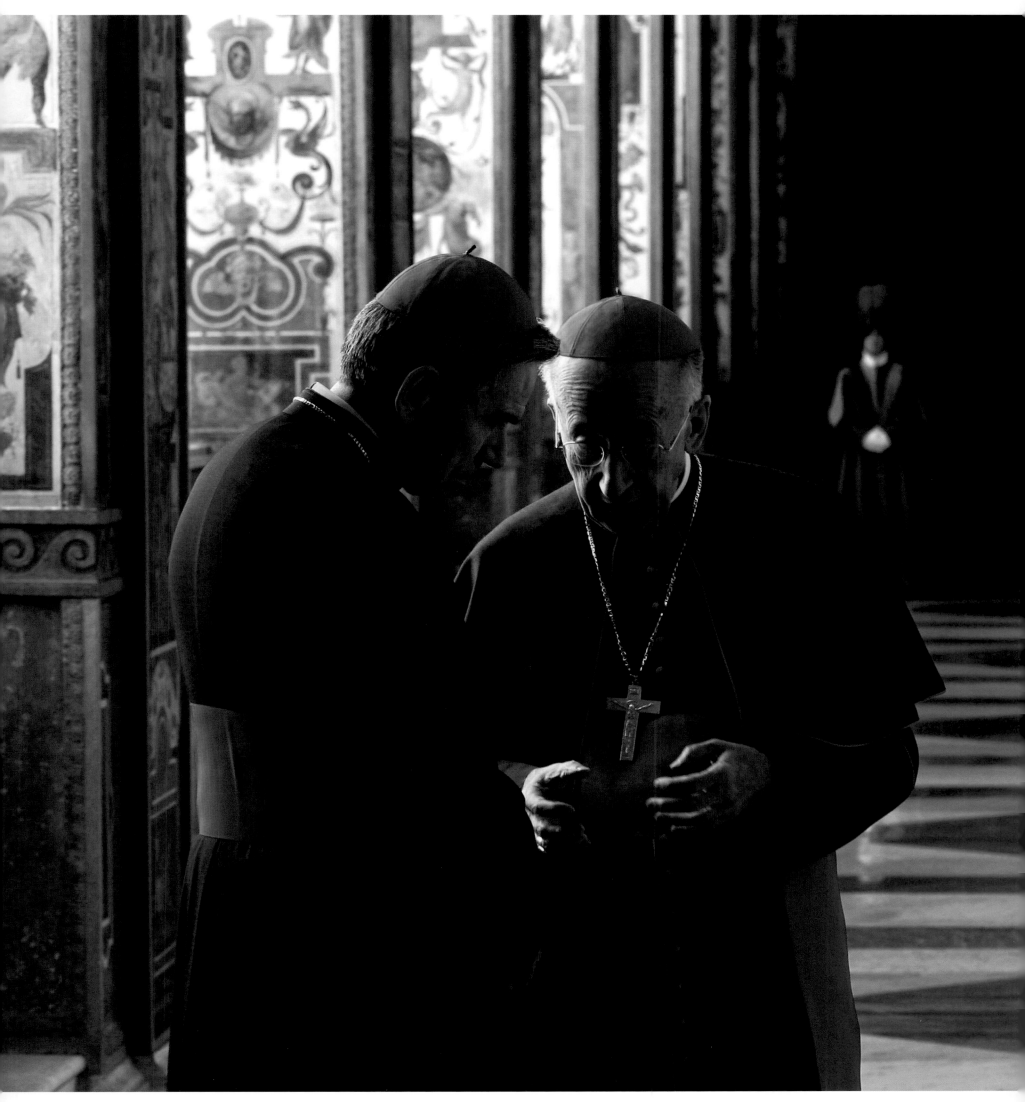

CARDINAL CAMILLO RUINI

*Vicar of Rome and President
of the Italian Bishops Conference*

Long an influential figure in the Curia, Ruini saw his stature grow even further in the early months of Benedict's papacy as he led battles to defend Church teachings in Italian public life, and was hand-picked to write the introduction to the pope's first published collection of writings.

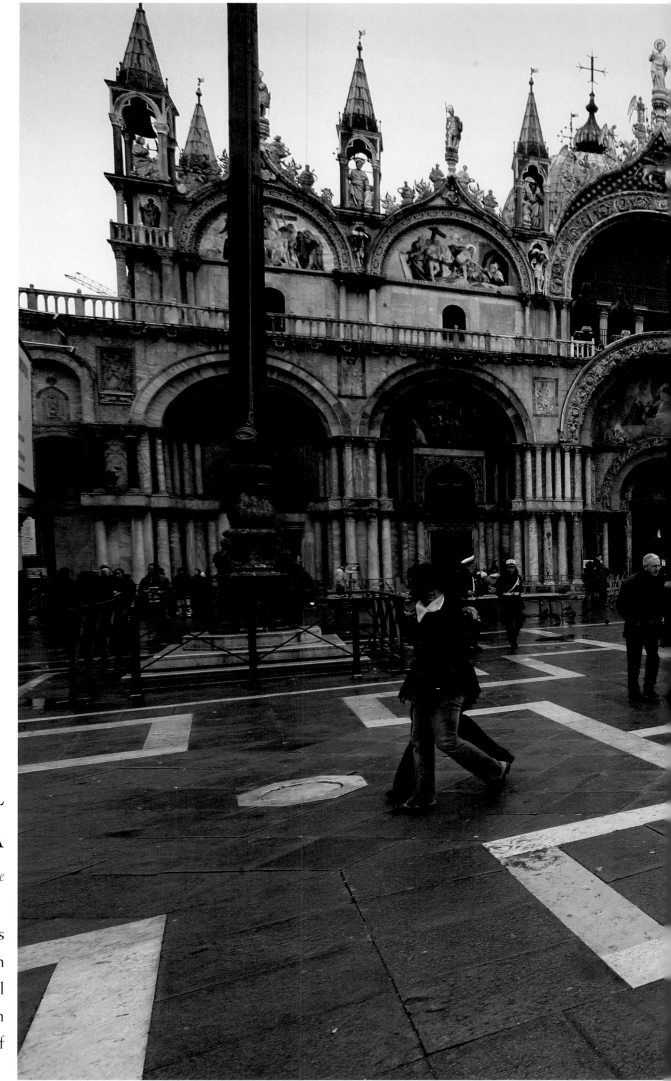

CARDINAL ANGELO SCOLA

Patriarch of Venice

A trusted disciple of Ratzinger, Scola is among the leading theological voices in the Church with a firm stance on moral and doctrinal issues. Benedict chose him to be the relator of the first Synod of Bishops in October 2005.

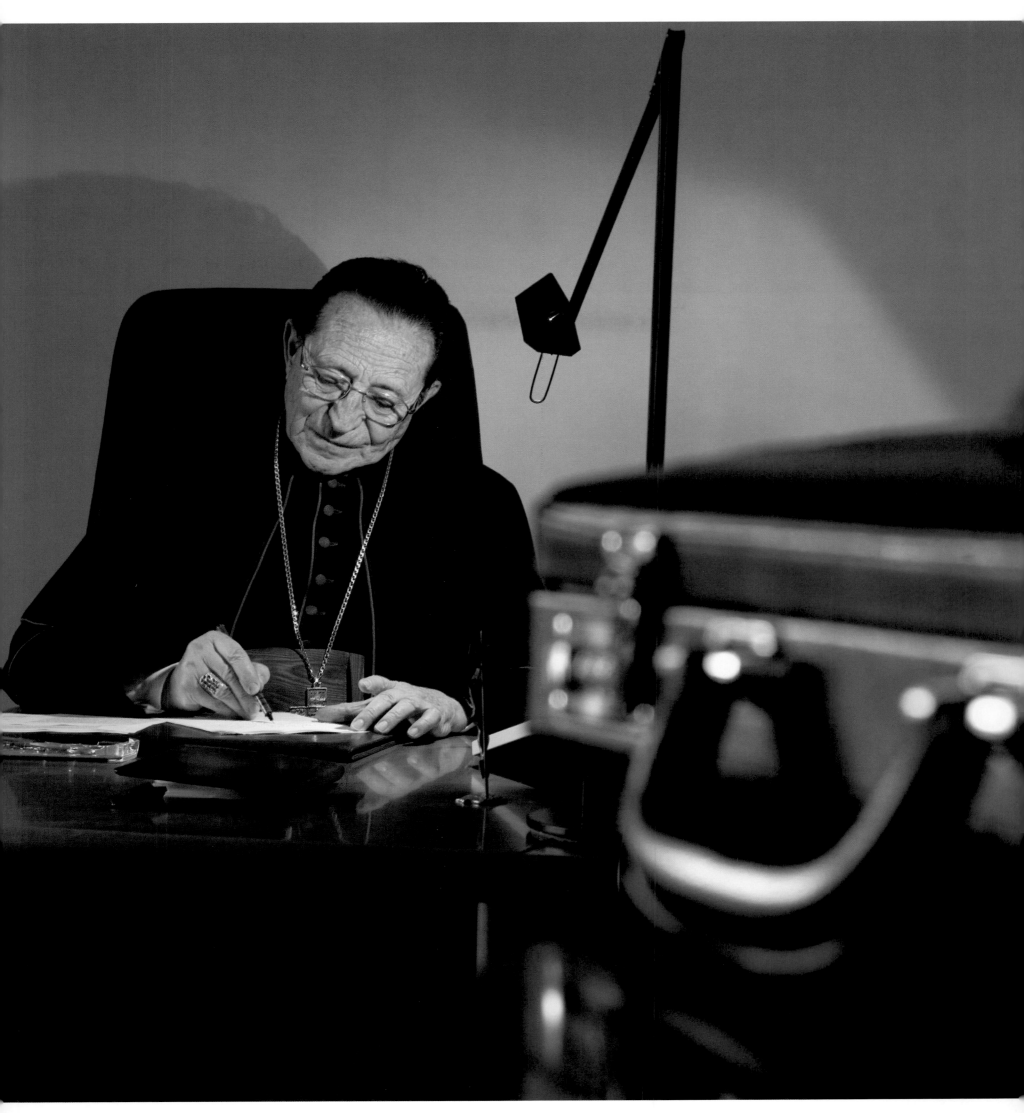

CARDINAL
JULIAN HERRANZ

*President of the Pontifical Council
for Legislative Texts*

A longtime Curia colleague of Ratzinger's, who has degrees in medicine and canon law, Herranz was ordained a priest by Opus Dei in his native Spain. He is considered both learned and likeable, whose influence in the Vatican is exercised with a quiet authority.

CARDINAL
WILLIAM J. LEVADA

Prefect for the Congregation for the
Doctrine of the Faith

Benedict surprised almost everyone
inside and outside the Vatican by choos-
ing the then Arcbhishop of San
Francisco to take his old job. Levada
worked under Ratzinger in the early
1980s at the same Congregation. Now
he is the Church's top man on ortho-
doxy, with the benefit of knowing
where to find the previous man in the
job.

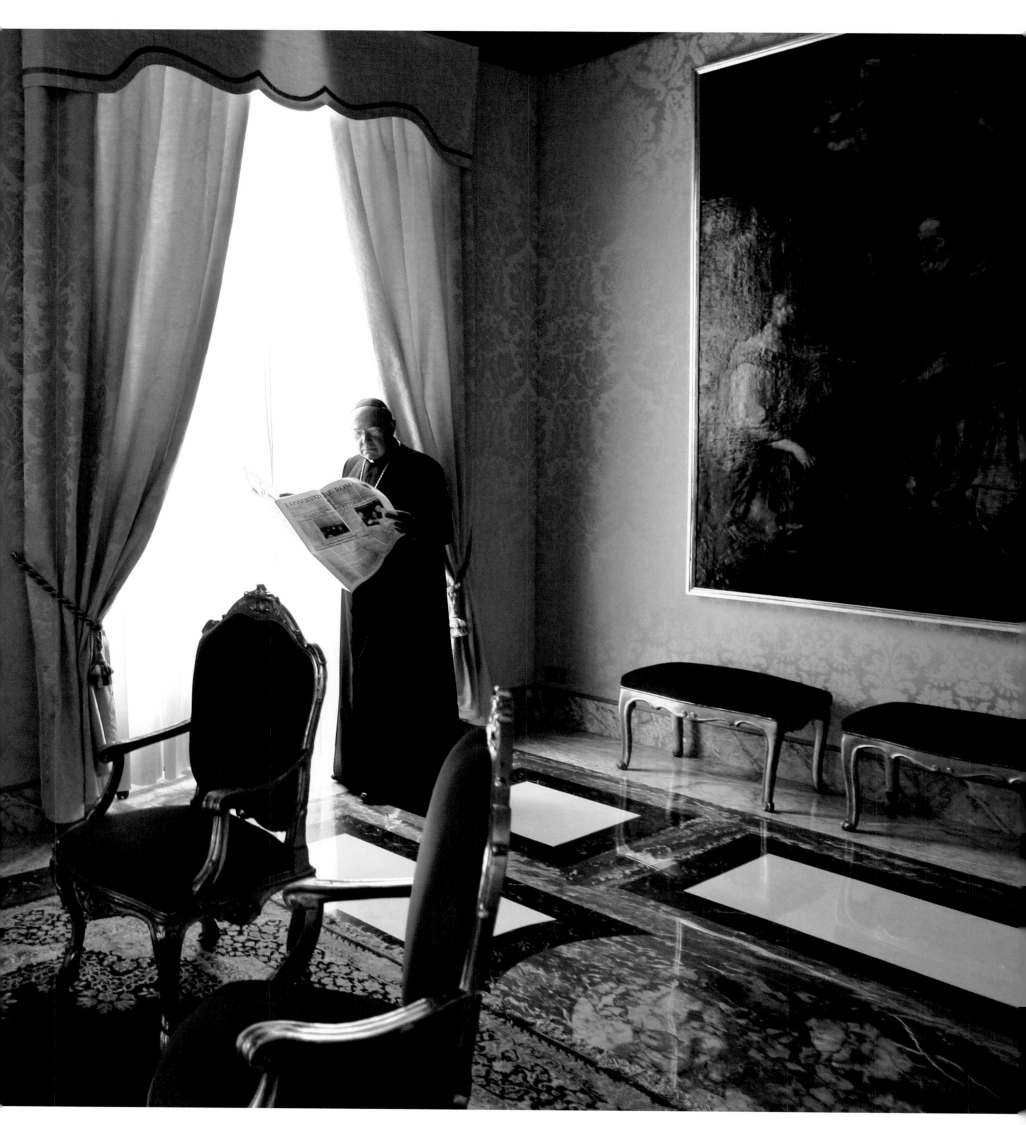

THE MESSAGE

An ancient story for a modern world

150-151 Benedict XVI has decided to keep in his papal crest all the symbols he used as a cardinal, albeit with a few modifications. The shield is divided into three: in the center, the shell represents the legend of St Augustine, who, coming across a child on a beach who was trying to scoop all the water in the sea into a hole in the sand with a shell, realized it was impossible for men to comprehend the mystery of God. On either side are two symbols from Bavarian tradition: the Moor on the left stands for the universality of the Church, while the bear recalls the legend of St Corbinian. The keys are the symbol of St Peter.

152 Smiling and relaxed, the Pope meets the Roman Curia in the Sala Clementina.

154 The pope's open car is surrounded by the faithful, who greet him with enthusiastic applause and call out his name after the Mass in the church of Santa Maria Consolatrice, in Casal Bertone in the outskirts of Rome.

155 The pope seems to have been captured in the act of leaping. In fact, it's a typical example of his long stride as he hurries onto the stage next to President of the Federal Republic of Germany Horst Kohler, for his arrival speech at Cologne airport.

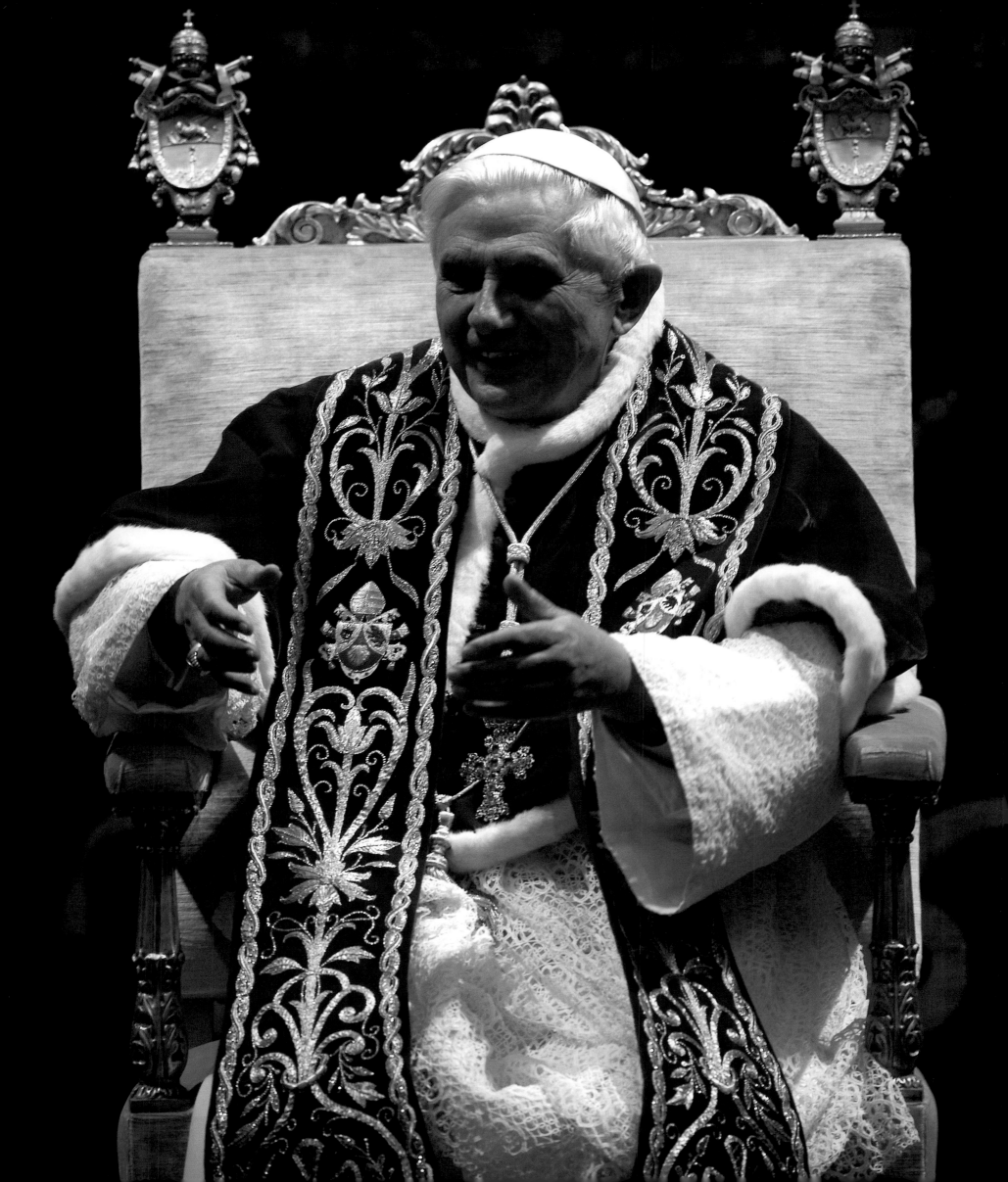

The triumphant life story of the man who would become Benedict XVI can also be read as a tale of the "theologian denied." Turning back in time to the bright-eyed priest immersed in St Augustine and Romano Guardini – and dabbling in Einstein and Dostoevsky – it is not hard to imagine Joseph Ratzinger destined to create a body of work that one day might place him among the all-time greats of Catholic theology. From the start of his studies, the young scholar caught the eyes of many of the top minds in the the rigorous world of German academia.

By the early 1960s, his growing reputation and collection of writings prompted Cardinal Frings, the Archbishop of Cologne, to bring the unassuming 35-year-old professor to Rome as his theological advisor at the Second Vatican Council.

Ratzinger's subsequent book, *Introduction to Christianity*, was a sensation in theology circles, stunning both in the breadth of its ambition and the remarkable simplicity of its argument. Could this be the next John Henry Newman or St Thomas of Aquinas, or even Ratzinger's own intellectual guiding light, St Augustine? The sheer brilliance and intellectual passion went far towards reconciling the eternal questions of faith with the unique challenges of the moment. With the Catholic Church still digesting the meat of Vatican II, it would seem just what was needed – and what this humble scholar was put on earth to do.

But suddenly, in 1977, this biographical trajectory was forever detoured. Pope Paul VI called on the 49-year-old Ratzinger to become the Archbishop of Munich. Four years later John Paul II would bring him to Rome to head the Congregation for the Doctrine of the Faith.

And though his own theological explorations and illuminations would never cease entirely, Ratzinger's personal studies would inevitably be held back by the weight of his institutional responsibilities. There was perhaps still a chance to write his magnum opus – back in the tranquility of his native Bavaria – when he twice submitted his retirement late in John Paul's papacy.

Those requests were gently denied by the ailing pontiff. And with Ratzinger's election to the papacy, the door finally and forever closed on his chances of entering the very top canon of Christian theology.

And so, instead, life's 'Plan B' for this would-be lifelong scholar now includes the calling to be the 265th Supreme Pontiff of the Catholic Church. As with the other unexpected assignments, it is increasingly clear that Ratzinger is quickly adapting to the fundamental requirements necessary for success. He soaks up the affection of the faithful, and returns it in kind. With a quiet air of authority, he commands the papacy's worldwide public stage and manages the mammoth Church bureaucracy. When he throws open his arms to salute the crowds or welcomes a foreign leader inside the Vatican's frescoed walls, it's hard to imagine back to that solitary doctoral student immersed in his books at the University of Munich. Even that familiar figure of the Cardinal Prefect keeping watch over the Church's doctrinal affairs seems, at this point, like a distant memory. After 78 years as Joseph Ratzinger, he is now – and forever – Pope Benedict XVI.

Still behind the public affection and the growing ease amidst the grandeur, the exacting student of ideas is still in charge. More than ever that piercing intellect will hold sway over the entire spectrum of Catholic Church life – its customs, policies, institutions – and above all, naturally, the papacy itself. The quick analysis says that the new pope is busy trying to devise a way to "downsize" the role of the pontiff after John Paul's 26-year tour de force. One Vatican official who knows Ratzinger well, and admired Wojtyla, said soon after his election that Benedict "wants to simplify the papacy. Too many acts have become a simple devotion of the person of the pope." Much indeed would seem to point to a wholly new kind of pontiff: the natural sway of history's pendulum, the personality of the new man in charge, his age, and even the very ideas that Ratzinger, the theologian, had expressed in the past about the chair of Peter. In the throes of John Paul's greatest popularity, Cardinal Ratzinger was looking for ways to rein in

the papacy and the Curia. In his 2000 book *God and the World*, Ratzinger declares that the Vatican's essential purpose is "to ensure that the Pope has sufficient freedom to carry out his ministry. Whether this could be simplified further is a question we may ask." With the confluence of Catholic institutions in Rome, with the quantity of papal writings and discourses and other responsibilities, he wonders: "whether it is not all far too much." Meditating on the contemporary pope, Ratzinger concludes: "The

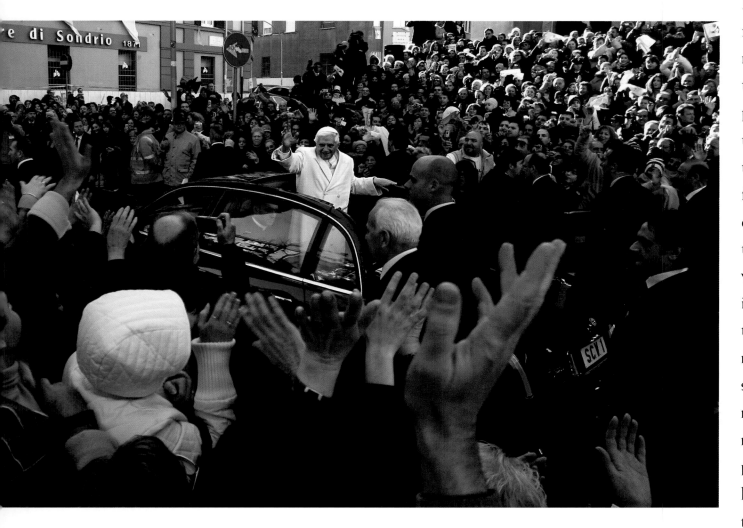

sheer quantity of personal contacts imposed on him by his relationship with the Universal Church; the decisions that have to be made; and the necessity, amidst all this, of not losing his own contemplative footing, being rooted in prayer – all this poses an enormous dilemma."

These very practical (and spiritual) concerns of Cardinal Ratzinger are already being addressed by Pope Benedict. He halted the practice of holding morning mass with visitors, there are fewer meetings with Church officials (apostolic *nunzios* visiting from around the world get a

brief chat – on their feet – at the end of Wednesday general audiences), speeches are shorter, lunches tend to be restricted to his personal secretary and perhaps one or two visitors. How far he extends this management policy into the heart of the entire Vatican bureaucracy remains to be seen.

But it is clear that the pope himself – who already plans fewer encyclicals and foreign trips journeys than his predecessor – is doing things differently. But before getting hooked on the "downsize" storyline, remember that this master thinker is too smart not to understand the singular power of his current office or to fail to appreciate the importance of how John Paul transformed the papacy. Benedict does not want to toss away this hard-won leap in relevance: for unifying and purifying the Church, for preaching to the world, and inspiring the masses. In this day and age, a strictly cerebral pope, or administrator pope, would waste much of what can be accomplished from this unique public perch. It is a challenge that the famed 20th century philosopher of modern communication theory Marshall McLuhan would comprehend. The Canadian-born writer, who coined the phrase "the medium is the message," was also a devout Catholic. In a conversation recorded by his wife, McLuhan once said: "Christ came to demonstrate God's love for man and to call all men to Him through himself as Mediator, as Medium. And in so doing he became the proclamation of his Church, the message of God to man. God's medium became God's message."

The challenge for a pope today is to transmit himself

(as messenger and message), without creating static interference between the faithful and the gospel itself.

Ultimately, the great gift that Benedict has to offer is his clarity of mind and ability to communicate with words. The would-be theological wunderkind has quite simply turned into a master teacher. His first encyclical *Deus Caritas Est* masterfully illuminates the Catholic Church's teaching that love – the essence of God – should be both the end and the means in human relations.

The 72 pages are as accessible as they are profound. Whatever the topic, wherever the occasion, Benedict aims to strike a contemporary chord, using language that often doesn't quite sound like a pope. On the feast of the Immaculate Conception, he turned his attention to Original Sin, employing the inimitably contemporary concept of "boringness." "There emerges in us the suspicion that the person who doesn't sin at all is basically a boring person, that something is lacking in his life, the dramatic dimension of being autonomous, that the freedom

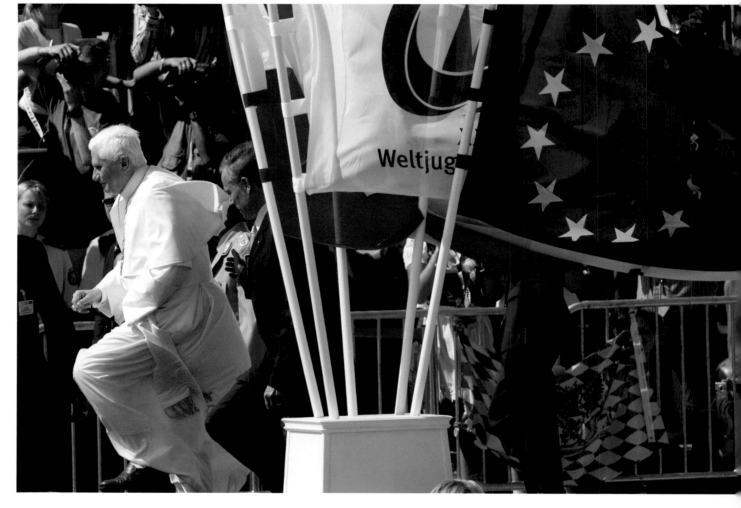

to say 'no' belongs to real human beings," he said. "We think that bargaining a little with evil, reserving some freedom against God is good perhaps even necessary. But if we look at the world, it is not so. Evil always poisons. It does not elevate man, it degrades and humiliates him." His predecessor's gestures made the faithful take notice. Benedict will connect with the power of his prose.

He is distinctly aware that his role also requires a dialogue with non-Catholics – and non-believers. It is a dialectic that he has confronted for decades. Nearly four decades ago in *Introduction to Christianity* he observed that "No one can lay God and his Kingdom on the table before another man; even the believer cannot do it for himself. But however strongly unbelief may feel itself thereby justified it cannot forget the eerie feeling induced by the words 'Yet perhaps it is true.'... In other words, both the believer and the unbeliever share, each in his own way, doubt and belief." The newly elected pope updated this notion by suggesting to non-believers to live their lives "as if there was God" for the moral guidance it could provide. Benedict's words however are not a mere intellectual exercise, they are a manifestation of his faith and his humanity. Day by day, we are starting to see this holiness manifest in ways that go beyond words. For the modern papacy will continue to be about gestures, large and small; about how that solitary figure in white carries himself before the masses, on television, in photographs; how the message, in whole new ways, becomes one with the meessage.

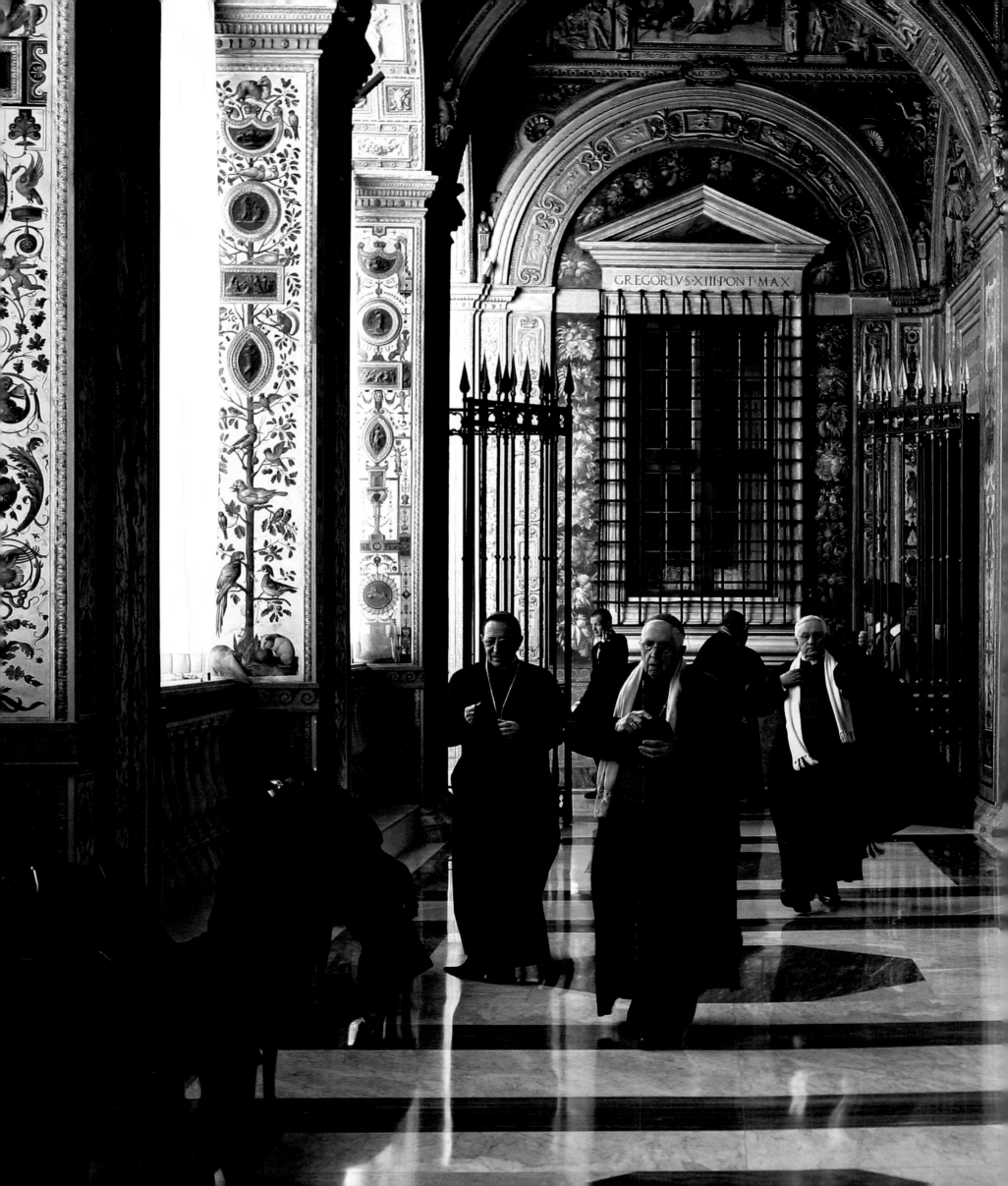

156-157 *The cardinals make their way through the splendid Loggia of Raphael, where they remove their overcoats, before going through to the Sala Clementina for a meeting with Pope Benedict XVI and an exchange of Christmas greetings.*

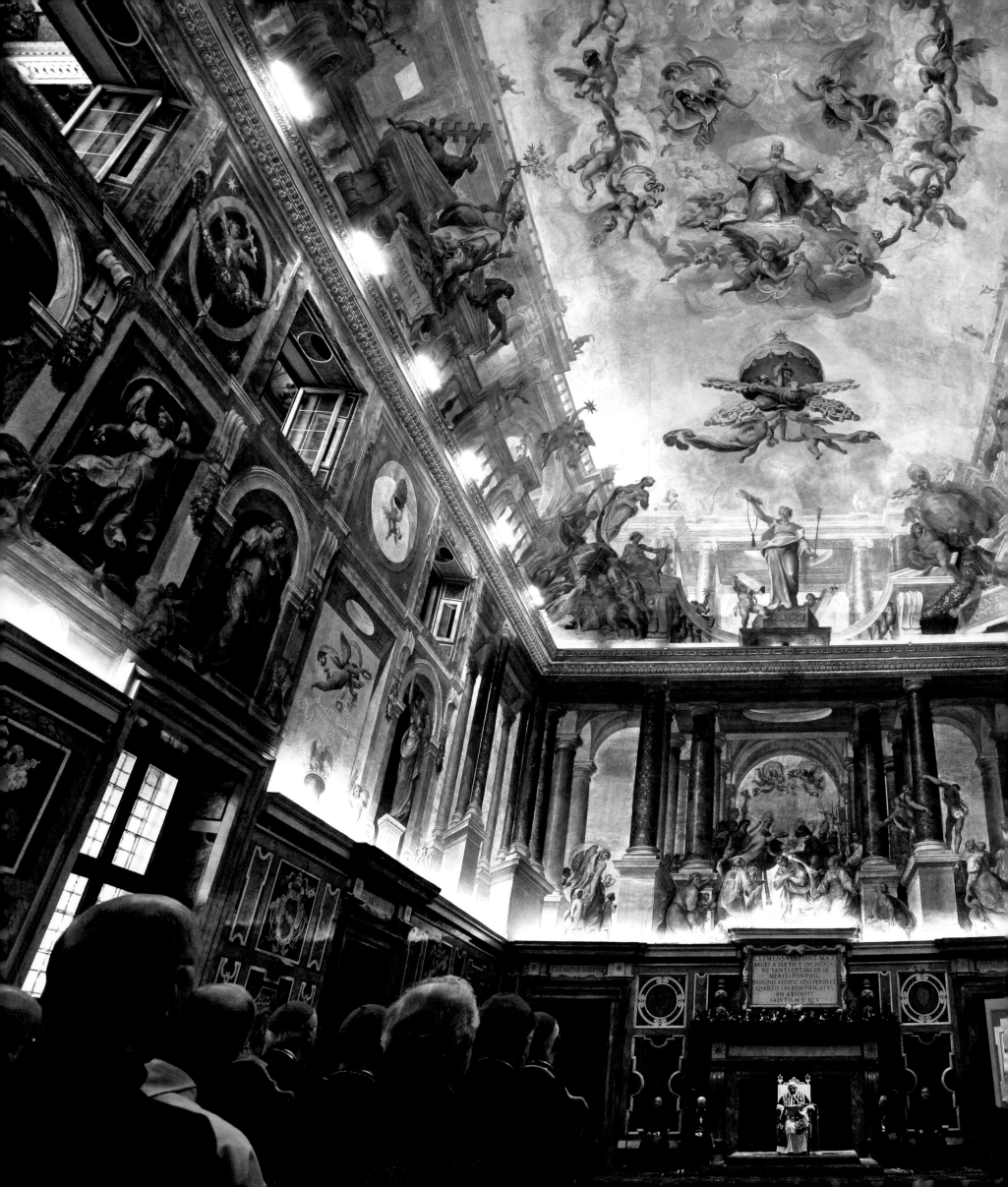

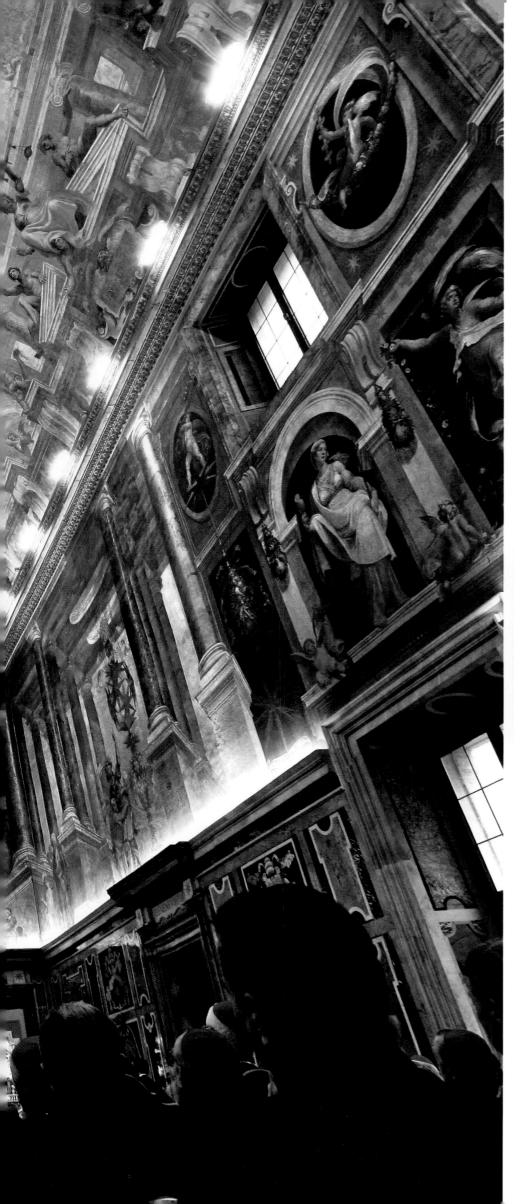

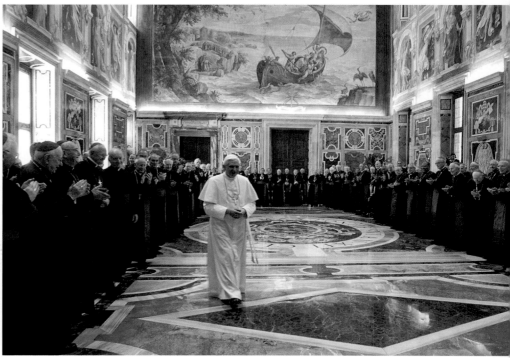

158-159 Benedict XVI is welcomed by the Roman Curia in the Sala Clementina.

159 Three days after his election, Pope Benedict meets all his cardinals in the splendid setting of the Sala Clementina. In a relaxed atmosphere of joy and affection, and recalling John Paul II, he asks for their support in guiding the Universal Church.

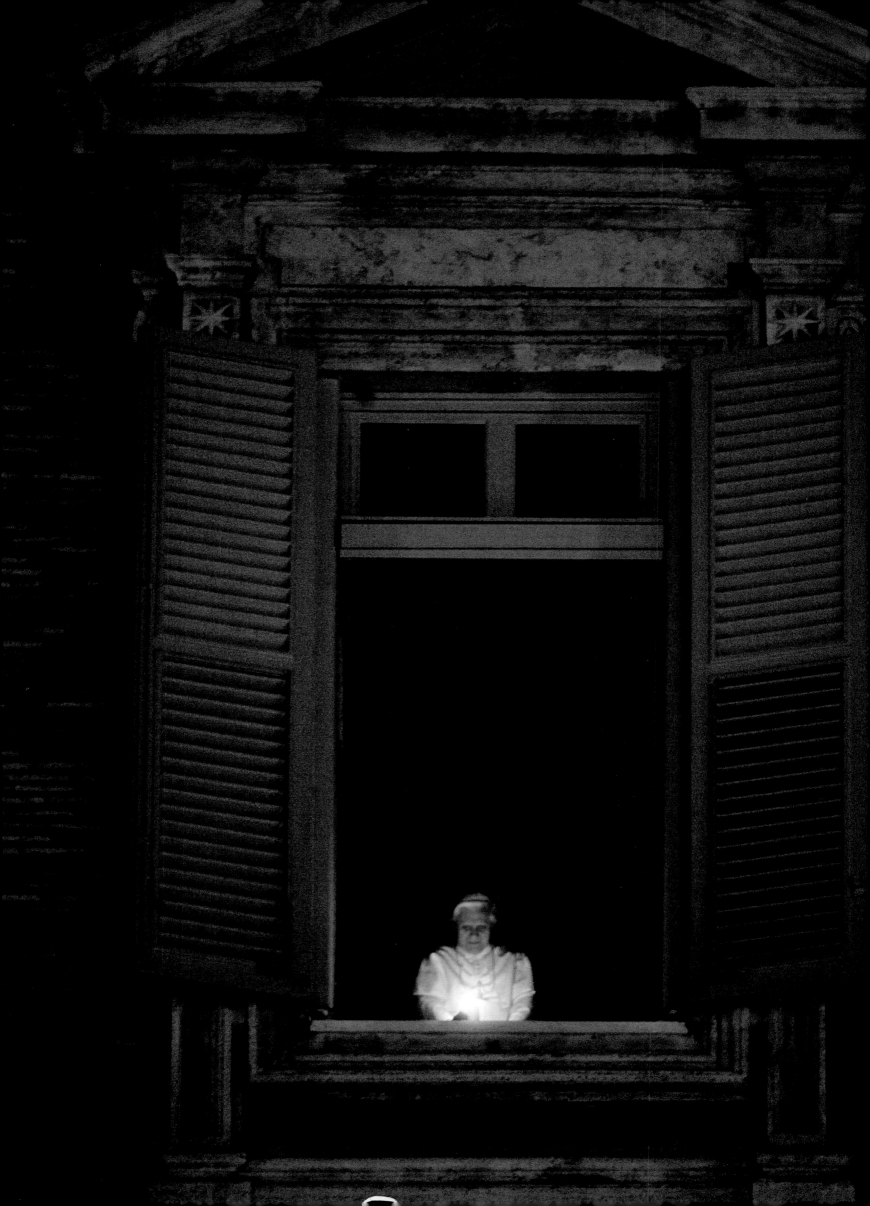

160 and 161 On Christmas Eve, Benedict XVI lights the candle of peace at the window of his private study. In his Christmas message the pope recalled that where there is love, light floods in, but where there is hatred, the world is in darkness. And in this spirit, the light of Bethlehem has never gone out.

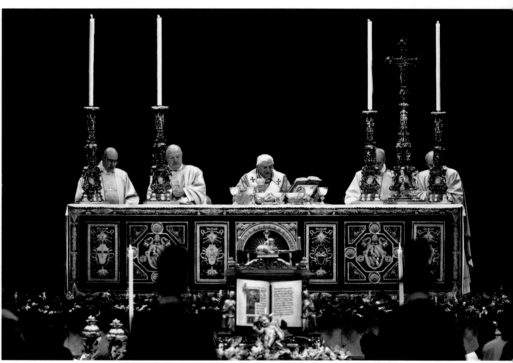

162-163 and 163 The statue of the Infant Christ placed on a carpet of flowers under Bernini's altar is at the heart of the atmospheric Christmas Mass, Benedict's first as pope, held at midnight in St Peter's Basilica.

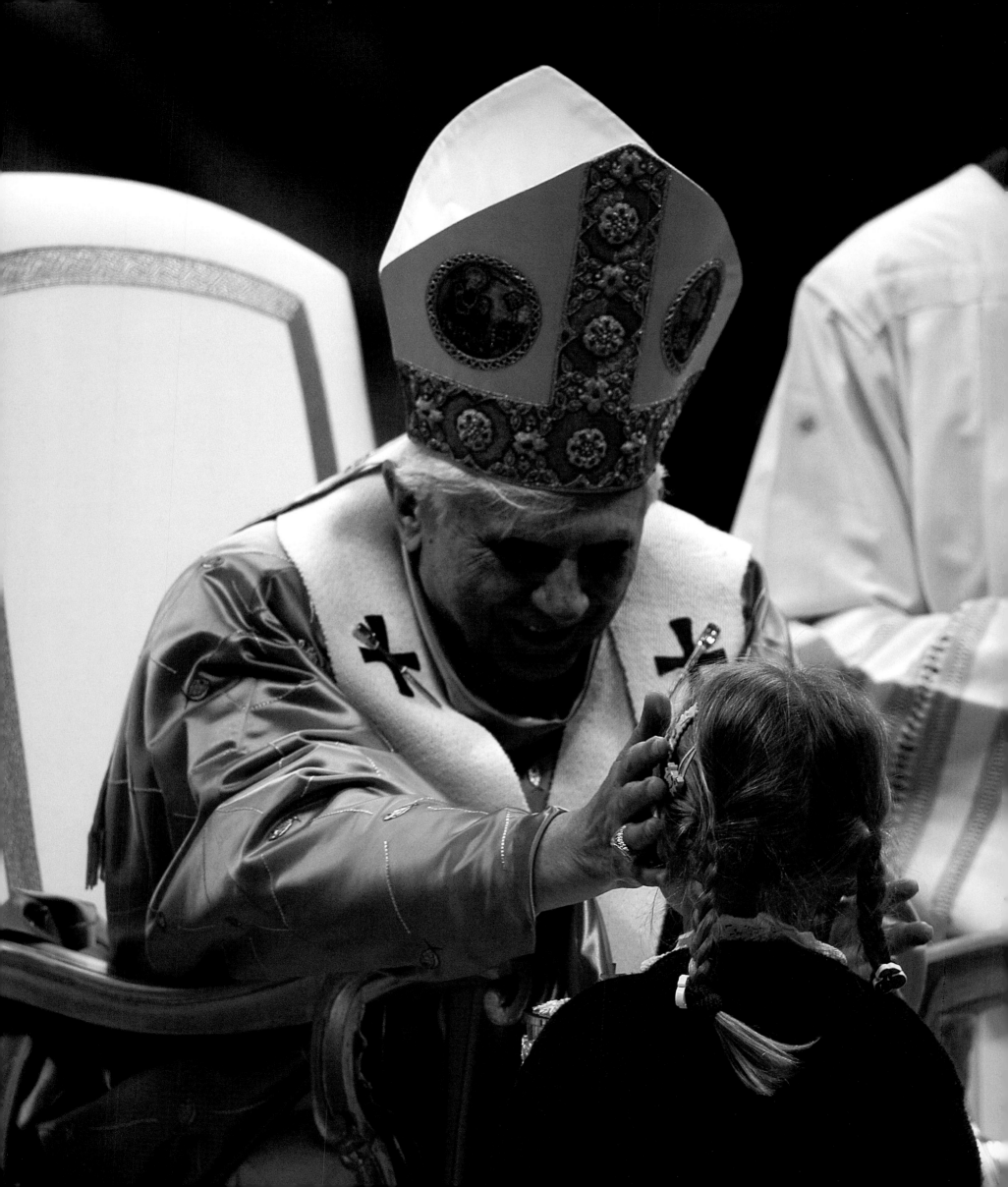

164-165 *Benedict XVI greets with a gentle stroke and a smile two little girls who have attended Christmas Mass. The Holy Father made an appeal for peace before the faithful crowded into St Peter's, broadcast live by television stations around the world.*

166-167 *At the end of the midnight Mass, during which he prayed for Bethlehem and for peace in the Holy Land, the pontiff leaves the basilica smiling and waving to pilgrims, who have been waiting through the cold, since 5:00 o'clock that afternoon.*

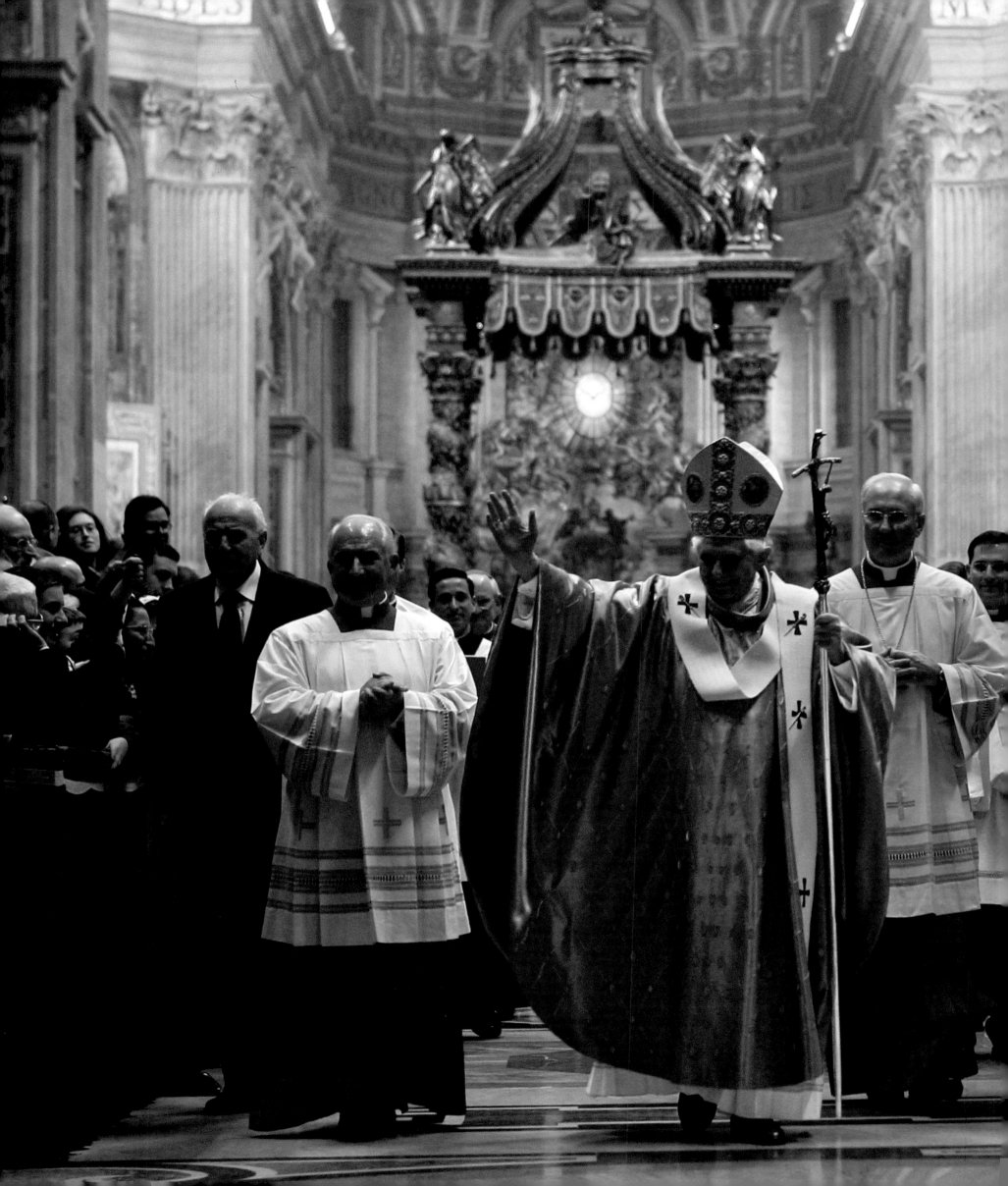

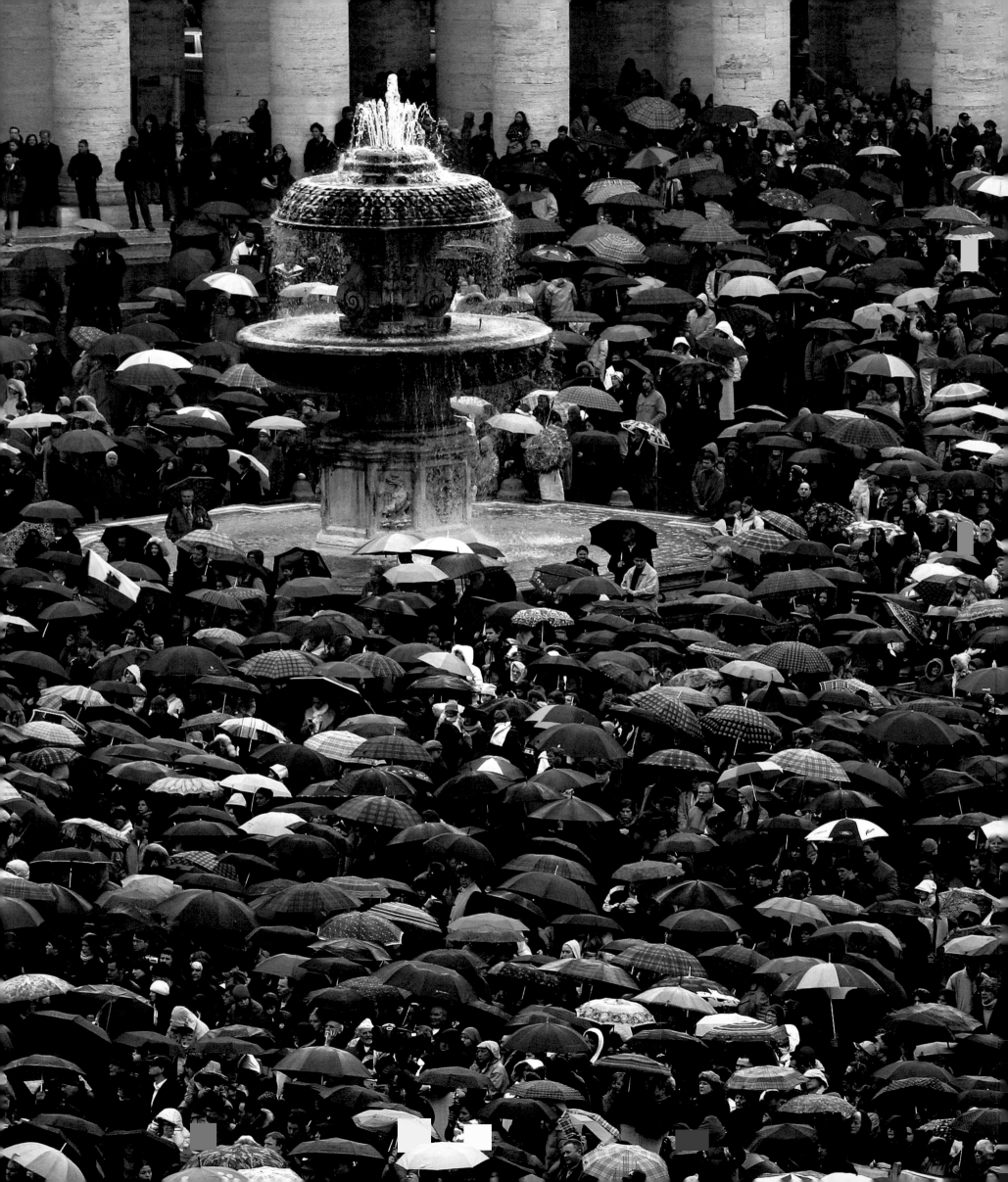

168-169 and 169 *The steady rain and cold did not stop the thousands of worshippers thronging St Peter's Square to hear Benedict XVI's first* Urbi et Orbi *message, their eyes fixed on the main balcony of the basilica. Recalling the terrorist threat and the poverty suffered by millions of human beings, he called for peace and a new world order based on proper ethical and economic relationships.*

170-171 *The Pope acknowledges the crowd from the central balcony of St Peter's Basilica at the end of his* Urbi et Orbi *message and expresses the hope that Italy will retain a firm hold of its Christian roots, exhorting everyone to keep alive their religious commitment.*

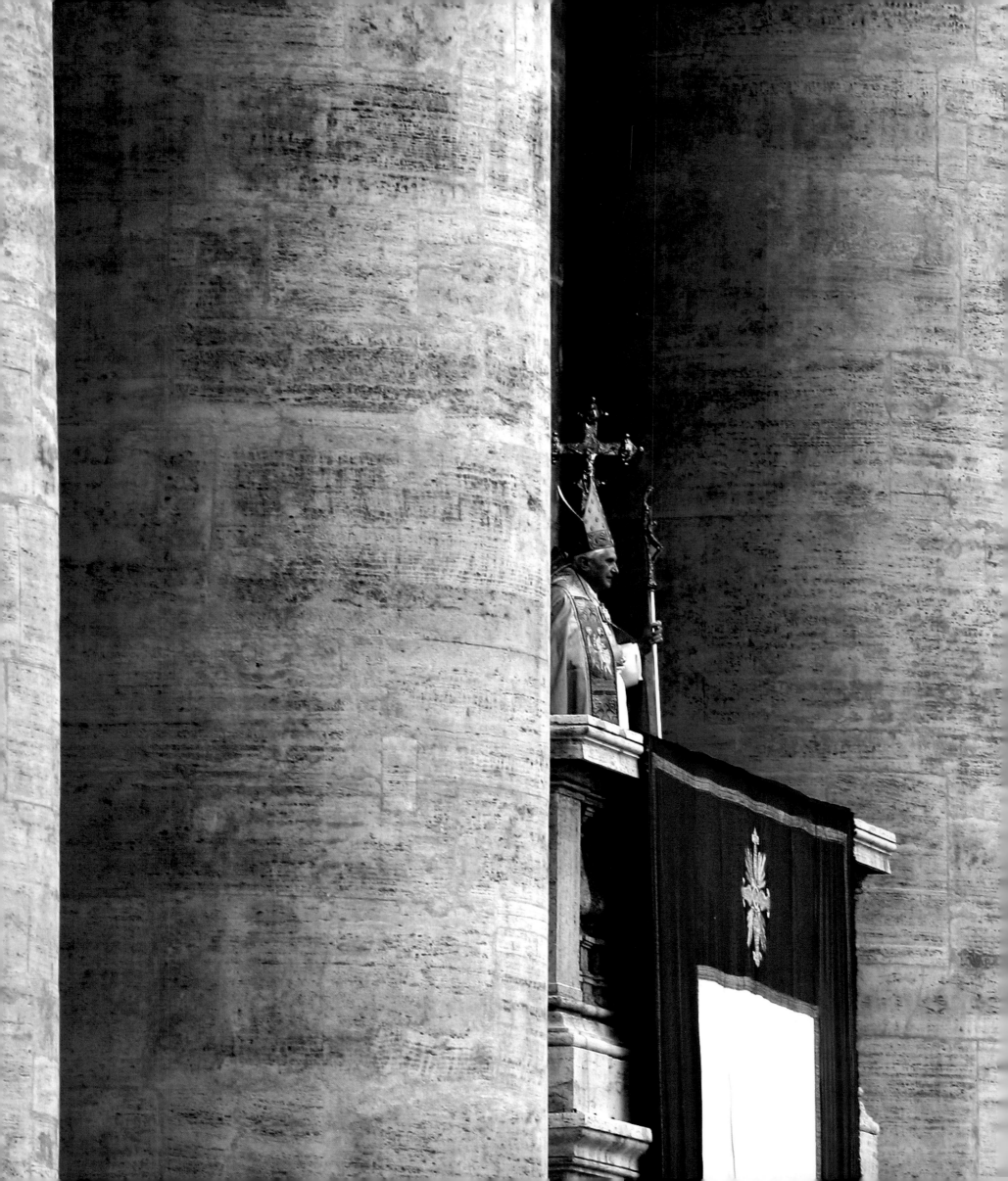

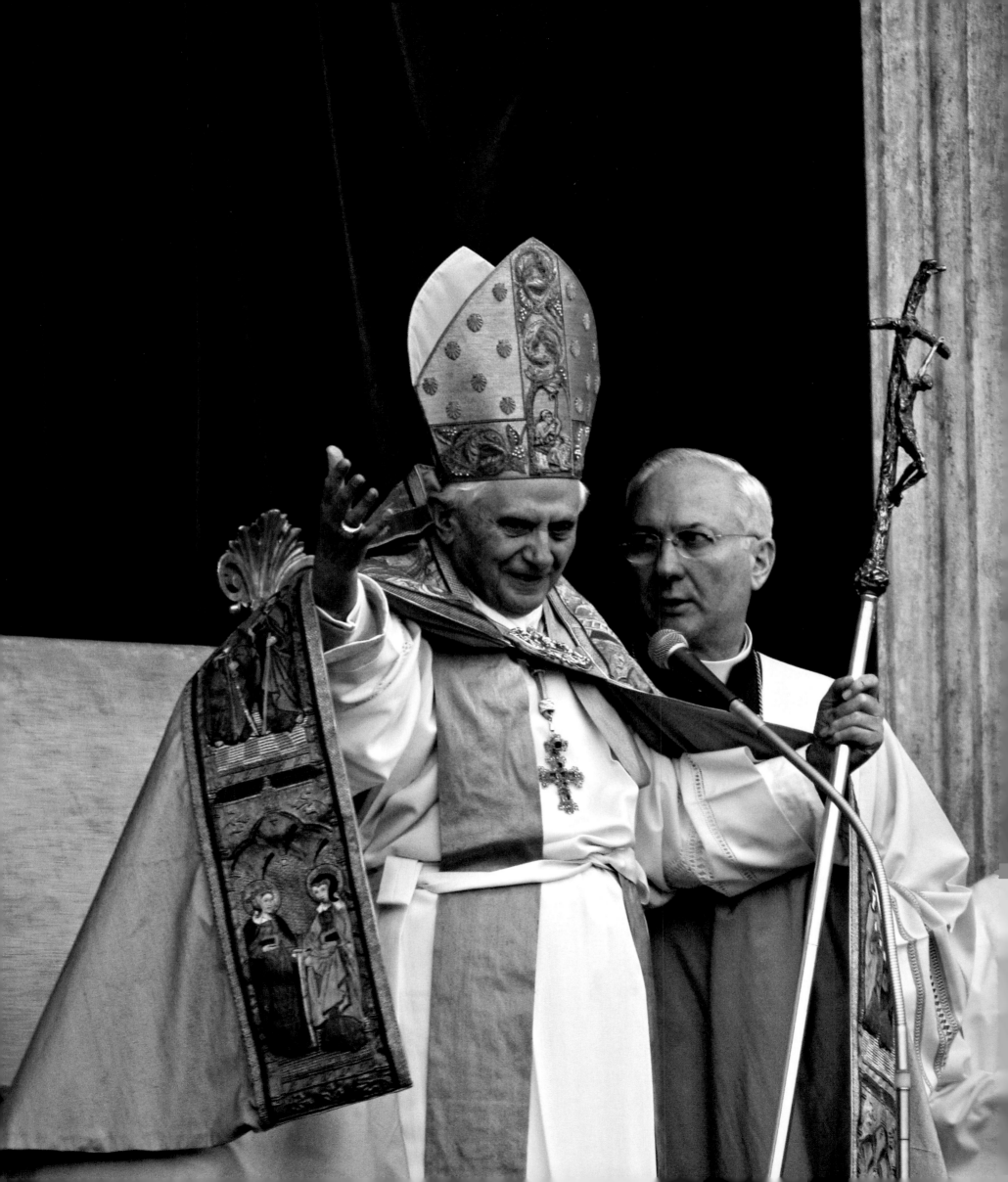

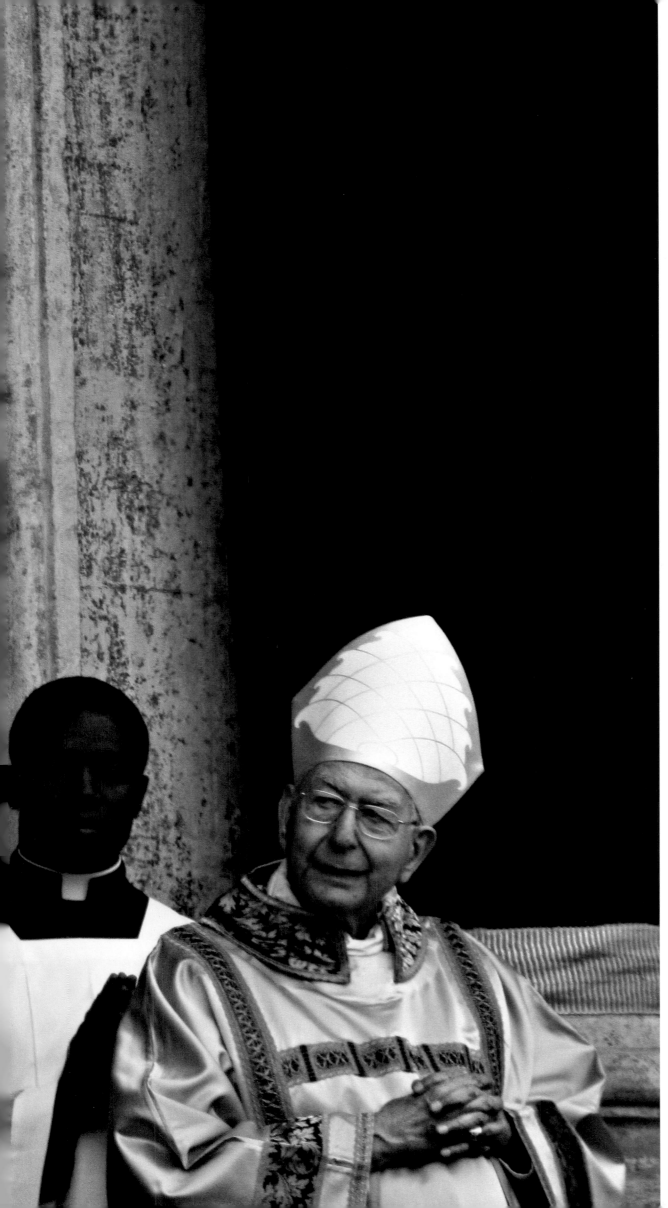

172-173 *After his Christmas greetings repeated in thirty-three languages, Benedict XVI reads a special wish taken from St Augustine in Latin, "Expergiscere, homo, quia pro te Deus factus est homo." ("Awaken, O Man, because God has become man for you.").*

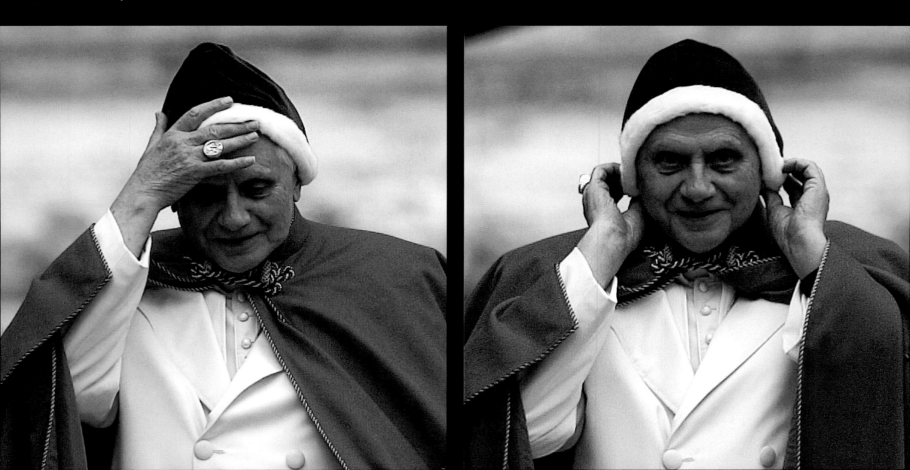

All photographs are by © Gianni Giansanti/2005,
with the exception of those listed below:
Pages 12-13, 34, 37, 39 top, 61, 74-75, 100-101, 104,
108-109, 159: Arturo Mari/Osservatore Romano
Pages 53, 84, 90-91: Giancarlo Giuliani/Vatican Pool
Page 78: Joaquin Navarro-Valls
Pages 105, 111: Franco Origlia/Vatican Pool
Page 108 top: Gregorz Galazka/Vatican Pool

© 2006 White Star S.p.A.
Via Candido Sassone, 22/24
13100 Vercelli, Italy
www.whitestar.it

Photographs © **Gianni Giansanti** - 2005
Text © **Jeff Israely** - 2005

Translation captions: **Julian H. Comoy**

ISBN 10: 88-544-0162-5
ISBN 13: 978-88-544-0162-4

REPRINTS:
1 2 3 4 5 6 10 09 08 07 06

Printed in China